Van Gogh

ALSO BY JULIAN BELL

Bonnard

What Is Painting? Representation and Modern Art

Mirror of the World: A New History of Art

Van Gogh

A POWER
SEETHING

JULIAN BELL

ICONS SERIES

amazon publishing

Published by Amazon Publishing, New York

www.apub.com

Amazon, the Amazon logo and Amazon Publishing are trademarks of
Amazon.com, Inc. or its affiliates.

ISBN-10: 1477801294
ISBN-13: 9781477801291

Author photograph by Elizabeth Roberts
Cover design by Rodrigo Corral Design

This book is dedicated to the memory of
Oliver Lindsay Scott, 1951–2011

Contents

Introduction

I HAVE WRITTEN THIS book out of my love for Vincent van Gogh, the uniquely exciting painter, and Vincent van Gogh, the letter writer of heart-piercing eloquence. Researching it, I have gotten to know something of Vincent the social animal, the misfit tearing a ragged course through the late nineteenth-century Netherlands and France. I have also come to love this third side of Vincent, although I do not always *like* him. I have written the book because, as I see it, there is an open space among the three facets of the man. Although the letters offer the greatest commentary any artist has ever supplied on his own work, they may often be at odds with what Vincent actually painted and with the record of his actions, and indeed they are frequently at odds with one another. These internal differences ask for some outside voice to interpret them. My objective has been to offer an interpretation that is up to date, unmystified, concise and at the same time compassionate.

Concision is the objective because at the point at which I write, in 2013, the resources for biography have become so huge. When it comes to the more than twenty-one hundred paintings, drawings and prints that Vincent produced during his ten-year career as an artist, the one-volume catalogue raisonné by Jan Hulsker (last revised in 1996) is now being supplemented by a series of catalogues detailing the collection of Amsterdam's recently refurbished Van Gogh Museum. The volumes that have

been published to date are models of contemporary scholarship. The same is true of the marvellously produced complete edition of the letters, published in 2009 and edited by Leo Jansen, Hans Luitjen and Nienke Bakker. When it comes to the factual record of actions, anyone such as myself who is interested in Vincent can only be deeply grateful to Steven Naifeh and Gregory White Smith for the thoroughness with which they have compiled and interrogated the evidence in their 953-page *Van Gogh: The Life* (2011), however one may judge their deductions.

I come to this task with my own experience of working as a painter. From that angle, Vincent's actions seem to matter because his paintings matter, rather than vice versa. I believe he would have agreed with that order of priorities, and I also believe that much of his life was spent joyfully because it was spent in this kind of work. Nonetheless, my sense of the occasion, as I put forward this account of Vincent, has less to do with painting than with performance. With such an orchestra of information as is now at hand, with such a complex score, a newcomer can only mount the stage in trepidation. Here follows an attempt to find the melody and pitch.

Van Gogh

I

Saint

I

AS A BOY, Vincent van Gogh liked exploring scrub and
stream banks. His eyes would be drawn to a wren's nest
hidden in a heathland bramble patch, with its cone of
stalks and leaves and moss, or to those of sparrows and thrushes
in the hawthorns, or the woven hammocks of the golden oriole.
(Count the wren and the oriole "among the artists," he would
later write.)[1] Nearer home, he would crouch at a creek, reach-
ing between cress and rushes to snatch up diving beetles and slip
them in a bottle.

The province of Brabant, straddling the Netherlands' bor-
der with Belgium, is largely poor, sandy land, and as of the
1860s, the acreage won from its heaths and oak- and pinewoods
was still quite slight. These rye fields stretched beside one bank
of the stream, homes to larks that rose from them in summer.
On the other, meadows and potato plots bordered the path
sloping up towards the garden gate. Elisabeth "Lies" van Gogh,
six years Vincent's junior, remembered the figure her brother
cut as he approached that gate: stocky, forceful, with his shoul-
ders hunched and his brow furrowed over "small and deep-set
eyes."[2] He would brush straight past the game she was playing
with Anna and Theo — the children in between, born two and
four years after him — make his way past his parents, who spent
much of their time in the garden, and head upstairs. In the
second-floor bedroom he shared with Theo, he would empty

the bottle. He added the expedition's insect haul to a collection in a lined cardboard box, neatly inscribing Latin names above each pinned specimen.

Vincent's mother — also Anna, née Carbentus — was in the garden to tend its beds of marigolds and moss roses, to instruct the gardener as to the pea rows and fruit trees beyond and to encourage her children to work the plots she'd assigned them. Her husband, Dorus (short for Theodorus), liked to sit there to write his sermons. Sunday mornings, Dorus stepped out the front door — his family behind him, likewise dressed in black — and headed right along the south side of the market-place of Zundert, crossing another sandy village square, to take up his duties as rector to the Dutch Reformed Church. Little admired in the pulpit — a short, slight man who mumbled and rambled — he nonetheless maintained moral, educational and financial authority among his small congregation, standing up for Protestant interests in a predominantly Catholic corner of the Netherlands.

While most of Zundert's peasantry shared a faith with their fellow Brabanters across the adjacent Belgian border, the Van Goghs upheld urban Dutch culture in the straggling heath-side settlement. Improving reading matter filled the parsonage. The Bible held supremacy, but so much in modern writing seemed to complement it. Charles Dickens's *A Christmas Carol* urged those huddled together at the fireside to feel how desolate life could become without mutual compassion. Johann David Wyss told the tale of *The Swiss Family Robinson,* in which the close-knit members, shipwrecked on a tropical beach, take on the wilds of nature and master them. Here was an imaginative overlay on Vincent's forays to the heath and the stream, to complement the species identifications that natural history volumes could offer him. Equally, the boy's feel for the life of small things found a voice in the fairy tales of Hans Christian Andersen, which lent quirky, tremulous personalities to saplings, flowers and shoes.

Dickens, Wyss and Andersen steered their readers towards kindly social responsibility, and this chimed with Dorus's preferred line in contemporary Dutch Protestantism. The Groningen school of theology proposed that God speaks to each of us through our hearts; that our experience of the natural world is one of the languages He employs; and that the church's role was less to instil than to nurture and facilitate this moral education. It was a temperately progressive position in an era resounding with the Romantic writings of the early nineteenth century and with the aftershocks of the French Revolution and its radical sacrilege. Dorus's own remit, however, was not so much to move things forwards as to stand firm, upholding his own denominational "pillar of society" (as Dutch phraseology expressed it) — one component of the stout edifice that was the nineteenth-century Kingdom of the Netherlands. One hand he outstretched to help the needy — such Protestant peasants of the parish as were ailing or down on their luck — while the other saluted the fortunate, the respectable. The rector's ambitions were as modest as his physical stature; his whole working life would pass this way, uncomplainingly spent in the backwoods of Brabant.

Dorus had followed his own father's footsteps into the church, taking up the Zundert post in 1849. Nonetheless, the Van Goghs had long considered themselves somebodies — persons with "honorable positions in the world," as Johanna "Jo" Bonger, Vincent's sister-in-law, would express it in a memoir. Among them, as in the Dutch state more generally, pious duty walked shoulder to shoulder with worldly success. Two of Dorus's older brothers had gone into the military — one, Jan, to end up an admiral — while another three started businesses. Hendrik "Hein" van Gogh with his bookshop in Rotterdam and Cornelis "Cor" van Gogh with another in Amsterdam were both outshone by the spectacular good fortunes of Vincent "Cent" van Gogh, for whom Hein would end up working.

"Uncle Cent" rode the midcentury European economic boom by selling pictures. Reproductions — steel engravings, and then photogravures, showing historical or religious scenes, far-away places, cute children and animals and whatever else would grace a respectable home — were the mainstay of his emporium in The Hague. With numerous local picture makers to draw on from a Dutch tradition of *fijnschilderij* (meticulous naturalistic painting) that had on some level survived since the nation's artistic "golden age" two centuries before, Cent also brought in lines of imagery from salons and academies abroad. His flair for the picture business caught the eye of a yet larger player in that field, Adolphe Goupil in Paris, who invited him to join forces. From 1861 onwards, after Cent became junior partner in Goupil & Cie, he inhabited a lofty financial and social plateau, with one mansion in Paris and another custom-built outside Breda, the town in Brabant where his father had preached.

Cent and the slightly younger Dorus — the debonair cosmopolitan and the earnest rural parson, the man of a thousand pictures and the man of the true Word — made unlikely brothers, yet marriage interlinked them. Anna Carbentus, Dorus's wife from 1851, was the older sister of Cornelia, whom Cent had wed the year before. It helped the matchmaking that the women were on a social level with the men: Their father, Willem, ran a prominent bookbinding business in The Hague. The Carbentuses were pious, sturdy hard workers, Anna, in particular, being credited by Jo Bonger with an "unbroken strength of will." They were also, it appears, cursed with psychochemical ill luck. One of Anna and Cornelia's seven siblings was classified "epileptic"; another died, in obscure circumstances, by his own hand; and Willem himself would succumb in his fifties to some form of "mental disease."

Cent and Cornelia's marriage produced no children. Dorus and Anna began their family with a son named Vincent ... began it this way, in fact, twice over. The first recipient of the

name was stillborn, and his headstone to this day confuses visitors to the Zundert Dutch Reformed Church. The other, born exactly a year onwards on March 30, 1853, would be buried in France thirty-seven years later.

2

There were beetles, birds and their nests, and the words in the books that identified them. There were garden games in which to organize the little ones—Anna, Theo and Lies, to be joined by Wilhelmina, or "Wil," when Vincent was nine years old, and Cornelius, or "Cor," five years later. Beyond one another's birthdays, there was the deeper thrill of Christmas, hallowed each year by fir trees and Dickens readings. There was the making of family presents, which might well be drawings done from observation, since their mother had introduced all her children to this standard accomplishment of the educated classes. There was the reinventing, after lights out, of tales of adventure for the benefit of little Theo, in the bedroom they shared.

And then there was school. At first Vincent attended classes in the village, but after a year Dorus and Anna pulled him out, fearing the company was coarsening their son's behaviour. Three subsequent years under a home governess were meant to prepare him for boarding school at age eleven. But neither the establishment in Zevenbergen nor the one he joined two years later in Tilburg, another Brabantine town, seems to have left Vincent with anything to be thankful for. He learned, evidently—extending his grasp of French, English and German and of the European literary canon—but he took to no teachers and made no close friends. The only recollection of Zevenbergen he would later write down was of "standing in a corner of the playground when they came to tell me that someone"—his father—"was waiting for me."[3] The main evidence of the Tilburg years is an

1867 school photo in which a sullen, stiff-necked fourteen-year-old can be made out, his body language staking out a distance from the surrounding "they." The separation became a severance in March 1868, when, for unrecorded reasons, he quit school to return to the parsonage halfway through the school year.

Parents must open their arms to wayward children; there's nothing the Gospels spell out more surely. But this was a burdensome homecoming, family records imply. Their forceful eldest son had been hard work from the start — "I was never busier than when we only had Vincent," his mother remembered.[4] Dorus and Anna, with their liberal inclinations, fell back to accommodate a boy who was insensitive to the social niceties they valued and who threw his weight around when thwarted. The energy of concentration that Vincent could apply to a nest or an insect showed up as sheer ferocity when engaged in a battle of family wills, and very early, it seems, this feral strength set his lighter-framed father into a defensive containment mode. What was he up to now, the broad-shouldered teenage lout with the shock of red-blond hair who could be heard slamming the back door? Gone out to roam the heath again, no doubt. They never knew when he'd be back; he took little more account of rainstorms, blizzards and nightfall than of the rituals of coffee drinking with the doctor's family and other such "good folk" of the parish, beloved by his mother.

Over a year of stalemate ensued before the lad could be set on fresh tracks. If he wasn't cut out for his father's role in society, he might yet do something in his uncle's line of business. In July 1869 the sixteen-year-old Vincent left Zundert to begin an apprenticeship with Goupil & Cie in its art emporium in The Hague. He became one of the branch's two junior assistants who packed up prints for clients, helped hang canvases in the store's fine art gallery and kept the stock neatly filed. The job entailed getting a working knowledge of every contemporary line in "art," as defined from a salesman's perspective —

from medieval-esque "troubadour" romances to views of the pyramids, from bashful nymphs to the rugged heaths and glades painted by the Barbizon landscapists. Vincent became highly proficient at all this. As his sister Lies remarked in her memoir of him, the naturalist collector was now restyling himself as a collector of "imitations of nature."[5]

The youthful branch manager his uncle had appointed, Hermanus Tersteeg, presented the apprentice with a provisional role model — suave, natty and culturally self-assured. Vincent used what little free time he had to ramble around the staid, cold-hearted streets of The Hague and to extend his reading, getting a taste for Romantic poetry. At the same time, here was a late adolescent with the red light district just a short detour off the walk home from the store to his lodgings — a turning he avowedly took, heeding the standard wisdom of the era according to which sexploitation might be regrettable, but masturbation spelt ruin. A brothel, anyway, offered a quick fix for loneliness. A year into his apprenticeship, home was home no longer; the Reformed Church relocated Dorus and family from Zundert to another parish twenty miles away. The deracination added to the many reasons Vincent might have to feel "out of spirits" and, by way of consolation, to take up a pipe ("it does you a lot of good").[6]

Vincent's praise of tobacco sits alongside praise for Goupil & Cie — "such a fine firm" — in the earliest preserved pages of his correspondence, one of the great documents of nineteenth-century literature.[7] It would be handsome to call the addressee of these recommendations, Vincent's brother Theo, the other protagonist of this story, for in many ways he was jointly responsible for the Van Gogh oeuvre. But the evidence is lacking fully to present him in that role. The fact that Theo kept most of the thousand-odd letters he received from Vincent over the following eighteen years, whereas Vincent preserved only a handful of Theo's, is indicative. Not exactly of a one-way rela-

tionship, but of a deep interdependence, starting from the earliest days in the shared bedroom and expanding via their continued shared passions for pictures and for reading, that is evident throughout. But while Vincent had ferocious energy, Theo had diligence. Delicate both in manners and in physique, he had his father's "goodness of heart" (in Lies's words) and a responsiveness to others absent in his older brother.[8]

Theo was hearing Vincent's praises of Goupil & Cie because, at the turn of 1873, he was about to follow Vincent into that firm's employment. Their paths wouldn't cross there, however. Theo started at its Brussels branch, while a few months later the twenty-year-old Vincent was shifted from The Hague to London. His boss Tersteeg may have assessed that the heavy-browed, uncouth youth captured in the photo taken at the year's beginning would hardly make front-of-house material, for the Goupil London offices, on a side street off the Strand, dealt only with trade customers. But if Vincent was thwarted in his immediate career aspirations, he used his arrival in the city of Dickens to extend his expertise.

He was coming from a Continental art world dominated by Paris, a city in which he had stopped for a few days en route to his new posting. That visit had given him a chance to glimpse at first hand the Barbizon pictures he already admired in reproduction — above all those of Jean-François Millet, whose stoic images of peasants working the land would inspire in Vincent a lifelong devotion. To switch from that Frenchman's muscular, sure-footed picture making to the aesthetics of High Victorian England, so finicky and gutless by comparison, presented the prospective connoisseur with an initial challenge. Nonetheless, Vincent came to feel that the elegiac tone of John Everett Millais's lakeside landscape *Chill October* and the demure pathos of George Henry Boughton's costumed fables were values to salute. The literary qualities of English art connected it to moral qualities, to the types of handsome feeling that Dickens

loved to commend. Much as that writer delighted in "painting" scenes with his pen, so Millais composed pictorial poetry. The sister arts shared a common, sentiment-improving purpose; the thought was in line with Vincent's father's theology.

During his first months in London, Vincent wrote of hanging out with a hearty, music-loving crowd of young Germans who shared the unidentified house in which he lodged. His penchant for introversion resurfaced, however, after he took up lodgings in the suburb of Brixton in autumn 1873. In a precarious, hard-to-articulate reverie, the young poetry reader tried to frame the admiration he had formed for his new landlady, Ursula Loyer (a widowed schoolteacher), and her teenage daughter, Eugenie, within a constellation of other tendernesses held dear in his memory. During the following months Vincent wrote fond letters to a distant cousin he had been sweet on back in Holland, despite the fact that she was now married; posted tentative, timorous landscape sketches to Tersteeg's eleven-year-old daughter; and thought to open doors for his eighteen-year-old sister Anna by inviting her to join him in London to find work as a governess. Anna's presence would somehow complete the emotional equation set up when, as Vincent told her, he and Eugenie had agreed to treat each other as brother and sister. What feelings that pledge might have been stacked against one can only guess: Eugenie, like his former crush, had a fiancé somewhere in the wings. Predictably, however, the whole house of cards collapsed soon after Anna actually arrived at the Brixton terrace in July 1874.

Again, we don't exactly know what happened, but within weeks, the two Van Goghs had quit the premises. Perhaps Anna, a no-nonsense young woman, had challenged her gauche and whimsical brother to put up or shut up to Eugenie. A letter written to Theo at the point of their departure implies that Vincent had indeed opted for a more pragmatic approach to sex: "Purity of soul and impurity of body can go together."[9]

That dare to conventional, paternal wisdom followed an appeal to the ideas of Jules Michelet, a writer whose copious career was just coming to a close. Famed for his rhapsodic historical interpretation of the French Revolution, Michelet gripped Vincent still more with his wisdom-dispensing essay "L'Amour"—"a revelation and immediately a gospel for me."[10] Here was a contemporary, worldly-wise yet inspirational sage telling the young male what he must make of the eternal feminine, providing a charismatically Parisian template for modern life that was exciting beyond anything offered by the duty-bound preachings of his native land. Echoing another contemporary on Vincent's shelf, Ernest Renan — a revisionist trying to unveil a "real" Jesus underlying the fallible Gospels—Michelet intimated that a new age was dawning in which new forms of belief might be required.

What were these to be? Vincent's job at the Goupil & Cie entrepôt acquainted him daily with images of social concern, such as Honoré Daumier's lithographs of the hard-knock lives endured by the Parisian poor, or the dark, dystopian London portrayed in Gustave Doré's volume of etchings, named after that city and published in 1872. Doré's chiaroscuro threw melodramatic shadows over the cheap London terraces Vincent passed after heading back south across the Thames; there was ample incentive for a solitary migrant clerk to reflect on the huge, brutal pressures of modern capitalism. But this was the 1870s, a decade before the cause of socialism started to gain popular momentum. There was no voice within the young clerk's immediate hearing to translate social concern into activist politics. What more likely drew him in, following his departure from Brixton, was the powerful Christian movement centered on the Metropolitan Tabernacle, not far from the Kennington terrace where he now found his lodging. The preacher there, Charles Spurgeon, attracted thousands with a plain-spoken oratory that beamed down through the fogs of contemporary

urban living to cast each listener's fate in a stark eternal light.
Reinvigorating the "Reformed" Calvinist tradition in which
Vincent had been reared, Spurgeon pointed towards a salvation
that was clear-cut and certain.

We can only infer this preaching's influence because the very
few letters Vincent sent between August 1874 and May 1875,
when he was relocated to another Goupil & Cie office, this time
in Paris, were unusually terse. During these months he quar-
relled with Anna (who did in fact land a job in England); wor-
ried his parents, who regarded it as a Van Gogh family duty to
constantly busy the postal service with "how are yous" and "I'm
fines"; and, quite likely, fell out with his London boss — at least,
that might explain the relocation. At all events, the correspon-
dent who reemerged in the summer and autumn of 1875, writ-
ing from an apartment in Montmartre, had an altered perspec-
tive. He continued enthusiastically to collect Millet prints and
Jean-Baptiste-Camille Corot paintings, savoring the noble sen-
timents they represented but adapting those sentiments to a
new vein of feeling.

Biblical verses and quotations from hymns began to punctu-
ate the letters. They reported on the "glorious and grand" ser-
mons delivered by another Metropolitan Revivalist, Eugène
Bersier, in his newly built neo-Gothic Reformed Church a
little west of the Arc de Triomphe.[11] Bersier, like Spurgeon,
used straightforward language to set modern anxieties and criti-
cal thinking against loftier ultimate perspectives. The prayerful
daily regimen that Vincent was now intent on was supported by
his flatmate Henry Gladwell, a younger Goupil & Cie appren-
tice who proved equally receptive to the Christian message. But
this immediate brotherhood with "my worthy Englishman" was
not enough.[12] It was necessary that Theo (presently working
under Tersteeg in The Hague) participate in Vincent's cultural
revolution. He must now, the letters demanded, chuck out the
heterodox volumes of Renan and Michelet recommended only

a short while before. Likewise, the Romantic lyrics of Heinrich Heine were "pretty dangerous stuff."[13] Indeed, even the honorable feelings that Vincent and Theo shared for art needed to be held in check, as did their feelings for nature. The latter wasn't "the same as religious feeling," although, Vincent added, respectful of his father's theology, "I believe that the two are closely connected."[14]

As to the art trade he was serving in the Goupil & Cie headquarters — well, it was just work: "At the gallery I simply do whatever the hand finds to do, that is our work our whole life long, old boy, may I do it with all my might."[15] *No, Mr. Van Gogh, that is not the right attitude. As the nephew of our respected senior partner, you have been a grave disappointment. You present yourself for work in a slovenly state of dress. Your manners hardly fit you for serving our clients, for whenever you personally supply them with prints, an impertinent disdain for their taste and discernment is betrayed on your sullen physiognomy. In truth, you would have left the firm long ago, had we —* the fanciful speaker here is Goupil's Paris store manager, the date January 4, 1876 — *not been sensitive to your uncle's feelings. But today you have shown your face after a two-week absence, over our busiest sales period, for which you had no authorization. The strength of your family sentiments at Christmastime can in no way serve as an excuse. You have three months' notice. As of April 1876, you are on your own.*

3

"When an apple is ripe, all it takes is a little breeze to make it fall from the tree," Vincent pronounced to Theo in his new preacher-like style.[16] Evidently he had known for some time he was in danger of dismissal; perhaps the unauthorized Christmas visit home was a test prod at the bough. But the apple proved far from ripe. At age twenty-three, with seven years' service come

to nothing, with his spiritual instincts aroused but as yet undirected, all that was immediately clear was that he needed fresh work. The next thirteen months were ragged and confused. At first, since Vincent was used to England and to an older-brother role—whether with Theo or with Gladwell—he applied for teaching assistant posts across the Channel. He picked up work at a boys' boarding school in Ramsgate, on the farthest eastern end of the south coast.

This proved to be a small and shoddy establishment, run by a capricious skinflint who was lousy at paying his staff and who removed the whole operation to Isleworth, just west of London, two months later. In Isleworth Vincent managed to transfer, come July 1876, to an alternative school headed by the Reverend Thomas Slade-Jones, who was little better at paying but who at least warmed to his religious earnestness. But on his Christmas visit home that year, Dorus and Anna attempted to take over the reins. Worried by the ill-focused zeal Vincent's letters displayed—he had been talking of becoming a missionary in South America—they steered him to a post as a clerk in a Dordrecht bookshop. He remained in this unlooked-for role for no more than five months before his religious promptings took on a more decisive form.

The reeling and staggering of this period was of a young man punched in the chest. To be expelled from an employment that was almost his birthright for faults of character that themselves seemed inborn—how was he to make sense of that? A few weeks into his school employment, he shared with Theo his prayer not to be, in the biblical phrase, "a son that causeth shame."[17] A further eight months on, at the Dordrecht bookshop, "everything which I undertook and failed at" was continuing to sweep over him like "a deluge of downcastness."[18] In the interval, Vincent leaned heavily on his two most restorative habits—walking and writing. When the boys' boarding school decamped from Ramsgate in June, for instance, he did the sev-

enty miles to London in two days on foot, crashing by a country pond till 3:30 a.m., when "the birds began to sing upon seeing the morning twilight, and I continued on my way. It was good to walk then."[19] Equally, he had started this sojourn in England with a literary exercise posted to his parents, rhetorically juxtaposing the voyage's golden sunset and glistening dawn with the modest truth of his feelings: "And yet I prefer that grey hour when we parted."[20]

Several verbal sketches of England followed, far more accomplished than the occasional stiff line drawings of buildings that sometimes accompanied them. The "peculiar beauty"[21] of London's straggling suburbs on a misty autumn evening, as the sun's red glow made way for streetlamps being lit; or, on another evening, the red glow of a train on an embankment with horses grazing among the thickets beneath[22]—in such passages of the letters a distinctive Van Gogh terrain began to emerge, a zone that was neither virgin nature nor yet quite brought to order. But typically, both the walks and the writing itself had a higher agenda.

The activity in which Vincent could most aptly give shape to his religious feelings was consolation. News of sorrows elsewhere had for him an almost aesthetic appeal. Theo struck down by fever or thwarted in love prompted Vincent to fill sheet after sheet with profusions of prayer and homily. Henry Gladwell's family mourning his sister's death in an accident and, later, Dorus reporting an old Zundert parishioner's terminal decline provoked more active responses—Vincent expressed his compassion by walking out to join the afflicted. It hardly mattered that on his return to his birthplace, his crossing of the heathland on foot meant he arrived too late to say farewell; the family members "were so sad and their hearts were so full . . . I was glad to be there."[23] The Gladwells, likewise, "did me good" by presenting "a house of mourning."[24] That epithet occurs in the Book of Ecclesiastes, where the next verse reads: "Sorrow is

better than laughter." Trouble brings us nearer to the essence of things, a truth that will set us free. Saint Paul's "sorrowful, yet always rejoicing" became Vincent's adopted watchword, to be inscribed on every print pinned up on the walls of his room.

Call him odd, call him ardent. The Reverend Slade-Jones, taking a positive attitude, let the young Dutchman try out a ramshackle, rhapsodic sermon in English on a Richmond Methodist congregation in October 1876. Some of it reimagined in prose a favorite Royal Academy exhibit from two years before, George Boughton's *Godspeed!* — a softly poetic costume drama in which, for Vincent, a pilgrim embarks on a long uphill road towards the eternal city and is met on the way by an angelic female, dressed all in black. Whatever fine dreams were symbolized here, Vincent's father did not share them. At Christmas that year Dorus was struck by the morose cast of his eldest son's piety — a problem he hoped to fix by rerouting him into commercial life in Dordrecht. But in fact the problem deepened. The job held no interest, leaving Vincent with thinking space in which to brood over his future direction.

4

If Vincent couldn't work in his uncle's line of business, then perhaps — whatever Dorus himself supposed — his destiny might lie with his father's. With the present surge of religious fervor to sustain him, was it really too late, now that he was turning twenty-four, to train for the priesthood? Vincent got up a head of enthusiasm, enough to swing the family around to support this new and time-demanding plan. It was agreed he would lodge in Amsterdam with Uncle Jan the admiral while he studied for the preliminary exams he would need to pass in order to commence a university course in theology; in all, it would be six years before he was fully ordained. And thus from May 1877,

Vincent settled down under the supervision of a Jewish scholar to master all the Latin, Greek, general history, algebra and so on that he had left dangling when, at fifteen, he had quit school at Tilburg.

What style of priest did he hope to be? While Dorus sensed that his eldest son was desperately lacking in levelheadedness and joie de vivre, Vincent for his own part was full of admiration — indeed, envy — for his father's patient keeping of the faith. "Pa can count on his services and Bible readings and visits to the sick and the poor and his written sermons by the thousands, and still he doesn't look back but goes on doing good," he wrote to Theo.[25] Perhaps Vincent could add another name to this time-honored family tradition of ministry. And yet the Reformed Church of the nineteenth century was not simply a static backup to Dutch society. Its leaders had acted as men of letters in a broad sense — not just as preachers but as poets, critics, all-purpose commentators, creating for the Netherlands a cohesive cultural scene quite the opposite of that in France, for instance, where intelligentsia and clergy were customarily at war. Vincent's favourite preacher during his time in Amsterdam, the Reverend Eliza Laurillard, was a literary figure who specialized in linking nature, art and religion through homely rural images. "He paints as it were," wrote Vincent, "and his work is at once lofty and noble art."[26]

"As it were," painting with a pen — an art already attempted the previous year in England — continued to attract the academic latecomer. His uncle the admiral had quarters by the Amsterdam docks, offering an early morning prospect ideal for Vincent to test his skills on: "The ground and the piles of timber in the yard were drenched, and the sky reflected in the puddles was completely golden due to the rising sun, and at 5 o'clock one saw all those hundreds of workers looking like little black figures fanning out on all sides."[27] Workers became meaningful by looking like "figures" in pictures, and to think of pictures was to

think of the noble purposes that artists in general should aspire to — purposes nowadays represented by Millet or by poignant, poetic Dutch tonalists such as Jozef Israëls or Matthijs Maris. Another of Vincent's uncles in town — Cor van Gogh, who kept a bookshop on Leidsestraat — teased the priggish young devotee, pointing to a slick nude figurine by the French Academic sculptor Jean-Léon Gérôme: Beautiful, no? No! "I said I would much rather see an ugly woman by Israëls or Millet." Ah, but what about a girl like that, heh? "I said I would have more feeling for and prefer to be involved with one who was ugly or old or impoverished or in some way unhappy, who had acquired understanding and a soul through experience of life and trial and error, or sorrow."[28]

The practice sermons gained in force — particularly when addressed to Theo, who, working twenty miles away with Goupil & Cie in The Hague, was suffering career uncertainties. "There is a God that lives — and He is with our parents, and His eye is also upon us, and I am certain that He intends us for something, and that we do not belong entirely to ourselves, as it were." That was Vincent on May 30, 1877. Come April 3, 1878, he was developing similar themes of reassurance, adding that "I must become a good minister ... Perhaps it's good after all that I have a relatively long time of preparation." And yet, it was all desperate. Impossible, in fact. What he was attempting went deep against the grain. The earlier letter had started by reviewing "the nearly insurmountable difficulties, of much and difficult work which I have no passion for." The dead languages and algebra wouldn't stick in Vincent's mind, for all the hectic, dogged ferocity he applied to their study. In the intervening period, successive quarterly reviews of his academic progress warned that success was increasingly unlikely. "One sometimes gets the feeling, where am I? what am I doing? where am I going? and one starts to grow dizzy," he admitted in December.[29] A month or so after the April letter, he threw in his hand.

He was not cut out to serve God as an ordained minister. Scholarship and he had no business with each other. His long-standing favorite among spiritual primers, Thomas à Kempis's *The Imitation of Christ,* could have told him as much: "Cease from an inordinate desire of knowing, for therein is much distraction and deceit . . . It is tedious to me often to read and hear many things: in Thee, O God, is all that I would have and can desire."[30] The brusque urgency of the fifteenth-century Netherlandish text chimed with a style in preaching Vincent now came across in Amsterdam's French church. (He liked to flit between congregations and denominations, an ecumenical connoisseur.) The focus here was on the hardships of the industrial working classes and how to reach out and redeem them with Gospel missions. Earthly toil and care, heavenly love and solace — surely this was the essence of Vincent's religious vision. Why trouble with anything more? Bypassing the protracted training for the priesthood, he now wished to set out as a simple educator of the simple-hearted, a missionary to the poor. He would be a catechist — in the familiar imagery of Jesus's parables, a "sower" of the Word.

Well then, he was not cut out to follow his father, just as his father had all along suspected. But this new rerouting grieved Dorus and Anna further, as a social demotion. A catechist could never amount to more in the world than a poorly paid nonentity. Nonetheless, after the twenty-five-year-old family headache returned home from Amsterdam in July 1878 (the home parsonage being now in the Brabantine village of Etten), Dorus enquired around for some institute to help his son qualify for missionary work. Whatever simplicity and directness Vincent might yearn for, he would still require preparation and training. A place was found in a tiny evangelical school in Brussels. Once again, however, the autumn of that year saw him fall foul of inculcation. Theology merely exasperated him, and a fellow student remembered an exchange in the Latin class: "Van Gogh, is

this dative or accusative?" "Och, teacher, I really don't care!"[31] After a three months' trial was completed, the school informed Vincent he would not be accepted: He had shown himself incapable of study.

He became desperate; he became high on desperation. Falling into a rhythm of self-reproach and self-mortification he had dallied with during earlier crises, he stopped eating, would sleep on the floor and refused his father's offered financial assistance. Yet at the same time Theo—who visited him in November 1878, a handsomely dressed success story fresh from his recent Goupil & Cie posting to Paris—received a thank-you letter full of Vincent's now distinctive lyrical eloquence. It evoked evening's onset in the working-class quarters of Brussels—the "dirty, dingy" street sweepers returning with their carts to their depot by the sludge works, and how their tired nags reminded him of "a certain old aquatint" of an "indescribably lonely" dying horse, and how "I'd like to speak to the dustmen, if they would only come and sit in the paupers' pew . . . [Y]ou see, it always strikes me and is remarkable, when we see the image of . . . the end of things and their extremity—the thought of God comes to mind."

From which Vincent moved on to reviewing the Brussels gallery-going the brothers had inevitably bonded over, and to comment on a little inserted sketch of a workmen's café:

> I should really rather like to start making rough sketches of some of the many things one sees along the way, but considering I wouldn't actually do it very well and it would most likely keep me from my real work, it's better I don't begin.

And then Vincent wrote of what he'd read "in a geography book": that southwest of Brussels, on the Belgian-French border, there lived the Borins, who "do nothing but mine coal." A Borin's life underground was dangerous and arduous, and for

him "daylight hardly exists," yet he "has a cheerful character" and "he entrusts himself to his God." The Borinage was Vincent's new destination. "I should like to go there as an evangelist."[32]

5

A "very picturesque country, everything speaks, as it were, and is full of character."[33] The great coalfield around Mons, Continental Europe's largest, fulfilled Vincent's aesthetic expectations. With its pitheads, slag heaps, squat hovels and grimy, ravaged fields, it would, he felt, supply Matthijs Maris with material for "a beautiful painting." In fact, Vincent told Theo, he himself would "make a sketch to give you an idea of it."[34] As at the Amsterdam docks, swarms of "small black figures"[35] animated the scene, and their principal destination, the seams far underground, prompted a bravura set piece description, penned after taking the giddy cage ride seven hundred metres down. "Looking upward, the daylight appears to be about as big as a star in the sky." The dread of that ride stayed with the workers —"not without reason," Vincent added; but "they get used to it."[36] As they must to their hazardous, ill-paid working lives, supplying "this mineral substance whose great usefulness we know."[37] In the pit village of Wasmes, where he was now boarding, the sole individual of superior "intellectual development," a foreman risen up from the ranks, had made sterling efforts in tempering the workforce's propensity to strike.[38] (The Borinage was in fact a center for working-class activism throughout the nineteenth century.)

As for himself, Vincent was keen to serve the community as a Protestant lay preacher and children's catechist, having landed a six-month trial in this role soon after his impulsive arrival in December 1878. Switching from Dutch (or Flemish) to French, he reached out to the hard-pressed Borins, so "uneducated and

ignorant," yet so "shrewd" and "courageous." His surest connection with them lay through visiting and tending the sick. On April 17, 1879, a day after he posted off the description of the mine, a neighboring pit blew up, resulting in over a hundred deaths. Vincent responded to the disaster with strenuous, heroic efforts at nursing. Why, his landlady asked, must he rip up the bed linen specially sent him from home to make bandages for the wounded? "Oh, Esther, the good Samaritan did more than that! Why not apply in life what one admires in the pages of the Bible?"[39] Back in Amsterdam, Vincent had shared with Theo speculations about an elusive heart of experience, transcending formal religion and art — an "it" implicit in every eureka cry of "That's it!" Here, giving himself over to sheer human need in this apocalyptic, black-soot heaven, he was no longer speculating.

What need had he of the linen, compared with that of the wounded? What need had he of soap or fine meals? Or, indeed, of a bedroom? (He took off from Esther Denis's farmhouse to sleep in an outside shack.) What need had he, for that matter, of rhetorical polish?

> If a talent for speaking, indispensable to anyone placed at the head of a congregation, had been added to the admirable qualities he displayed in aiding the sick and wounded, to his devotion to the spirit of self-sacrifice, of which he gave many proofs by consecrating his night's rest to them, and by stripping himself of most of his clothes and linen in their behalf, Mr. Van Gogh would certainly have been an accomplished evangelist.[40]

Such was the report of the synodal board at the end of the six months. The Union of Protestant Churches of Belgium had no use for saints. While Vincent was casting around for an alternative position, Theo paid a flying visit. A letter Vincent began in its wake, probably on August 11, 1879, reflects back its

remit. You must turn your life about, Theo had told him as they walked together. You are heading nowhere. You are causing your parents agony. (Madame Denis had written to them about his distracted and haggard condition.) Put your hand to some trade — lithography, carpentry, baking, whatever — and I beg you, return to this world.

The letter composed in response is harrowingly sad. Vincent confessed to finding it hard to bear the thought that he had caused the family "so much discord, misery and sorrow" and conceded he might have lost his way, even implying that he stayed on in the Borinage merely to avoid a home reckoning with his own uselessness, as the family's "fifth wheel." How could he return to Etten? "I really dread going there."[41] He promptly did, however, to no good end. All that resulted from his few days back in Brabant was a grim falling out with Dorus, who, trying to push the same point as Theo, ended in exasperation by cursing his eldest son, a malediction Vincent would not soon forget.

He took himself back to an obscure position he could tag on to as assistant to an evangelist in another of the pit villages. What he did for this Monsieur Francq is not known; in fact what he did, as 1879 turned into 1880, is hardly known at all. He wrote no more to Theo; we don't know whether he acknowledged the money Dorus forwarded for his upkeep. Possibly he drew, as certainly he had been wont to do earlier that year. (But nearly all drawings of the Borinage period, along with almost the whole run of his letters home, are lost.) On the other hand — pictures, letters: What need? What need?

Two matters we do hear of from later letters. First, that Vincent was reading the tragedies of Aeschylus and Shakespeare — undoubtedly including *King Lear*. That play, by default (or design?), falls into place as his script. The ridiculous outcast glimpsed in the half-appalled recollections of his Borin neighbours — shoeless, whimpering to himself in his hovel, anxious

for the safety of caterpillars, going out near naked to meet the storm (so as to witness "the great marvels of God")[42]— is acting out *Lear*'s "Poor Tom," the prince mocked as country madman, as much as he is acting out Thomas à Kempis's Christ. "Our basest beggars / Are in the poorest thing superfluous": He has that text by heart and will prove it.[43]

Indeed, the second memory recovered from that zero season serves to illustrate it. It is of an eighty-mile walk undertaken for uncertain objectives (work, perhaps), just before another temporary descent on Etten, during which a despairing Dorus tried unsuccessfully to have his son declared insane. The journey got as far as Courrières in the Pas-de-Calais, the home of Jules Breton, a painter Vincent had admired in his Goupil & Cie days. Vincent offers us a verbal picture of a blistered vagabond hovering outside the studio, not daring to knock, before turning back towards the black land: three more nights to go on the road, one hunkered down in a frosty abandoned carriage, one in a woodpile, one in a drizzle-soaked haystack. The creature in that picture is given over to the landscape. He has become a scuttling rat, a nesting bird, an *it*.

Sinner

1

THEO VAN GOGH was his parents' hope and joy. They told him so often, in letters addressed first to Brussels, then to The Hague and to Paris, as this nimble-minded and obliging young man made his way up through Goupil & Cie's ranks. He impressed the firm with the way he did business at its stall in the Paris Exposition Universelle in 1878, and from then on he had a permanent foothold in the metropolis. In 1881, at a mere twenty-four years of age, he would become manager of one of its three branches there.

The flair Theo brought to the Parisian art market reflected his Dutch origins. "Bourgeois" is a French word, in all its complex connotations. When Charles Baudelaire, the most provocative art critic of the mid-nineteenth century, sardonically hailed the bourgeoisie — a mighty swarm of black-suited, right-thinking, cocksure men of property — as the masters of the age,[1] he left implicit the option that a thinking individual might somehow stand apart from that class — most likely as some form of "bohemian," a positive identity linking the unpropertied, the left-thinking and the, as it were, *wrong*-thinking with the cause of the imagination, of the fine arts. The bourgeoisie, Baudelaire argued, was psychologically dependent on its counterpart — "You can live three days without bread — without poetry, never"[2] — and of course even the most inspired poet, after three days, might need some bourgeois patronage to put bread on his

table. But that didn't mean the two groupings loved each other. Far from it.

In the Netherlands, this stand-off of identities didn't exactly apply. The assumption on which Theo, like his uncle Cent before him, could rely was that property and the visual arts were mutually beneficial. He was a businessman making good money by satisfying the legitimate and laudable desire of homeowners to hang objects of refinement on their walls. The customer was most certainly right, and he gave each his full respect. At the same time, for there to be an art market, it was necessary that there be artists. And it was in the nature of an artist to view the world at a somewhat unusual tangent; without such a mental remove, how could he create refined visual poetry? But as long as Theo got the equation right, both client and artist would end up winning.

Take such a painter as Anton Mauve, for instance. Theo knew him because Mauve, who was nineteen years his senior, had married Jet Carbentus, a cousin on his mother's side of the family. The Mauves settled in The Hague in 1871 and both Theo and Vincent liked to visit them during their times in the city. In his art, Mauve took Millet's elegiac evocation of the way French peasants inhabited a certain landscape and adapted it to the polders, dunes and moisture of rural Holland. In a typical Mauve canvas or watercolour, a bare horizon is interrupted by some rider, shepherd, ploughman or beast, silhouetted between rain-heavy skies and rutted, claggy mud, all local color being suspended in muted, greyish harmonies. The creator of this stoic poetry was known to succumb from time to time to melancholia, and the Van Gogh brothers regarded him as something of a philosopher; it was from him they had first taken the notion of an ineffable "it," a quintessence of experience. At the same time, here was a career steadily on the rise. Thanks in large part to the Goupil & Cie network, Mauve and like-minded colleagues in what came to be known as the "Hague School"—Jozef Israëls;

Hendrik Weissenbruch; Willem Roelofs; and the brothers Matthijs, Jacob and Willem Maris — gained international sales and critical renown for their louring Dutch landscapes during the 1870s. Mauve demonstrated that as long as both artist and dealer were tenacious, a poetic temperament needn't be a bar to worldly success.

Theo was notably good at handling artists, with all their propensities to prima donna eccentricity, because he was so much a man of sensibility himself. Although his side of the correspondence is lost, we know he swapped enthusiasms in literature and painting in a two-way dialogue with his brother. It also appears that he got involved in a succession of stormy romances with young women of slender means. His passions spilt over into business projects, and he could find his superiors' lack of imagination frustrating: At one point during 1877, tensions with them were such that Theo was thinking of quitting Goupil & Cie altogether. Yet he reined himself back, returning to his habitual role: the middleman, good and modest like his father; the conciliator; the effecter.

And increasingly, from that point onwards, the provider. Dorus's income as a village priest didn't stretch far. Theo's sister Anna made a respectable marriage in 1878, but his younger siblings, Lies, Wil and Cor, were not yet standing on their own feet. The payments that Theo sent home in order to help out tugged at his Goupil & Cie earnings one way, and payments to his mistresses another. Moreover, who else, if not Vincent's one-time confidant, was equipped to address the ever more distressing problem of the family's "fifth wheel"? After Theo's attempt to lecture Vincent in July 1879 and Vincent's pained reply, all went silent between the two until the following March, when Theo mailed an offering of cash to Etten for his brother to collect on his visit there. The money was duly pocketed, and Vincent scurried back to the coal pits, having evaded Dorus's

attempts to have him declared insane; nothing more was heard for a further three months.

Finally, in late June 1880, a letter arrived at Theo's apartment in the genteel ninth arrondissement. "With reluctance," Vincent proposed to break their long estrangement and to send belated thanks for the cash.[3] Why was he doing so now? Vincent wrote as if to find some provisional point of arrest in a months-long drift of rueful reflection. His letter tried to set what he supposed was his outward appearance — a ragged, distracted "man of passions"; an idler, "impossible and suspect"— against his inward life, which had chiefly been focused on pictures, preaching and reading. He could as yet see no onward direction —"it's true that the future's not a little dark," he wrote — but he had to believe that all this intense mental activity must lead somewhere, must somehow come together, in much the same way that the highest things — Rembrandt, the Gospels, Shakespeare — all pointed towards God when rightly understood. How, however? "My torment is none other than this, what could I be good for? couldn't I serve and be useful in some way?"

Theo's response to this heartfelt plea is lost, as, seemingly, is the reply Theo received in turn — but some lines that Vincent wrote him two years later suggest what these letters contained. "I remember very well that when you spoke to me back then about my becoming a painter, I thought it very inappropriate and wouldn't hear of it."[4] Theo had connected that phrase of Vincent's about "really rather liking to start making rough sketches," written just before departure for the Borinage, with his frequent references to drawings done there. From this, he had deduced that though his brother's preaching career had hit a dead end along with his earlier career in the art trade, he might yet find some role in that trade's other sector — supplying the product. The glaring force of this proposition was at first resisted by a "man of passion" who was so intent on reaching for

the topmost branch that he failed to notice the fruit already lying at his feet.

This resistance, however, was brief. By late August, when Vincent wrote his next surviving letter, his thoughts had switched to a well-known drawing manual, published twenty years before by Goupil & Cie. He was trying to follow its guidelines by copying from the great masters, which in his own case meant copying Millet. And he mentioned a "scratch" he'd lately attempted — an "idea" at least, even if not yet properly realized — a recollection of miners making their way to work in the winter snow. Vincent himself was on his way at last, at age twenty-seven. He had caught hold of a lifeline. "If only I can go on working, I'll recover somehow."[5]

2

The recovery rapidly gained ground. Tersteeg, his old Goupil & Cie boss in The Hague, posted further drawing manuals, avidly studied according to Vincent's letters. Piles of pencil, pen and charcoal exercises (themselves now vanished) mounted up in the rented room in the Borinage, and in October Vincent decided it was time to move on, to reenter city life by lodging in Brussels, in search of artistic contacts and instruction. Here he called on another old Goupil & Cie staffer, who told him to enroll in the city's Académie Royale des Beaux-Arts — advice apparently heeded, though again, no work done there remains. More significantly, Theo put Vincent in touch with a young Dutch painting student who had just moved from Paris to Brussels. His encounter with Anthon van Rappard gave Vincent his first real taste of friendship since the times with Henry Gladwell some five years before. Soon, the wild ex-preacher and the affable, well-bred young man about town were to be found working side by side in the latter's studio. To further the transformation,

Vincent even bought himself some respectable, but afford-
able, secondhand suits — as he carefully reported to his parents,
whom he wished to please and who held the purse strings. But
now that Vincent's life looked to be moving forward, that awk-
ward arrangement could be superseded. In April 1881 he learnt
that Theo planned to make regular contributions to his upkeep.

All of which begs the question: What course did Vincent
reckon he had now embarked on? What, initially, did it mean
to him to be an artist? *Miners in the Snow,* a large pencil draw-
ing with light washes of color mentioned to Theo in August
1880, is in effect the latecomer's first declaration of intent. It is
the work of someone who expects pictures to tell stories about
the "how it is" of people's lives. Let art interpret the ways that
people occupy the land they work — this was the lesson that
Millet, the artist who "reawakened our eyes to see the inhabi-
tant of nature,"[6] had taught Vincent. Only here, Millet's lesson
was adapted to a heavy-industrial environment, to be enacted
by a cast of stoic workers. The breadth of the concept — the way
their procession swings into view, then winds up and back to-
wards the looming works and slag heap — is earnestly ambitious,
and at the same time there's an innocent pleasure about the
scribbling of the thornhedge the miners pass before. (A similar
friskiness flavors an odd few sketches from the decade before,
prior to Vincent's committing to art.)

As a connoisseur of contemporary graphic art, Vincent was
dissatisfied with this naivety. Figures drawn half from memory,
half from Millet, and in insecure perspective — they "might be
about 10 centimetres high," he complained — needed to make
way for the structured methodology that Charles Bargue's
Cours de dessin could supply. *A Marsh,* a pen sketch done af-
ter the winter in Brussels, suggests how Vincent's approach had
moved on. Instead of an overarching mental vision, his draw-
ing here was started from observation, in an attempt to unpick
the spatial construction of the shimmery, watery scene before

his eyes. Each channel and meander of the marsh was carefully nailed into place with his pen nib; the sheet bristles with virtuous hard work. And yet that work itself turned into a kind of reverie, an intent private rhythm of hatching.

Not Millet but Millais, the painter of the Scottish marsh scene *Chill October,* was the destination Vincent had in view, a journey's end of refined plangent poetry he drove right past in an excess of zeal. It may also have been a spur that, as of June 1881, Van Rappard was sketching beside him in the same marsh. Vincent had found a junior companion who was sufficiently self-confident to tolerate and indeed appreciate his own unusual cast of mind. Once Van Rappard had adapted his manners to this eccentric original (whom he would remember as the "noble" yet "industrious and struggling, fanatically sombre Vincent"),[7] he would serve by turns as pupil, sparring partner and stylish social trophy. The marsh that they were sketching was a day's walk from Etten, where the judge's son was currently making a twelve days' visit, to the delight of Dorus and Anna: such a surprisingly presentable friend for the family's black sheep to bring home.

Vincent had, in fact, moved into the Etten parsonage five weeks before. His Brussels lodgings, like those in the Borinage, gave him no elbow room for drawing, and Van Rappard would soon be quitting the city, along with the studio in which Vincent had taken refuge. Maybe a Brabant village would offer "subject matter enough" to allow him to pursue his training, before that happy day when — as he kept promising Theo — he was able to start earning money, most likely from the sale of graphic work to illustrate magazines.[8] As for the difficulties of the two previous years, he now felt "willing to conform" to his parents, who for their part offered him the run of an outhouse, glad to encourage this new direction in life — especially when it brought such social bonuses.[9]

The subjects on which Vincent could now practice his

drawing included, besides his staple diet of Millet prints, the cottages, mills, woods and low hills of the countryside around Etten, and indeed the parsonage itself. Like the marsh, these presented the basic perspectival challenge of how to fit the world in a rectangle. But above all, once he got settled in, Etten offered Vincent the figures he needed in order to compose an art concerned with how people lived their lives. His material was ripe for the taking: "He was drawing sowers then, and went into small dwellings to draw the woman doing some domestic chore. He forced people to pose for him." So remembered Jan Kam, a local artistic hopeful who spent some time with the "oddly dressed" roughcast redhead that summer. "They were afraid of him, and it was not pleasant to be with him."[10] There is indeed scant empathy in all but a few of the surviving figure studies of 1881. Vincent simply tried to map, without thought for the body beneath, the shapes made by the clothed peasants he had required to freeze in their digging, sweeping or sewing.

As long as it looked as though his subjects were working, he had something to work on. His letters to Theo became unusually brisk, driven along by a forward, upward stride. That summer, a summit to reach for suddenly swung into view. There was a woman for Vincent. He would marry.

3

Cornelia "Kee" Vos came to stay at the Etten parsonage in August 1881 because her parents were Vincent's maternal aunt and "Uncle Stricker," an Amsterdam pastor who had made efforts to acquaint Vincent with theology during his futile bid to train for the clergy back in 1877. In those days Vincent had met Kee in the company of a preacher husband who had since succumbed to lung disease. The widow now calling on her country relations was seven years Vincent's senior and accompanied by an eight-

year-old son. A photo of them taken at this time suggests she bore her bereavement with a defensive, straight-backed dignity.

Vincent's letters to Theo hardly confer fleshly substance on that image. His future sister-in-law, Jo Bonger, later consulted Kee and noted in her memoir of Vincent that though "they walked and talked together," Kee "was unconscious of the impression which her beauty and touching sorrow made on her cousin ... 'He was so kind to my little boy,' she said when she later remembered that time." Kee, however, "quite absorbed in her grief," gave an immediate and "very decided no" when Vincent proposed.[11] What emboldened him to do so? In part, as his subsequent letters to Theo make clear, the fact that Kee was a theologian's daughter. She stood, as he saw it, in need of a double rescue, both from her mourning weeds and from a renunciative religiosity Vincent had now put behind him. Nonetheless, the principle of consolation remained his high ideal, and here, he convinced himself, stood his best opportunity to put it into practice. This, rather than Kee's erotic allure, seems to have been the driving force behind his nuptial campaign.

Consolation — but also a sense of entitlement. Vincent was twenty-eight now, with a mission in life at last opening up before him. He too, like any other adult male, had a right to proclaim "I love" and to nominate an object for that declaration. He wouldn't take that object's "no, nay, never" for an answer. After Kee returned to her parents in Amsterdam, he pestered her with letters, causing Uncle Stricker to write demanding he back off. He started pestering Theo for the price of a train fare to run after her and make her see sense. Come November 1881 Dorus and Anna, at first neutral, felt obliged to represent the Strickers' case in Etten, causing a whole new line of fracture to crack open.

Vincent and Dorus had a showdown. It was time for his father to treat him like a man. Surely his own reading and ideas stretched further; surely it was this bigoted old minister who

was thwarting his right to love, deeming it "untimely and in-delicate"—the same domestic dictator who had tried to im-prison him in an asylum, who had cursed him to his face. The armory of modern writing that Vincent had been amassing on the rebound from Thomas à Kempis's *The Imitation of Christ* was launched into the fray: the paperback editions of Michelet and Victor Hugo, incendiary to Dorus but equals to the family Bible in Vincent's provoking valuation. After his father ended the shouting match by ordering him out of the room, the boil-ing inside continued to spill over in letters to Theo. A further modern author—Eduard Douwes Dekker, a.k.a. Multatuli, the sole native critic of nineteenth-century Holland's closed-ranks complacency—would soon be invoked: "Perhaps *God* only ac-tually begins when we say those words with which Multatuli closes his *Prayer of an Unbeliever:* 'O God, there is no God.'"

The man who departed from Etten a few days after the row (Theo in Paris having tried to defuse the tension by mailing his fare) was empowered by a stirring discovery: Whatever the saints and theologians might think, his own need was actually greater than the needs of others. Oh yes, he was full of love—it was exactly because his soul was so full that he could never, however those dry old churchmen might judge him, call him-self an atheist. But let no man stand in the way of that force. Vincent arrived in Amsterdam and made his way to the Strick-ers' home at Keizersgracht 8. Once admitted—after all, he was their nephew—he demanded access to Kee. She left the house on hearing you were coming, the reverend replied, repeating his formal demand that Vincent desist. Another shouting match arose before they could persuade him to leave. Yet the next night he was back. Still Kee was not to be seen. As if in some melodramatic yellowback novel, Vincent thrust his hand over an oil lamp: "Let me see her for as long as I hold my hand in the flame."[12] The reverend (or maybe his son Jan) simply blew the flame out, which wasn't in Vincent's script; afterwards Jan

pitched in with sneers about Vincent's lack of funds. The message at length came home: "No, nay, never" it truly was. End of story.

No, no, that wouldn't do! The drama demanded a sequel. Travelling onwards to The Hague, Vincent headed for the Geest, the red-light district of his apprentice years, determined to make amends for his insufficiently misspent youth. A night with a veteran streetwalker—unaffected and full of that "drubbed by life quality" in which he found "such infinite charm"—got written up in the best modern manner for his one-man readership in Paris.[13] But in fact the life artist had other business in the Dutch capital. He had visited it three months back, in late August 1881, to call on Anton Mauve, the nearest available family model for artistic success. Mauve had seen something in him—a shared melancholia, perhaps—and handsomely offered technical advice. Vincent did his best to take it up, trying his hand at charcoal and, rather against the grain, at the delicacies of watercolor.

Returning now at November's end, he appealed to Mauve for further support. Reporting to Mauve's well-appointed residence over the following weeks while boarding in town, he was inducted into a much more congenial medium. He painted his first oils. With their warm, homely browns laid on primed paper, these still lifes were humble but happy exercises. The sensuality hinted at in his novelizing of the one-night stand came through another way in his rendering of the glistening of cabbage veins or the dirt brushed onto "drubbed" potatoes. Vincent enthused to Theo about the refined intelligence of his tutor, who for his part offered generous, if gruff, encouragement: "I always thought that you were a bloody bore, but now I see that this isn't so."[14] It would make sense, Vincent suggested to his paymaster brother, if he were now to settle in The Hague, to work in Mauve's ambit.

The option became a necessity after he perversely chose to

return home for Christmas. On the morning of the twenty-fifth, full of righteous apostasy, he refused to join the family as they set off for church. It was more than Dorus could take: There was further shouting; Vincent was told to leave for good. By the twenty-ninth he was installed, still a little shocked at his own behavior ("Was I *too* angry? Was I *too* violent? — so be it"),[15] in a room in a cheap modern row on the far side of the railway station from the center of The Hague. Schenkweg, this as yet only half-developed zone of urban overspill, would remain his address for the next twenty-one months.

4

The inner repositioning, however, had further to go. "Theo, I feel an energy in me," Vincent wrote, three weeks into 1882, "and I'm doing what I can to release it and set it free."[16] Aware how much he had yet to learn, he had returned from oils to pen and pencil, concentrating on figures — an old woman, for instance, hired to sit and knit in his new studio. Under Mauve's guidance, a command absent the previous year was beginning to come through. Vincent loved Mauve, this wise and generous apostle of the cult of Millet. Yet between them lay an awkward generational difference of fifteen years. The now-celebrated master of landscape pushed Vincent towards training by way of the traditional academic plaster cast and professional life model. His pupil, with a mind already largely moulded, resisted the former as inauthentic, going so far as to smash some casts lent him by Mauve. His instinct was to stick with the poor and elderly in their actual working clothes, rather than the pretty girls posing nude for the Pulchri, the artists' club to which Mauve had introduced him.

Landscape, Vincent told Theo, was not the direction in which his own firmly figural instincts lay. Nonetheless he con-

structed his own method of mastering the genre — or had one constructed for him. He used some of Theo's cash to pay a carpenter to create a "perspective frame," in other words a wiregridded window, mounted on a tripod. If you gridded your sketching sheet likewise, your eyes could shuttle between the two, guiding your pencil as it transferred the view. This device, adapted from a manual he'd studied, came into its own in March 1882 when Vincent's uncle Cor offered a commission: twelve drawings to show a variety of scenes from The Hague.[17] Why did this job not become the entry into the world of steady paid work that Vincent was constantly promising to Theo? The bracing bleakness of the vistas on which the frame got trained — gasworks, raw estates, factories behind railway sidings — no doubt had something to do with it, the severe heavy pencilling something too.

It was not for nothing that Vincent lived on the wrong side of the tracks. Among the various artists' club acquaintances he briefly hung out with and very soon fell out with in early 1882, George Hendrik Breitner, four years his junior, played a part in the reshaping of his persona. Breitner was hip. His art was about "street" as we now use the term, about snatching at the action, wherever it was, which generally meant the working-class quarters. Breitner had got hold of the latest word from Paris; he had read the novels of Émile Zola. Here was a painter introducing a new cultural temper to the Netherlands, the tone of the Tachtigers, a movement of 1880s writers for whom realism or naturalism no longer signified the stoic, pastoral, socially cohesive values observed by Mauve and his Hague School generation.

Vincent came along on some of Breitner's street expeditions. (Breitner would cringe when he hauled out his perspective mechanism in public.) *Torn Up Noordstaat with Diggers,* a sketch done that April, looks as if it might have started, at the top, with the use of the frame. But then Vincent seems to have

broken free of it, as if he had interpreted the newfound artistic ethos as a cue for anarchy. Glimpsed, momentary poses of diggers and bystanders were spliced with figures (an old woman, a kneeling girl) that had been studied earlier at home, and all perspectival decorum got cast aside as Vincent rustled up an abrupt, all-at-angles community of anomalous urban loners. In a sense, he was taking the aggressive new urban agenda more radically than either Breitner or Zola, whose infectiously energetic novels he was starting to devour.

It was an agenda he was putting into practice in his life. The view in the sketch was in fact taken from a first-floor window at Noordstraat 16, a couple of blocks north of the Geest. In the back rooms lived Vincent's woman. She was called Sien (for "Clasina") Hoornik and she shared the flat with her fifty-three-year-old mother, nine-year-old sister and four-year-old daughter. Sien, herself age thirty-two, was the oldest of a brood of eleven. The horizons of the Hoorniks' world were cramped and inner city: the odd small business, much casual labor, some charity handouts, some hustling, some whoring. Vincent had come across Sien while cruising the street one night in January. She wasn't well and was in the fourth month of her fourth pregnancy, two sons having died young, and the present father being nowhere in sight.

"Mater Dolorosa" was one label he would hit on, seeking to convey her appeal.[18] His portraits of Sien dwelt less on her hard-worn skin (she had gone through smallpox) than on the grave and dignified bone structure beneath. Though she was "no longer beautiful," and though she could never aspire to the status of Kee (he retained a certain pride in having pursued that lost cause), she was a far more compliant candidate for consolation, and above all, she knew how to get on with him.[19] After he'd used his brother's cash to pay the doctors to restore her to health, she gave good service as a model. The background hum in the letters sent to Paris that spring — behind all the demands

for more money, behind all the rows with fellow painters — is of gathering confidence sustained, as hardly ever before, by a relaxing companionship.

There was such a thing as Vincent's own art, he was becoming sure. The proof lay in another project from April 1882, his riposte to the arty nudes of the Pulchri, a drawing he inscribed *Sorrow.* This recourse to the English language affirmed the difference in his stance. Yes, the London painters and printmakers whom he had begun to love a decade before were "literary." Mauve, like most Continentals, held that quality against them, but wrongly, for the urge to speak poetically about life could have its own pictorial power and "nobility."[20] Here, devising with Sien a pose in which her nakedness could turn eloquent, he had arrived at a breakthrough, a truly capacious symbol, with a personal gloss for good measure: to add a line from Michelet — "How on earth can there be a woman alone, abandoned?" — was to speak of the pity that moved him to his rescue of the prostitute.

Proudly, Vincent produced multiple versions, including one that placed beside the posed figure — by way of a further didactic gloss — an inset sheet of a riverbank tree, drawn also from life but a little while later. Landscape motifs, it had come to Vincent, could serve the same emotional purposes as figures themselves, but by another route: "I wanted to express something of life's struggle, both in that white, slender female figure and in those gnarled black roots with their knots."[21]

5

"Life's struggle" might have been a matter for artistic contemplation on May 1. But by May 7 Vincent was back in the fray, fists flailing, teeth bared. That day, out on a walk, he'd chanced upon Mauve. His mentor of the winter had been avoiding him

for months. Vincent invited Mauve to come and see the new work. I won't, said Mauve. I'm through with you: "You have a vicious character." Why (apart from the loss of his plaster casts) should Mauve have turned so on his protégé? Vincent paranoically—but quite possibly rightly—suspected that Mauve's ear had been bent by Tersteeg, the Goupil & Cie manager whom Vincent had admired as an art-store apprentice and to whom more recently he had applied for support as an apprentice artist. This importuning of Vincent's exasperated Tersteeg, a self-made success who soon sized up Vincent as a ham-fisted fantasist leeching off his respectable family and—worse, from what he now heard—a breaker of class etiquette. How dare he funnel his brother's well-earned money into the upkeep of a prostitute?

"Well, gentlemen, I'll tell you—you who set great store by manners and culture"—Vincent's riposte of May 7, directed over Theo's shoulder at all his notional accusers, was sheer shameless, stagey chutzpah—"what is more cultured, more sensitive, more manly: to forsake a woman or to take on a forsaken one?" The bluster didn't impress Theo, from whom Vincent had kept the Sien situation more or less veiled. Still less, of course, his estranged parents, who thus learnt of it secondhand.[22] Vincent met Theo's forthright objections by upping the ante and proposing to marry Sien, at which point Dorus began, once again, to discuss having his eldest son committed as a person incapable of managing his own affairs.

Yet Theo continued with financial support, and only a few weeks later, on June 12, Dorus found his own opportunity to offer Vincent consolation. He visited him in The Hague's municipal hospital. Bathetically, inconveniently—Sien being so near her term—yet predictably, Vincent was laid up with gonorrhea. A woozy, feverish reunion with his sorrowing father came amid three weeks enduring a succession of catheters being forced up his penis. He managed to get down a little word-painting, since he wasn't allowed to draw, noting the "splendid"

bird's-eye view of roofs, canals, wharves and gardens presented by the ward window, with its "mysterious" morning and evening "light effect like, for example, a Ruisdael or Vermeer."[23] But most of the thoughts he expressed while bedridden were for the harsher pains awaiting Sien, who daily visited him until her confinement began. Come July 2, he was on his feet again and himself in attendance when, after a difficult labor, she gave birth to a baby boy.

With the arrival of Willem Hoornik, this new life that was not of his blood yet that asked to be loved for its own sake, Vincent reached a kind of giddy summit to the arduous, courageous, crazily wayward slither and scramble he had undertaken since the previous November. Having delightedly installed Sien, Willem and her other little child, Maria, in Schenkweg — where he'd switched to a larger apartment next door to his first, one he'd furnished in preparation — he came to rest on July 2 in a precarious equilibrium, a position from which he would merely tilt a little this way or that over the following year. Between July 1882 and August 1883 the ever-hard-up, ever-fractious edge-of-town loner with the benefactor brother shuttled between various lines of artistic research.

He continued employing the perspective frame: A watercolor of the rooftops seen from his new apartment, done that July, is one of his most virtuoso uses of the device. He did a certain amount of sketching of his adoptive family — some plangent drawings of Maria kneeling at Willem's cradle, for instance — and put much time and borrowed money into further sessions with working-class models. A reliable old pensioner named Adrianus Zuyderland became his mainstay for much of the autumn, posing for a powerfully effective clothed variant on *Sorrow* named *Worn Out*. English printmaking, more than ever, became Vincent's ruling passion. He expansively mulled over his connoisseur's collection in correspondence with Van Rappard, and in January splashed almost two months' worth of

rent money on a twenty-one-volume set of *The Graphic*. Both
before and after, he made homespun bids to match the high-
production-value social realism of his favourite *Graphic* art-
ists such as Hubert von Herkomer and Luke Fildes. There was
a sooty watercolor of a crowd outside a lottery office in Octo-
ber, didactically entitled *The Poor and Money,* and in March the
Schenkweg flat got mocked up as a soup kitchen. For a short
while in November, Vincent tried out some calling-card images
(such as *Sorrow*) in the medium of lithography.

The liveliest episode of the year followed a visit by Theo in
early August. Oils are what sell, his art dealer brother suggested,
providing some cash to stock up on paint tubes. Vincent took
these, his frame and some boards on the tram to Scheveningen,
The Hague's coastal suburb. At once he found himself driven
along by the bright fluent paste he was handling, as if by the sea
breezes whipping at his clothes. He was thrilled. It drove him
into a sudden new empathy with the stuff scenes were made of,
demonstrated, for instance, in a slabbed, abrupt embrace of a
sand dune that cannot have resembled anything in his encyclo-
pedic acquaintance with European art. "I'm glad that I've never
learnt to paint," he would soon write. "Probably then I would
have LEARNT to ignore effects like this ... *I don't know myself*
how I paint," he added in wonder. "I see that nature has told me
something, has spoken to me and that I've written it down in
shorthand."[24]

Yet not knowing how to integrate these discoveries within
his plan to deliver a poetic, graphic, figure-based art, Vincent
dropped his brushes within two months and would not use
them again until he went out to paint various landscapes (some
of which are lost) the following spring. Not that this plan of
his was gaining commercial traction. Theo, perhaps too inured
to his brother's noisy, nonstop psychological attacks to sift out
their moments of eloquence, doubted that anything could be
marketed, and Theo had become his only ally. The dynamics of

the situation were transparent: "If it's at all possible send me an-other 10 francs. A week's work depends on it . . ."[25] "I promised to pay my landlord 5 guilders . . . I hope you'll send me what I so greatly want . . ."[26] "In a few days, you understand, I'll be ab-solutely broke . . ."[27] That juncture was one that nearly all the letters, however long, eventually came around to. Was that the point of all the verbalizing? Was the loquacious connoisseur and critic of modern fiction no more than a beggar with an act?

There they were, businessman and bohemian, two natures fraternally locked in a predicament that Baudelaire might have understood but which defied Dutch logic, Tersteeg logic — since Tersteeg had become Vincent's bête noire, an emblem for all he was up against. Indeed, the sheer fact that Vincent was the way he was refuted his family's belief structures:

> One can't present oneself as somebody who can be of benefit to others or who has an idea that's bound to be profitable — no, on the contrary, it's to be expected that it will end with a deficit and yet, yet, one feels a power seething inside one, one has a task to do and it must be done.[28]

So wrote Vincent one Monday evening in late November 1882, after a day working on lithographs — in the course of the same letter putting out uncertain hands in the dark to feel for the existence of an indefinable "something on high" and, on a different level, for the existence of a "movement" over in Theo's Paris "that was known as Impressionists, I believe" — a phenom-enon he had merely heard about in Zola's novels. While he read, reflected and wrote, Sien, across the fireside, relaxed with cigars or gin.

Their good companionship probably started to sour after Sien's mother joined the household later that winter. Sien, the evidence suggests, lived on low expectations. She herself could make do with this downwardly mobile middle-class misfit with

his rather exhausting, angry goodness and his nagging. (He thought she didn't clean the flat well enough.) The Hoornik clan, however, had Vincent down as a tricky loser, pushing a claim where he had no business.[29] As they tugged at Sien's allegiances in the spring of 1883, Vincent dreamt of the two of them and the children breaking free, perhaps to the country, perhaps to England—or, at least, that he himself might do so. The utter unfriendliness of The Hague was beginning to oppress him, one reason why he was now taking his oils out into the fields. Sien's alienness—her incurious near illiteracy—began to weigh on him likewise.

Over the course of the summer, the nearest thing to a marriage he would ever know succumbed to the class pressures it had tried to defy. While Sien's brother—a pimp—pulled one way, Theo took Vincent firmly by the arm, descending on The Hague for a flying visit on August 17. I can no longer afford to subsidize your charity charade, came the message. (Times were indeed currently tough in the art trade.) Your Schenkweg setup has to end. Vincent raged, yowled, submitted. "I can't say exactly what her expression was like," he wrote to Theo a couple of days later, "but something like a sheep wanting to say, if I must be slaughtered I won't resist."[30] What would happen to the little boy, his happiness, the one who needed him? What would happen to her, his good cause? (Short answer: She returned to the Geest and threw herself into the Scheldt River twenty-one years later.) As the train whistle blew on September 11, he passed Willem through the window back into her arms.

3

Dog

I

EARTH BLACK AS SOOT, stretched out flat and endless beneath a pale clear sky, and "melancholically overgrown with eternally rotting heather and peat." Traversing its expanse, Vincent sensed that all human concerns were gone: "One feels nothing any more, however big it may be in itself, one only knows that there is land and sky."[1] The train from The Hague had taken him to Drenthe in the Netherlands' deep northeast. He had heard word that this, the kingdom's poorest and barest province, was a painter's paradise: Van Rappard had visited it in the summer of 1882 and Mauve the year before. Their reports suggested that here, "the true heath" still existed, the wilderness he felt was vanishing from his native Brabant in the face of "land reclamation and industry."[2] There would be "stimulating" effects to capture in Drenthe, and besides, life would be so much more affordable than in The Hague.[3]

At Hoogeveen, where the train pulled in on September 11, 1883, he spotted "really authentic peat barges and the figures of bargemen."[4] A couple of days later, a still more "authentic" moment occurred while he was painting a stick-and-turf hut in the surrounding heathland: The peasant woman inside stepped out to chuck a broom at a goat that had climbed up to browse on its thatched roof.[5] But humble Hoogeveen — hardly the town his map had made out — was merely a staging post in a quest for the sublimely stark that led him to the bogs farther east. At the be-

ginning of October Vincent travelled by barge to a peat cutters'
base named Nieuw-Amsterdam. He put up at the inn there, and
it was from Nieuw-Amsterdam that the rapturous description
of a black-earth infinity was posted a month later, following a
day trip to a farther outpost called Zweeloo. The day's experi-
ence, from the mossy roofs shining golden green in the dawn
light to the red glow of tiny hut windows in the dusk, had been
aesthetic beyond compare: "One feels exactly as if one had been
at an exhibition of one hundred masterpieces."[6]

The artist seeking out these effects had moved on in two
ways from the would-be social realist who had been busy draw-
ing in The Hague throughout most of the previous two years.
Using pen, black chalk and pencil, he had arrived during that
period at his own confident graphic shorthand for figures, a
resource with which to construct his long-intended art about
people's lives. But this notation — hard hacked, heavily hatched,
jagged and severe — had snarled up on its creator. Its "dryness,"
he felt, was a reflection of his own poverty, and perhaps its cause
as well: He could see why it didn't sell.[7] Theo agreed with him
that oil paint might be the best way forward. Stocking up on
tubes involved greater outlay, but their contents, so much richer
and more sensuous, promised greater rewards. Now in Drenthe,
Vincent was trying to steer the enthusiasm for oils that he had
impulsively happened on at Scheveningen a year before, putting
paint to service as his primary medium.

Painting the beaches and dunes at Scheveningen, Vincent
had surprised himself by letting go of himself. He had supposed
that his art was through-and-through figural and that he could
only approach landscape by investing its motifs with bodily
emotions. (For instance, the tree roots and troubled woman in
the drawing *Sorrow* both pointed in the same direction, telling
of "life's struggle.") But might not open space, stretching end-
lessly beyond human bodies and habitations, provide a counter-
weight to those emotions? To take his paints to the eastern flat-

lands was to reach out to that possibility. Equally, it was to trace a nostalgic reconnection with what he had known as a boy in Brabant. "Here on the silent heath where I feel God high above you and me,"[8] as he wrote to Theo at October's end, he thought he had found "my country."[9] Moreover, it was a feeling for the country, not the city, that sustained a person spiritually, "even if one is civilized or whatever."[10]

One was released; one felt "nothing any more."[11] Or else one felt too much. The autumn rains swept over the bogs and hamlets, curtailing his oil sketching. Light from an overcast sky, trickling through the single glass roof tile in Vincent's rented attic onto his empty paint box, struck him as "*so* curiously melancholy" that it was virtually comical. But when he went out alone and caught sight of "some poor woman on the heath with a child in her arms," his eyes would start raining too.[12] With no other "civilized" company — all the other painters in search of a "primitive" Drenthe had passed by in the summer — he was left alone on the long damp evenings, to sit scribbling sorrowful reflections over the separation with Sien and Willem to his paymaster in Paris.

On October 12 a reply arrived that swung his thoughts in another direction. Theo, not for the first time, was at loggerheads with his seniors at Goupil & Cie. His letter (now vanished) evidently railed at their cool commercial indifference to his artistic sensitivities, and talked of leaving for America. Vincent saw an opportunity for once to do his brother some good. He would tell Theo the truth about himself: that he too, at heart, was an artist! The notion of Theo wielding a brush, once mooted, soon possessed Vincent, and for the next month his letters would not let go of it. The fact that it was blatantly impractical — after all, to put Theo out of paid work was to cut off the branch Vincent sat on — only proved that it was a test of faith and as such must be embraced. One moment Vincent was inviting Theo to

join him painting on the heath, the next he was manfully releas-
ing him from the duties he'd assumed: "If you want to be rid of
me, very well, I also want to be rid of you, but amicably and in
good order."[13] By November 13, he was pushing his case so far as
to claim that if Theo submitted to his Goupil & Cie superiors
and stayed, then he, Vincent, would positively refuse any more
of Theo's money.

When Vincent next wrote, on the twenty-sixth, his opening
indignant demand was, sure enough, where's my money? With
no reply forthcoming from his no doubt exasperated brother,
enclosing the customary banknotes, Vincent was once again
almost broke: so much for his altruistic dream. It began to hit
home, after Theo told him he would be staying at Goupil & Cie
after all, that the whole vague project Vincent was pursuing in
these far-off marshes was no more than a will-o'-the-wisp. The
natives regarded him as a madman, and maybe they weren't far
wrong: "I'm absolutely cut off from the outside world—except
for you—so that for me *it was enough to make me crazy when
your letter didn't come,*" he wrote, excusing—or expanding on—
his anger on December 1.[14] Three days later, the despair held at
bay during two years of embattled contrariness broke its banks
and swept him away—out of the godforsaken inn at Nieuw-
Amsterdam, out into the rain and sleet, and down the road that
led back to Hoogeveen, a six hours' walk away. He boarded a
westbound train, never to return.[15]

2

From this point the story turns less pleasant. There was no-
where for Vincent to go but home. But was home *home* any
longer? Dorus van Gogh had the previous year been posted to
Nuenen, yet another parish in the backwoods of Brabant. His

footsore eldest son, now knocking for the first time at this village's parsonage door, had, if nothing else, a fine gift for describing the situation that arose:

> There's a similar reluctance about taking me into the house as there would be about having a large, shaggy dog in the house. He'll come into the room with wet paws—and then, he's so shaggy. He'll get in everyone's way. *And he barks so loudly.*
> In short—it's a dirty animal.[16]

Vincent's letters to Paris, in effect, acknowledge that his father was physically frightened of his presence. This animal was "wild," as male animals tended to be, according to zoology.[17] Particularly when cornered. Here was a thirty-year-old man with nothing left to call his own—no funds, no roof, no partner, no plausible plan—except for the self-appointed role of "artist," for which the world cared nothing. He had even mislaid the principles to which his art was supposedly committed. Any talk of "consolation," let alone of "something on high," had been left behind with his abandoned pile of oil sketches in the inn at Nieuw-Amsterdam, and nothing more would be heard of them for a long while to come.

The only instinctual response on which Vincent could rely, in order to clear a fresh space for himself, was naked aggression. He was shouting at his father almost as soon as he was through the door. Why hadn't he received the parental support that had been provided to Van Rappard? (Never mind that Van Rappard's father was a legal grandee, not a country parson.) Once again, the Kee Vos debacle got blamed on Dorus. Once again, the superior wisdom of France's godless modern writers got thrown in the old man's face. If Theo wrote to rebuke Vincent for this behaviour, then Theo was too much on the "Van Gogh" side of the family, too much of a temporizing, money-minded cold fish. And besides, weren't Vincent's tactics pay-

ing off? For Dorus and Anna had yielded to him an outside room to use for his studio, and he would now be living rent-free. Nuenen, it seemed, could serve him for the time being as a viable kennel.

To retrieve his studio gear from storage Vincent visited The Hague, where he met up again with Sien — at least she was currently taking in washing, rather than turning tricks — and that gave him occasion to open a fresh line of fire. Wasn't it Theo who had forced the two of them apart? What were the true intentions of that uncaring, that oh-so-politic businessman? Why in fact was Theo bothering to subsidize his elder brother? Were the payments from Paris sent out of mere pity? Was Vincent's work really so negligible, so terminally unsaleable? It was time to force Theo's hand. Doing his best to play the businessman himself, Vincent posted off a redrafting of their arrangements on January 15, 1884:

> I have a proposal to make for the future. Let me send you my work and you take what you want from it, but I insist that I may consider the money I would receive from you after March as money I've earned.[18]

Two days afterwards, a ceasefire was called on Vincent's war against his father. His mother, Anna, who was sixty-four years old, broke a hip by falling on a frosty railway platform. The doctors sent her home with a plaster cast to begin a lengthy process of healing, and immediately Vincent's energies were rerouted towards nursing. Devoting his physical strength and mental persistence to this straightforward loving duty, Vincent did "exemplary" work, Dorus was glad to tell Theo.[19] Vincent's own letters praised the efforts of his favorite sister, Wil, now twenty-two and still based at the parsonage. (He spoke less highly of its other part-time residents. The literary effusions of twenty-five-year-old Lies were "half-sentimental,"[20] and seventeen-year-

old Cor needed to seek work: "Otherwise they go to seed, these young fellows."[21])

Good to his mother, Vincent remained hard to his closest brother. The wrestling with Theo would heave, twist, flag and resume throughout the year that followed. Parallel to this grim-faced push and pull, Vincent spent the first half of 1884 creating the sternest set of pictures in his oeuvre. In Nuenen a fifth of the population worked in the age-old Brabantine home industry of weaving. Soon after his arrival, Vincent's practice became to call on weavers and, offering cash or much-valued coffee, to plant himself in their front rooms and draw. The way the vast looms dominated both their operators and these interiors evidently fascinated Vincent. It made his own work hard and awkward: Squeezed against a cottage wall, he had no space to employ the perspective frame on which he still liked to rely. And yet the designs of the pictures prodded at the analogy between the one type of frame and the other, between the tool operating of the painter and that of the weaver, each bound to his cloth, to his day's labor, to a venerable craft tradition that was bigger than himself.[22] The ten or so canvases from this body of work are formal and self-conscious in a way that his own written descriptions, sent to Theo or Van Rappard, never quite touch on. Increasingly, Vincent's two tools, the pen and the brush, were going their separate ways.

The letter descriptions are hardly more explicit for an alternate body of work — a suite of large and exquisitely delicate pen drawings, done in March 1884, that are the nearest Vincent would ever come to the British literary artists (Boughton, Millais) whom he so admired, and yet surpass their work in poetic intensity. The initial impetus for these sheets seems to have come from a recent volume of plangent late Romantic lyrics by the French poet François Coppée, lent to Vincent by Lies. Vincent projected Coppée's triste scenarios onto his immediate environs in Nuenen. The neighborhood's own "bare trees"

and "faded grass" became choral metaphors for the emotions of a solitary female protagonist, a widow whom Vincent could discreetly associate with his own romantic lost causes, Kee included.[23] Her figure receded and dissolved into the landscape in the course of the sequence, leaving a faint glow of valedictory tenderness that seems almost bizarre when juxtaposed to Vincent's ongoing rages against his brother.

Surely a returning sense of his own artistic worth spurred the irritable demand that Theo take him seriously, but then, Theo hadn't seen these drawings. They had been sent instead to an admiring Van Rappard, who was becoming Vincent's preferred reference point and whose presence, to his delight, he was able once again to secure as a visitor to his parents' home. In May, the poised young aristocrat—last entertained at Etten three years before—toured Nuenen with the uncouth *schildermenneke* ("little painter guy," as the villagers liked to term him) who had lately descended on the parsonage.[24] Reobserved in this refined and optimistic company, the locality looked brighter to Vincent, to judge by a subsequent view of a watermill in which his customary dun and murky palette lifted in hue to become positively lyrical. As the poetic drawings had already acknowledged, Nuenen, this quiet country backwater, was turning out to be as near to the "true Brabant" as he could ever wish to find.

3

Vincent might cut an uncouth figure, but with his fire and his prodigious range of cultural reference, he might also present an alternative to rural boredom. A good neighbor from one of the parish's few Protestant families called regularly on the parsonage to help with Anna's nursing. Margot Begemann was not just bored but squashed. Her forty-three years had been spent under the possessive regime of a wealthy father, continued af-

ter his death by three equally thwarted elder sisters. Margot fell
for Vincent. It was for him an unfamiliar experience, and by
his own account he parried, refusing the spinster's dangerously
compromising offer of ready sex.

Of course, Vincent may have preferred the houses that pur-
veyed this commodity in the nearby market town of Eindhoven.
Frequenting Baijens's, a store where he bought his paints, he was
beginning to get taken for an artistic pundit. A retired antiques
dealer named Antoon Hermans asked him to come up with de-
signs for a decorative scheme that Hermans himself—who had
a taste for dabbling—could commit to the walls of his man-
sion. Vincent, persuading his patron to switch from religious
to pastoral imagery, supplied six proposals for scenes to span
the countryman's annual round. They reveal a desire to charm
distinctly at odds with the snarling, tooth-baring persona dis-
played to family members. But he was now getting out of the lat-
ter's way. He had a new, bigger studio away from home, rented
from Nuenen's Catholic sacristan. He was making a space for
himself—at least, after a fashion.

Here was this good, kitten-eyed, earnestly desperate middle-
aged woman after him, and while he himself was less than pas-
sionate (he would picture her to Theo as a badly restored
Cremona violin),[25] her funds might somehow serve the cause of
art; surely he might show some compassion . . . Late that sum-
mer, one way or another (the evidence here is shaky), Margot's
elder sisters caught wind.[26] They summoned Vincent to a fam-
ily court. Facing up to the logic of the situation, he declared he
would marry Margot. Her sisters decreed that on no account
would he do so, damning him for a money-grabbing cad. As for
Margot, dismal dupe that she was, they decided to hustle her
away, out of reach, to Utrecht to avoid village scandal in the
event that she was bearing his child. Vincent and Margot set off
on a last walk through the fields before the carriage departed.
Margot fell to the ground. No, it hit Vincent, this was not just

another of her nervous fits: "Have you taken something?" he asked. "Yes!" she screamed.[27]

Vincent did his best to make Margot vomit up the poison, which, he reported to Theo, was the formidably toxic strychnine. He took her to her brother—the one Begemann sibling with whom he was on speaking terms—who took her to an Eindhoven doctor, and her life was saved. Away she went to Utrecht. The information that got out around Nuenen in general seems to have been relatively restricted, though poor Dorus was evidently confronting a bad odor that had settled on the parsonage when he wrote to Paris on September 30—a fortnight after the event—that he and Anna might need to move from the village to another parish if "our relations with people were to become difficult because of circumstances."[28]

There is a cynical aside in the opening to *The Brothers Karamazov* in which Dostoyevsky's provincial narrator tells a "true story" of a local young woman who contrives gratuitously to break off a romance and hurl herself off a "picturesque" cliff, "solely in an attempt to imitate Shakespeare's Ophelia."[29] That is rather how the lives here were conducted, or at least Vincent's: So much between book covers that it would be idle to attempt to trace where the writing gives out and the body damage begins. "Still, at last I have loved," Margot was able to tell Vincent "in a sort of triumph" when he came to visit her in Utrecht a few days after, a kindness he seems quite soon to have discontinued.[30] For his own part, trying to claw back some moral self-possession in a letter sent to Theo on October 2, the avid reader-cum-rewriter of Zola and *Madame Bovary* (to which, in this situation, he had instantly turned for analogies) was at his most magnificently monstrous:

> To be good—many people think that they'll achieve it by *doing no harm*—and that's a lie, and you said yourself in the past that it was a lie. That leads to stagnation, to mediocrity. *Just slap some-*

thing on it when you see a blank canvas staring at you with a sort of imbecility.

You don't know how paralyzing it is, that stare from a blank canvas that says to the painter *you can't do anything.* The canvas has an *idiotic* stare, and mesmerizes some painters so that they turn into idiots themselves.

Many painters *are afraid* of the blank *canvas,* but the blank canvas is AFRAID of the truly passionate painter who dares — and who has once broken the spell of "you can't."

Life itself likewise always turns towards one an infinitely *meaningless,* discouraging, dispiriting blank side on which there is *nothing,* any more than on a blank canvas.

But *however* meaningless and vain, however *dead* life appears, the man of faith, of energy, of warmth, and who knows something, doesn't let himself be fobbed off like that. He steps in and *does something,* and hangs onto that, in short, *breaks, "violates it"* — they say.

Let them talk, those cold theologians.[31]

The life artist was on the attack once more. His invective against a cold, timid bourgeoisie now came with political trappings. Drawn to the cause of French radicalism ever since he had first read Michelet, he imagined Theo on one side of the Paris barricades and himself on the other — "a revolutionary or rebel" with a pistol in hand, as in Eugène Delacroix's *Liberty Leading the People.*[32]

It was a handsome dream platform from which to step down and proceed to a village workroom to study pots, clogs and jars. That autumn Vincent returned to the still-life work that had been his first experience of painting with Mauve three years before. He, in turn, was trying to inculcate, having got together a small art class in Eindhoven. In the examples with which he led the way, a lush, brisk touch moves about small canvas boards, loading them up with dark, ruddy warmth; the connotations of-

fered by the displayed kitchen items are as homely as could be. Vincent now trusted in a realism devoted to "the dead simple, most everyday things."[33] And yet discussions with Van Rappard — who was visiting again — combined with what Vincent had read of Zola, hinted that French radicalism might somehow disrupt the art of painting itself. But in what manner? "Here in Holland it's hard to work out what Impressionism is actually trying to say."[34]

While he might be a big fish in an amateur provincial art group, Van Rappard, with his studiously constructed social-realist scenes of almshouses and laborers, was catching the new left-leaning temper of the 1880s and starting to win international prizes. Vincent, reflecting that autumn that he had now spent over a year working in oils "entirely outside the world of painting," decided he needed to up his game, with a view towards exhibition.[35] He adopted the approach lately pursued by his friend, of working away at sequential head studies. His would portray the folk of "old Brabant,"[36] with the "coarse, flat faces with low foreheads and thick lips," so "full and Millet-like,"[37] for which he had a special taste. He imagined (as so often) that here he had hit on a project with sales potential. The specimens of ethnic authenticity, male and female, were summoned to the studio from nearby cottages. The harvest was in, the slump had hit the textile market; it wasn't hard to find recruits.

Vincent sat facing them and aimed his brush freely at little upright canvases prepared with brownish or greyish grounds; the paint landed to this or that side of those undertones, lusciously bright or still more lusciously dark.[38] The head before him was dismantled so as to be retied together as a raft of heavy colors, afloat most often in blackness. The day's session — or maybe just the morning's — would be capped with highlights in the eyes that assigned to the performance a life and a soul. For these unnamed sitters were at once representatives of a race and

individuals possessed of dignity, in all their peasant finery — to be regarded with the wary, alert admiration that Vincent would maintain throughout most of his subsequent portraiture. He aimed first at completing thirty heads, then fifty, and realized that ambition during the early months of 1885. The brushwork accelerated and turned skittery and rhythmic. Vincent was now overcoming the earlier awkward disjoint between his intentions as a drawer and his instinctual feel for oil paint. Alone in a quiet nowhere, he was pushing that medium as hard as any of his contemporaries in Europe.

Every few evenings, between sessions, he would pick up his pen and resume the tussle with Theo over the relation between the one brother's money and the other brother's art. This too was enlarging in scope, so much so as to take on near-philosophical implications. Nowadays, Vincent's life was no longer sustained by the religious faith upon which he had once wagered his very body back in the Borinage. Instead he had reverted to the modern default belief system, the belief that we owe one another and that money — credit — is the universal vessel for that debt. But money, the more he prodded at it, kept alternating from real to unreal. Necessary banknotes came his way because a certain businessman in Paris deemed that the subsidy was a sociocultural obligation. Yet they bore no relation to his daily physical activity, to his emotional needs, to "the pleasure of being able to make something"— to all that was "warm" and lifelike.[39]

Money and painting mocked each other: "The artist is the desolation of the financier" and, conversely, "The financier is the desolation of the artist," he wrote, reworking a social theorist's formulation. Somehow, in this "age of innovation and reform," there had to be a way to break free from the financier's cold and "sterile" anti-god; it seemed so ringingly obvious, as he reflected on these themes on December 10, 1884. Goodbye, money; goodbye, Theo. "We must split up — *in both our interests*."[40] By the fourteenth — ah, but of course — he was back on

his knees: "I don't need much, 20 francs or 30 francs . . ."[41] The rebound against the walls of his cell only served to underline that this place was named prison.

Even as he made his attempted adieus, Vincent noted that "my duty compels me to love my father, my brother — *and I do.*" And to read his correspondence in bulk is to believe that the assertion was at least half substantial. Beneath all the interminable ranting postscripts dispatched to Theo, beneath what Vincent himself had termed the "seething" in his mind, there lay a need to share that went back to their childhood.[42] It would be good to think that a comparable love continued to connect Vincent to his father after his life changed course, so that the admiration he had expressed as a religious young man merely became inverted in its expression. But we hardly have the evidence. What we have — amid all the havoc raised by Vincent's endless discourtesies and blunderings, the subject of copious family comment — are lines in the letters from Nuenen such as "I wish to *hit no-one;* wish that Pa hadn't sometimes gone and stood *right in front of me.*"[43] Or witnesses' memoirs of the parsonage dinner table, such as Van Rappard's, recounted to a friend who would later speak of it in public:

> At lunch a theological controversy: father and son at odds over a verse from the Sermon on the Mount. [For all the "icy coldness" of present-day Christianity, its founder was still in Vincent's eyes "sublime."[44]] Suddenly the son gets so furious that he rises from his place with the carving knife from the tray in his hand and threatens the bewildered old man.[45]

Dorus van Gogh fell dead on March 26, 1885, at age sixty-three. A stroke cut him down just outside the parsonage door, on his return from an evening spent with friends in another village, having walked the five miles back across the heath in a sharp north wind.

4

Seven months later Vincent painted an allegorical memorial, after a fashion. That old standby of the memento mori, the extinguished candle, stands behind a massive doughty Bible, propped open on a tabletop. Vincent slapped down busy blocks of brushwork to stand for the columns of biblical text, but added scored-in chapter headings pointing us to the Book of Isaiah's verses on the "man of sorrows."[46] Another book, a cheap frisky yellow-back, cuts into the table edge's near-at-hand blur. Its title is plain to see; it is Zola's *La Joie de vivre*. Very plain, in fact, the way that Zola's salvo of modern secularism zips away, reckless and dynamic, from the religious miseries of the past — as if to say, "Goodbye, old man, I'm off." By this stage — late October 1885 — Vincent literally was about to go; he would soon be leaving Dutch territory for good. But hardly had the funeral guests departed before he was setting to work with an air of liberation. In the interval his art rose up and stretched its arms and swaggered.

A register of this unfilial triumph is another canvas intended to contrast the dying away of religion with the buoyancy of fresh life — as Vincent explained, with typical sermon-like eloquence, in a letter sent to Theo in the second week of June. During the fortnight before he had been rushing across the meadows to a graveyard beside an ancient, derelict church tower that the Nuenen village council was about to demolish. The precinct's buttercups and wheeling rooks would poetically counterpoint the soil's embrace of the peasantry of yesteryear and the forlorn relic of old Brabantine Christianity. The canvas became one of Vincent's great feats of attention. In fact, his didactic exegesis undersells and almost distracts the viewer from a uniquely warm-hearted and subtle portrait of a building, saluted brick by brick in all its mass and hollowness, its spatial logic and temporal vulnerability.

But before Vincent stepped up to the happy stride of the summer, there were "petty vexations" (as he had long loved to term every obstacle) to be overcome. Most immediately, there was his married sister Anna, the family hardhead, who, having descended on Nuenen for the funeral, delivered the home truth that if Vincent didn't get out of the parsonage, he'd be the death of his mother, just as he'd been the death of his dad.[47] Lies and Wil did not disagree. Vincent was obliged to retreat, muttering and indignant, and turn the studio rented from the sacristan into his full-time base.

Meanwhile, there was the challenge that the forbearing and generous Theo had set Vincent when, back in February, he'd offered to submit a canvas of his to the Paris Salon. Rather than meet it with a composition of people working outdoors, of the kind he'd tried painting before back in The Hague, Vincent settled on a scene that had lately struck him while visiting some locals who sat for him. He had come upon the De Groots tucking into their evening meal under a paraffin lamp. An open, unfussy family, they seemed happy to let him sketch and sketch again. His glimpse of their domesticity got transferred to a 112-centimeter-wide canvas — capacious, but still domestically scaled. (It would later sit over a mantelpiece in Theo's apartment.) In the transfer, Vincent took the evanescent hints of bodies offered by the lamp's chiaroscuro and used them as the basis for a paint surface that he meant to be fat, palpable and everywhere immediate. This and the fact that he was piecing together a patchwork of sketches of faces and hands, none too sure about the bodies they belonged to, account for the pathos of *The Potato Eaters,* a heroic awkwardness to match that of the *Bathers* paintings that were currently under way in the studio of Paul Cézanne.

But that pathos is not just technical, not just a flailing hands-on struggle to equate light with mass. These peasants themselves *were* mass, were earth, were the natural cycle in hu-

man form, so the middle-class visitor hovering by their hearth longed to believe. (He projected onto the project a remark made about Millet: "His peasant seems to be painted with the soil he sows.")[48] By the same token the painter himself, witnessing this sacramental moment in the peasants' earthy round, could not fully partake in it — a separation marked by the central silhouette of the little girl who divides the table's "earth-apple" eating from its coffee-taking. The canvas, which Vincent would come to cherish most of all his own works, asserts that sheer yearning has its own aesthetic power and advances the case by supplying an unforgettably close-packed, even bizarrely inhabitable image.

It presented Theo with an impossible-to-sell challenge to his own fraternal diplomacy, once it had been dispatched to Paris in early May. And a lithograph of the composition that Vincent enthusiastically printed and sent off to his one real painter friend left Van Rappard entirely nonplussed. The picture's "cavalier" disregard of gestural and spatial plausibility failed the standards of Millet-style realism, which Van Rappard had imagined they shared. "You can do better than this," he wrote back.[49]

There was fury on both sides. It would simmer down sufficiently for Van Rappard, later that year, to post Vincent his own new major composition in sketch form, to which Vincent responded with equally academic-minded criticisms of his own; but after that, the five-year friendship seems to have finally expired, stabbed on both sides. Vincent's attentions were turning instead towards the Paris scene, which he had discussed with Theo when the latter visited for the funeral. His letters, once again genial in tone, dwelt on a pantheon of French artists known largely through prints — not only Millet but Delacroix and the contemporary peasant painter Léon Lhermitte.

Not that Vincent was thinking of heading in their direction. No, better to stay in Brabant, whose countrymen offered subjects enough for a lifetime, he declared that spring. To follow the winter's fifty painted heads and what he conceded was the

dubious figure drawing of *The Potato Eaters,* he set himself to sketch a hundred sheets of the peasants working outdoors over the summer. This project he delivered, pretty near to the letter, with big black-chalk studies of men and women digging, reaping, binding sheaves and cutting wood, in which workwear assumes a unique rolling eloquence. As with the derelict church, Vincent was here submitting with rapt concentration to the object close before him: to a heaving convolution of clothes obeying a unitary rhythm and at the same time responsive to the surrounding air. At their best, these sketches of 1885 are breathy and free-limbed in a way that Vincent's tight earlier figurework had never hinted at. Vincent now paid little heed to portraying his subjects as individuals. But his hope that as the peasant worked, so he might work — that intrusiveness might make way for collaboration — was at its most fervent and lyrical.

To sustain that spirit, the "little painter guy" living in the rented studio was donning a peasant's straw hat and clogs as he went out to the fields and heaths each day in a spirit of happy reverie. "Painting is becoming as stimulating and enticing as hunting," he wrote, after a week in June during which he'd been joined by peasant lads in his old boyhood pursuits of stream wading and bird's-nest collecting.[50] Quite possibly Vincent's collaboration with Gordina de Groot, the unmarried villager pictured in *The Potato Eaters,* had turned sexual. At any rate, she came often to Vincent's studio, and when she found herself pregnant in August, Vincent was the first man the village suspected. (On the other hand, neither she nor he claimed the child was his.) For the style of that studio, the best witness is Anton Kerssemakers, a middle-aged Eindhoven tannery owner who, after joining Vincent's art group and accepting his eccentricities, became a good friend:

> All the available hanging or standing room was filled with paintings, drawings in watercolour and in crayon ... A great heap of

ashes around the stove, which had never known a brush or stove
polish, a small number of chairs with frayed cane bottoms, a cup-
board with at least thirty different bird's nests, all kinds of mosses
and plants brought along from the moor, some stuffed birds, a
spool, a spinning wheel, a complete set of farm tools, old caps and
hats, coarse bonnets and hoods, wooden shoes, etc., etc. [Kersse-
makers also itemizes the familiar "perspective frame."][51]

The muddle grew, still lifes and landscapes getting added to
the stacks of head studies and views of the old church. As the
summer of 1885 turned to autumn, Vincent was painting with
awesome celerity and grace, not only in these traditional genres
but in variations all his own, such as a monumental vision of a
sheaf of wheat or intimate homages to his collection of bird's
nests — not to mention the Bible-and-Zola canvas, which, he
was proud to claim, was the work of a single day. Was he coming
any nearer to selling his work? No, he was positively evading the
issue, preferring to remain in a penurious dependence, to judge
by what he wrote on November 7: that when Kerssemakers en-
thused over a newly painted study of trees, "I had such a tingle
of good spirits... that I COULD *not* sell. But because it had af-
fected him, I gave it to him."[52] (How must Theo, after five years
of start-up subsidy, have felt on reading that?)
 Nonetheless, something about this art was moving forward.
The gift Vincent bestowed on lucky Kerssemakers depicts au-
tumn trees dappled and wind shaken in a manner he had never
quite hit before; as he himself remarked, his heretofore dun and
earthen palette was "thawing, and the bleakness of the earliest
beginnings has gone."[53] It thawed yet further in early Novem-
ber, when he painted a shimmering vista of an avenue of poplars
just outside Nuenen that would be one of the very few pieces he
took with him when he left the village for good on the twenty-
fourth of that month.

Vincent van Gogh at the age of nineteen

Van Gogh Museum, Amsterdam

Theo van Gogh in 1882

Van Gogh Museum, Amsterdam

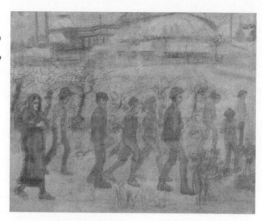

Miners in the Snow, 1880
Kröller-Müller Museum, Otterlo

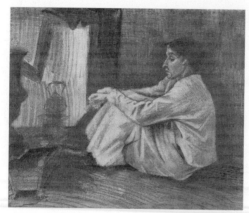

*Sien with a Cigar Sitting on
the Floor Near the Stove,* 1882
Kröller-Müller Museum, Otterlo

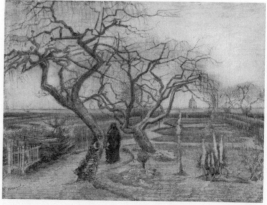

Winter Garden, 1884
Van Gogh Museum,
Amsterdam

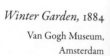

The Old Church Tower at Nuenen, 1885

Van Gogh Museum, Amsterdam

The Potato Eaters, 1885

Van Gogh Museum,
Amsterdam

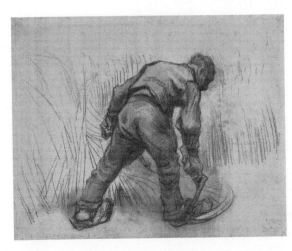

Reaper, 1885

Van Gogh Museum,
Amsterdam

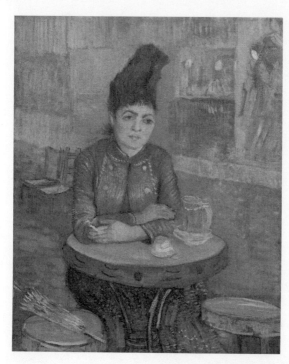

Agostina Segatori Sitting in the Café du Tambourin, 1887

Van Gogh Museum, Amsterdam

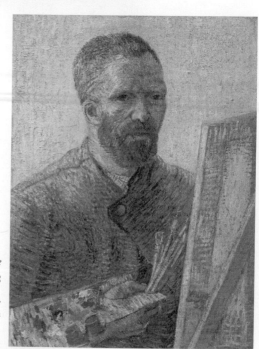

Self-Portrait at the Easel, 1888

Van Gogh Museum, Amsterdam

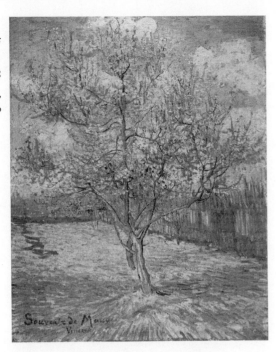

*Pink Peach Trees
(Souvenir de Mauve),*
1888

Kröller-Müller Museum,
Otterlo

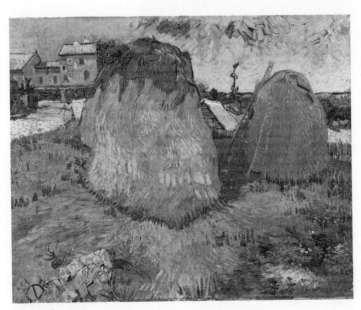

Haystacks, 1888

Van Gogh Museum, Amsterdam

The Night Café, 1888
Yale University Art Gallery

The Yellow House, 1888
Van Gogh Museum, Amsterdam

Wheatfield with Rising Sun, 1889

Kröller-Müller Museum, Otterlo

The Garden of the Asylum, 1889

Van Gogh Museum, Amsterdam

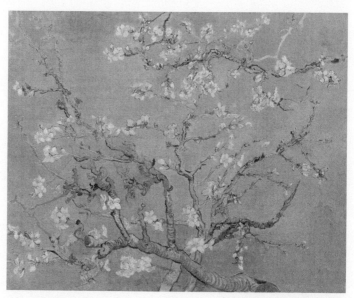

Almond Blossom, 1890

Van Gogh Museum, Amsterdam

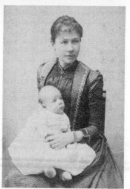

Johanna van Gogh-Bonger and baby
Vincent Willem van Gogh

Van Gogh Museum, Amsterdam

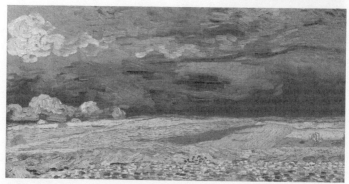

Wheatfield under Troubled Skies, 1890

Van Gogh Museum, Amsterdam

4

Adventurer

I

I AM NOT an adventurer by choice but by fate."[1] That, lit-
erally—for the language here was English—is how Vin-
cent described the pattern of his life, writing from Paris in
1886. Choice is for the free, who are able to push themselves
forward. Fate is for the shackled, who get pushed from behind.
The thirty-three-year-old exile from Brabant counted his own
person among the latter. But what about his painting? Vincent's
two-year stay in Paris might read one way if we focus on the
man, but another if we focus on the art. For this city, more than
anywhere, was where nineteenth-century painters tested out
the notion that their art held promises of freedom. To return
to the same letter with its parroted London saloon-bar idioms,
"What is to be gained is PROGRESS and what the deuce, that is
to be found here I dare ascertain."[2]

What choices, then, lay before Vincent the painter? About
a year before he wrote those lines, he and his Eindhoven friend
Anton Kerssemakers paid a visit to Amsterdam. The present-
day Rijksmuseum, in all its neo-Gothic pomp, had opened in
July 1885, and three months later they joined the crowds who
had come to pay homage to its newly hung collection. Vincent,
having seen no significant painting since he left The Hague
two years before, found himself before Rembrandt's *The Jewish
Bride*—and could not get away. When his friend at length came
back for him, he pledged that he would willingly exchange ten

years of life for a chance to sit for a fortnight, with nothing but dry bread to eat, in front of the masterpiece. "That heartbroken tenderness, that glimpse of a superhuman infinite"—Vincent's later words for what Rembrandt uniquely offered—gave painting its horizon, beyond which lay spiritual mysteries he had no desire to define.[3] In an adjacent gallery, however, Frans Hals's massive group portrait *The Meagre Company* swung before him. It delivered thrilling, this-worldly shocks to the eyes by pitting oranges against blues—"poles of electricity," grounded by "glorious blacks" and "glorious whites." Hals's emphatic brushwork spoke to Vincent (as it did, separately, to Manet)[4] of what a nineteenth-century materialistic sensibility might now achieve, by concentrating on pigment and on sheer speed of attack. As Vincent remarked to Theo, Hals "always remains—on *earth*."[5]

Between those great national masters and the present, there lay a long eighteenth century dismissed by Vincent—in standard Dutch Romantic fashion—as the effete "periwig age."[6] If his all-time hero Millet had thereafter led the fight back for the cause of nature and deep feeling, the figure of Delacroix loomed almost as large in Vincent's current historical scheme. For during the course of 1885 Vincent had become a backwoods theoretician of the direction of modern art. His thought processes had been set in motion, perhaps when Theo descended from the Paris art scene to attend their father's funeral in March. In July, while Vincent the straw-hatted painter sweated away at his hundred poses of the Nuenen peasantry, Vincent the widely read critic was attempting to pin down "that essential modernism—the intimate character, the actual DOING SOMETHING" that was lacking in French academic art.[7] (Although it was nine years since he had seen a painting by Jean-Auguste-Dominique Ingres at first hand, his visual memory proved awesomely tenacious.) Somehow such a "modernism" must involve the artwork being replete with physical work itself—and likewise, the depicted body becoming dense with fleshly feeling, inhabited as

if from the inside. Academicians such as Ingres interpreted the figure in terms of outline, and that wouldn't do. Delacroix, by contrast, talked about imagining a body "from the masses, from *cores.*"[8]

That phrase handsomely spoke for what Vincent had been aiming at with *The Potato Eaters.* In fact the principle so transcended academic correctitude (not to mention photographic values) that "I would be desperate if my figures were GOOD."[9]

But just as much as Delacroix's ideas pointed towards the sensed physical mass of the body being painted, so they pointed to the physical, sensory impact of the painter's pigments. Delacroix and Hals encouraged the painter to treat those pigments as energy-packed charges to be deployed in visually explosive contrasts. On hand to help plot the process of combustion were the artists' primers of optical science (Charles Blanc's *Grammaire des arts du dessin,* for instance) that Vincent had long loved to read. "COLOUR EXPRESSES SOMETHING IN IT-SELF," Vincent pronounced in late October 1885, just as he was laying down the vivid swipes and stipples of yellow and red on the Nuenen *Avenue of Poplars.*[10] It would make sense to parallel that chromatic program with a figure-drawing program. Having tackled so thoroughly the clothed body over the summer, he might now attempt to address, from his new theoretical standpoint, the major European tradition of the nude.

Aspirations of this sort — plus the taste the Amsterdam excursion had offered of urban excitement — were in Vincent's mind as he reanimated a long-deferred plan to try out his art in the great port of Antwerp, just across the Belgian border, twenty-five miles from Nuenen. He had a certain spring in his step that autumn. For any reader of the correspondence, it is astonishing, after so many years of unremitting, earnest logorrhea, to catch Vincent cheerfully admitting to Theo that "I'm most probably boring you."[11] Look further, however, and you see fate stepping close behind. Vincent knew that Gordina de

Groot wasn't carrying his child; so it seems did she; but the village of Nuenen didn't. Andreas Pauwels, the priest with responsibility for the village's mainly Catholic peasantry, didn't, or even if he did, he'd heard of the earlier Begemann scandal, and he'd seen the way a gang of village lads hung around this irreligious cognac swigger. He turned up at Vincent's studio door, warning the painter to keep clear of his flock. Vincent fought back, protesting to the burgomaster, but the warning had evidently been delivered in both directions, and religious authority held sway. The woodcutters and field workers no longer felt able to pose for him. Vincent's final, sneaky riposte to Pauwels, he whispered to Kerssemakers, was to buy a stock of condoms in town and pass them out to the lads.

There was no one left to draw. Moreover, the sacristan who had let him the studio was under Pauwels's orders and refused to renew the lease. Late November: Time to move on, before they could nail him down for the rent.

2

Antwerp was the home of Peter Paul Rubens; Antwerp was a port full of whores. Its two faces alternated and blurred as Vincent, rather confusedly at first, tried to devise a role for himself in this large commercial center in which he had no significant contacts. In the wake of transcendent Rembrandt, the Rubenses on view looked banal; ah, but when it came to the mere fact of female flesh, no painter was equal. And female flesh was the connecting theme to all the bars and dance halls of the dockside, the comfort zone to which Vincent naturally headed. The whores were so luscious, and he felt for their unpretentious "power and vitality."[12] Perhaps they would become his models. Perhaps he could become their portraitist, or someone's portraitist, anyway. His art would return to base and reaffirm that

its concern was the human being. Under this loose remit, a few heads did get painted: three of the girls and an elderly woman and man, perhaps neighbors from the low-rent quarter where Vincent lodged. The brushwork, creamier and blonder than it had been in Nuenen, nodded indirectly to the city's great old master.

By the beginning of 1886, five weeks after his arrival, Vincent had gotten back the chutzpah needed to face down the ever-returning spectre of penury. "The paint bill weighs on me like lead and yet I must *go forward*!!!" Hectoring his paymaster ("This is what we'll say—and say together, if you please"), he spelled out a surprising new plan for their notional joint enterprise: that he enroll at Antwerp's Koninklijke Academie voor Schone Kunsten so as to work from the nude model.[13] From January 18, his foot was in the door of this stately institution—nominally, in fact, as a member of the class drawing plaster casts rather than of that painting in the life room. He made his way anyway into the latter, a mature student eager at once to engage with a great artistic tradition and to demonstrate his disdain of its modern academic interpreters. This he did, according to a fellow student named Victor Hageman, by "feverishly" attacking his canvas with an impasto laid on "so thickly that his colors literally dripped from the canvas onto the floor." Hageman recalled the "very academic" class director inspecting the results and proclaiming, "I cannot correct such putrid dogs. My boy, go quickly to the drawing class."[14]

Vincent apparently submitted, retaining a spirit of mischief, however: The most memorable product of this venture in self-reeducation was a frisky little portrait (vigorously rendered à la Hals) of one of the Academie's skeletons, lent one of Vincent's roll-ups to smoke. It surely raised a laugh or two among his fellow international students, but the nonsensicality of his own student status soon became clear to the staff. Again according to Hageman, Vincent finally let rip when the drawing tutor re-

marked that a plaster-cast Venus had been all too physically in-
terpreted: "'You clearly don't know what a young woman is like,
God damn it! A woman must have hips, buttocks, a pelvis in
which she can carry a baby!'" Hageman added, "That was the
last lesson that Van Gogh took—or gave—at the Academy of
Antwerp."[15]

Meanwhile, it was to his own physicality that Vincent was
forced reluctantly to return. Over the previous seven years—
ever since entering the Borinage—he had taken a resilient frame
and kicked it about unmercifully, living forever on edge. The
dry-crust diet recently pledged to his adoration of Rembrandt
was, many witnesses report, a habit into which his self-reproving
impulses repeatedly pushed him. Instead of food, he looked for
sustenance to coffee, alcohol and tobacco. His hospitalization
for gonorrhea in 1882 had not jaded his taste for hired sex. Mal-
nutrition, possibly combined with the side effects of syphilis
treatment, now landed him with stomach cramps and a mouth
in which ten teeth were gone or going.[16] Even if his body was
only a vehicle for the cause of art, it was clear to Vincent, at the
beginning of February 1886, that a wholesale overhaul was now
required, and that the customary provider would need to bear
the expense. In fact, the rationalization surely needed to go fur-
ther. The joint enterprise that his letters so coercively proposed
could be run on leaner lines. What, anyway, was he doing here
in Antwerp?

3

"The most sympathetic person I have had dealings with in
Paris" and "a charming fellow to know": that was Theo van
Gogh, as described by the junior insurance broker Andries
Bonger to his insurance broker father in Amsterdam.[17] "Dries"
and Theo would head out together to enjoy the metropolis's

concerts, dances and boat trips down the Seine, after which the two clever young Dutchmen would return to Theo's small apartment on a street just down the hill from Montmartre, to settle in armchairs and converse over their reading. Dries's younger but cooler head provided common sense whenever Theo's needy heart led him into amatory complications. As of late, however — Dries reported to his parents in March 1886 — that arrangement had come unstuck: "Van Gogh's brother, who is studying to be a painter, has arrived here," and the two of them were out most evenings at the local hostelries.[18]

Theo had received a note by courier on February 28: "Don't be cross with me that I've come all of a sudden."[19] An arrival that had been scheduled for the summer in the letters Theo had lately been receiving was drastically brought forward. The scribbled sheet invited him to a rendezvous that day in the Louvre's Salon Carré, under the *Mona Lisa* and the Veroneses that Vincent had last seen a decade before. From the melodrama, one might imagine that Vincent had a plan to take the capital of culture by storm. Not quite. The agenda was to complete the personal makeover, binding himself to his brother so as to re-emerge a healthy, well fed and even respectably dressed member of the bourgeoisie; and equally, to continue the artistic re-education by drawing further from the plaster cast and the nude model. Theo had already made enquiries with Fernand Cormon, a Salon painter who ran an atelier that offered these facilities and who was happy to oblige one of the sharpest young men in the art trade by opening the door to his brother.[20]

Theo's second-floor apartment hardly had room to accommodate an easel, so Cormon's atelier, a few blocks west along the boulevard de Clichy, became Vincent's main arena of activity. It was one of several enterprises profiting from the progressive dissolution of Paris's old, hierarchical academic system while also catering to foreigners eager for Parisian sophistication. Some thirty students rubbed elbows under the skylights,

tackling a steady supply of bodies, both living and plaster. Cormon himself was an outline man, a believer in the Ingres tradition, but he was relatively relaxed. After his own fashion, Vincent tried to respond to Cormon's tuition, respecting house style with procedural hatching and stumping. Outside the atelier door, he was even trying to honor those age-old promises to Theo about paying his way by touting for work in the neighboring restaurants and cabarets — or so a couple of stray autograph items, a decorated menu and an illustrated chanson suggest.

Repartee in the atelier centred around two Frenchmen in their midtwenties: the tall and self-assured Louis Anquetin and a droll southern aristocrat with stunted legs named Henri de Toulouse-Lautrec. A bumptious, clever teenager called Émile Bernard was also causing a stir. The newly arrived oddball got stared at and laughed at for his bold and furious working methods — some remembered him concocting a searing blue background on his canvas to replace the drab fabric against which a model was posed — but socially, he gravitated towards an outer circle of foreigners. Vincent was quite soon swapping pictures as tokens of friendship with an American, a Spaniard and, more significantly, with John Peter Russell, a stylish, charismatic Australian who painted a formidable portrait of him. A mutual acquaintance explained what was successful about it:

> [Van Gogh] had an extraordinary trick of pouring out sentences in a mixture of Dutch, English, and French, then glancing quickly at you over his shoulder and hissing through his teeth as he finished a series. In fact, when excited, he looked more than a little mad: and this look Russell had caught exactly.[21]

In mid-May, there was reason to stroll down south towards *les grands boulevards* of the city center, where Vincent had already tried some desultory tourist sketching. The Impressionists, the much vaunted, never witnessed face of modern French

art, were holding their eighth group exhibition. Vincent was, in fact, catching up with the movement at the moment it evaporated. Of those who had dominated the first exhibition in 1874, Claude Monet and Pierre-Auguste Renoir were now at an alternative venue, to present their work there in June; whereas Edgar Degas and Camille Pissarro, though joined by an as yet faithful disciple named Paul Gauguin, were outdazzled by Georges Seurat's huge, spectacularly radical *A Sunday Afternoon on the Island of La Grande Jatte,* proclaiming the arrival of a new aesthetic that would soon be named pointillism.[22] Vincent confronted the visual challenge warily, armed with his own out-of-town preconceptions as to where modern art should head. He warmed to the figure-driven realism of Degas (one artist, at least, who knew what "a young woman is like, *God damn it!*")[23] and admired Monet, the kind of instinctual landscapist he himself never expected to be; but there was headshaking also. When you first see the Impressionists' paintings, he would later tell his sister Wil, you're "bitterly, bitterly disappointed and find them careless, ugly, badly painted, bad in colour, everything that's miserable."[24]

No, the secret answer to the future of modern art, unknown to the world at large, lay in a gallery a few blocks nearer home on the rue de Provence, where a friend of Theo's kept a stock of little panels by Adolphe Monticelli. This artist had left Paris to return to his native Marseilles in 1870 and was at this very point, in June 1886, on his deathbed, after decades of hard boozing. Monticelli's small-scale art was at once extremist, defiantly original and sweetly self-deprecating. Employing every traditional genre — but especially the flower piece and the fête galante, the fancy picnic in the woods — he pivoted all his effects on the ways that his brush could load bright, pigment-dense oil paints onto a warm dark ground. The copious production he turned out to meet his bar bills had never secured Monticelli much of a footing in the art world, and yet for the

Vincent who had painted the poplars at Nuenen, here was the next step, here was one painter who had really taken to heart Delacroix's ideas about expressive, meaning-packed color.

Monticelli's work showed "a greater love for the colourist's palette than for nature"—the very quality that Vincent had commended back in Nuenen the previous autumn, in a letter to Theo in which he argued that such a "dangerous" romanticism, such a "betrayal of 'realism,'" had to be accepted for the imagination's sake.[25] Yet nature could be made to resemble Monticelli's work if flowers were arranged in a vase. The southerner's singing yellows, reds and whites and his studded, emphatic paint clots could be tethered to actual blooms. Flower pieces, hardly attempted before, became Vincent's fascination over the summer of 1886. It helped that he now had a home studio. From June the two brothers installed themselves in a spacious four-room fourth-floor apartment on the rue Lepic, on the rise of the butte Montmartre. It was good to be looking down on central Paris from this distance, and to be keeping a distance likewise from whatever might be its artistic mainstream. When not painting his willfully eccentric experiments in this minor genre of flower-work, Vincent was taking his canvases up the hill—partly in vague hopes of catching tourist trade, for Montmartre's windmills had for decades beckoned Parisians in search of pleasure—but partly also to think more freely. Beyond painting panoramas, he wandered out onto the far side of the hill, into the type of half-formed, edge-of-town straggle that had been his preferred zone back in The Hague, and even before that back in suburban London. The vigorously bludgeoned nowhere-in-particular aspect of *The Outskirts of Paris,* with its distant factories and windmill, was at least implicitly a position statement.

As Vincent's focus shifted, the figure-drawing project dropped out of sight. By his own account, after working at Cormon's for three or four months, he did not return, preferring to

spread his canvases and opinions all across the breadth of the new apartment. (Not to mention plaster casts borrowed from Cormon, which he brought back there to paint.) Theo might be paying for more space, but for his own peace of mind it was not space enough, evidently, to get distance from this barely house-trained brother. Vincent "reproaches him with all kinds of things of which he is quite innocent," Dries pityingly reported of Theo, who was looking "frightfully ill." "That poor fellow," he added, "has many cares."[26] To add to them further, Theo had a two-prong plan to launch when he set off on his annual August journey back to the Netherlands. Exasperated as ever with the management of Goupil & Cie (or rather of Boussod, Valadon & Cie, as it had recently become), he wanted (a) to secure backing from his rich art-dealer uncles to set up his own independent concern in their trade, and (b) to start to build for himself a new emotional security. The previous year, Dries had introduced Theo to his younger sister Johanna. Fresh-faced, high-minded, dazzlingly literary — she was surely the one, and it was time for Theo to declare his feelings.

After he boarded the sleeper for Brussels, events at the rue Lepic turned ludicrous. Theo's Parisian mistress of the past year, a certain "Mlle S," turned up at the door, distraught at the confused messages he was giving out.[27] Vincent, combining the old principle of consolation with a distinct interest of his own in the young woman, invited her to stay. Then there was a further ring at the bell. It was Dries, explaining that Theo had invited him to bed down at the apartment in his absence — as a watchdog, no doubt. Thrown together thus, the two men hovered around each other and their anxious companion for several "strange days" before sitting down together to describe the situation to Theo and to berate him for his emotional incompetence. Vincent's section of the letter outrageously proposed to solve the problem by passing the woman from brother to brother. The

canny Dries (who elsewhere noted that Vincent was possessed of "a certain hint of droll mischief")[28] added some affable comments about the gaiety of the painter's flower pieces, with a qualification:

> Some, though, are flat, but I just can't persuade him of that. He keeps replying: but I wanted to get this or that colour contrast into it. As if I gave a damn what he *wanted* to do![29]

As to what Theo had wanted to do: his proposal to his uncles was rejected, with the consequence that the declaration was not made. Just how he disposed of the hapless Mlle S on his return is unrecorded. There could be no such disposing of his brother.

4

For Vincent, living elbow to elbow with his brother had practical benefits, yet Theo kept trying to get out of his way — not encouraging Vincent to visit his workplace, for instance. (Had he done so, he might have met senior Impressionists such as Monet.) Some time in early autumn 1886, Vincent cast around for an alternative soul mate. He thought back to the Antwerp Koninklijke Academie and to his most congenial companion of the few weeks spent there, a student from England named Horace Livens. A letter begun tentatively ("You will remember . . .") offered an invitation to "share my lodgings and studio" and went on to mention a notion of heading south, to follow the trail of Monticelli, perhaps. At length it developed into a strange, poignant (and, it would seem, unanswered) apologia for a loner who believed he was "struggling for life and progress in art." Paris, for all its hardships, being for now the place to do so:

Anyone who has a solid position elsewhere, let him stay where he is but for adventurers such as myself I think they lose nothing in risking more. Especially as in my case I am not an adventurer by choice but by fate and feeling nowhere so much myself a stranger as in my family and country.[30]

A few months earlier, this self-proclaimed outcast had attempted his first self-portrait. Having never stopped before the mirror back in the Netherlands, Vincent began studying his reflection repeatedly in Paris. What kind of figure do I cut to those others around me? he seemed to ask. The answers would come in terms of the current makeover, the latest hat, while at the same time Vincent tested out the technical possibilities that currently interested him. While he may have gained new ideas of color from looking at Monticelli, his palette was as yet pitched towards the deep, dark and dun — faithful to the chiaroscuro tradition of Rembrandt, and to his own long-maintained preference for sorrow over jollity, for the careworn over the slick. The same holds true of the several studies of shoes he painted this year. A Cormon-atelier colleague reports him buying the footwear at a flea market and battering it for aesthetic effect. The subject, hardly tackled by earlier still-lifers, became almost a self-portrait of his own sensibility.

Yet over the winter of 1886 that sensibility began to shift. After daylight ended Vincent would head down to the boulevard de Clichy, where he could pass *l'heure verte* —"the green hour," the hour for the first, fazing absinthe — at the Café du Tambourin. This was a large, flashy new bar-cum-restaurant set up to a seemingly surefire formula: sexy waitresses to bring in the tourist milords and a folksy, arty ambience to attract the bohemians, whose presence might in turn attract the urban trendies. Among his fellows in the bohemian contingent, Vincent now started drinking with Toulouse-Lautrec, accompanied some-

times by those other contenders from Cormon, Anquetin and Bernard. Toulouse-Lautrec appreciated the way Vincent was not thrown by his odd physique — "he had seen worse" — and let him hold forth on Zola, the Borinage and Jesus (reverentially intoned "*Yessous*").[31] In fact, early in 1887 Toulouse-Lautrec portrayed Vincent in conversational action, sitting righteous and alert facing some third party at a Café du Tambourin table, chin and chest thrust forward for an argumentative pounce — one deeply singular artist's salute to another. Toulouse-Lautrec's girlfriend, Suzanne Valadon, reported that Vincent never managed to make a mark in the large artistic gatherings that Toulouse-Lautrec liked to hold in his studio. Nonetheless, that studio, only a stone's throw from the rue Lepic, offered Vincent footholds in the "progress in art" he was seeking.

While the stunted aristocrat's quality of interest in his fellow human beings — alert, sardonic, warily compassionate — overlapped with Vincent's own, his actual handiwork brought together color and drawing in a way Vincent had not previously achieved. Toulouse-Lautrec showed how an image could be woven together out of fine strands of color scribbled, dabbed or hatched onto a warm neutral ground — with an end result in which the weave stayed naked to the eye, so that complementary pairings such as oranges and blues electrically vibrated, almost as Hals's had done in the Rijksmuseum. Vincent tried out this new approach on various still-life subjects and in a couple of portraits of Alexander Reid, a Scottish art-trade colleague of Theo's who passed an awkward couple of months that winter lodging in the rue Lepic apartment, with all its mayhem and fraternal tensions.

Vincent also moved towards Toulouse-Lautrec and towards the sensibility of his Parisian seniors — Degas, most of all — as he paid court to the Café du Tambourin's patronne, a forty-something former artist's model named Agostina Segatori, who

leaned forward at the bar, looking over each evening's drinkers and offering them a blowsy, bosomy, dark-eyed theme for absinthe-steeped reverie.[32] Vincent's only known paintings of the female nude date from this winter: two of a middle-aged prostitute on a bed, displaying all she has to offer to the viewer, and one rather more elegant, rather more youthful rear view. They are hardly Agostina, but he could dream. He not only persuaded her to sit for him out of hours at one of the joint's theme-decor "tambourine" tables, relaxing with a smoke and a second glass of beer (note the stacked beer mats), but he also persuaded her to give wall space to his enthusiasms.

Note also, briskly scribbled on the canvas's far right, an unmistakable (if unidentified) image of a geisha. Vincent had first encountered Europe's current taste for Japan when he got to the Antwerp dockside, and in his new urban-oriented persona, he willingly latched on. From this point onwards, his walls got covered with ukiyo-e, just as they had once been covered with Christian *bondieuseries*. Two decades in from the start of the import phenomenon, there were a number of consumers' guides to consult, and most usefully, there was Siegfried Bing's specialist gallery on the rue de Provence — just across the street from the gallery with the Monticellis — which allowed the Van Gogh brothers credit. At some point in early 1887 Vincent sifted his collection and got some things framed so as to mount a little selling exhibition at Café du Tambourin — not that this money-making notion of his, any more than previous ones, opened up a path to independence from his brother.

It all got intolerable for Theo: the way the dirt in the apartment kept visitors away, the way Vincent would come back from the bar or the brothel and draw up a chair by Theo's bedside in order to harangue him deep into the night, notwithstanding Theo's own poor health. Vincent really would have to leave. As Theo wrote to Wil on March 14, 1887:

You should not think that it is the money side that worries me the most. It is mostly the idea that we sympathize so little any more. There was a time when I loved Vincent a lot and he was my best friend but that is over now. It seems to be even worse from his side, for he never loses an opportunity to show me that he despises me and that I revolt him ... It appears as if there are two different beings in him, the one marvellously gifted, fine and delicate, and the other selfish and heartless.[33]

Yet when Theo wrote to Wil again on April 26, the brothers had "made peace." Spring had arrived. Vincent was working out of doors once more, heading out initially into Montmartre and the boulevards and precincts nearby. As he did so he pushed further at the research directions suggested by Toulouse-Lautrec. One possibility, explored in a painting of a local park, was that dabs and hatchings of color might vibrate more effectively if there was a clear white ground beneath them, half shining through. With this canvas — at 112 centimeters wide, one of his largest and most ambitious to date — Vincent was looking past Toulouse-Lautrec to the direction from which his innovations were coming, namely the challenging new pointillism that had fired up their café companions Anquetin and young Bernard. In fact this scene of Parisian leisure, with its lyrical shimmer and its own highly personal accent of amorous reverie, could be seen as Vincent's meditated response to the elephant in the room he had avoided over the previous year, the *Grande Jatte* of the pointillist maestro Georges Seurat.

The jump the canvas represented from the murk of the previous year's canvases — the studies of boots, or of the outskirts — is astonishing. From mid-May, Vincent headed out farther northwest from his base, taking an hour's walk each morning to the village of Asnières, where the curling downstream course of the Seine offered day-tripping Parisians a venue for lunch parties and boating. Doing so, he fell in with Paul Signac, the

extrovert cheerleader of the pointillist or "Neo-Impressionist" tendency. (Seurat, its reserved, daunting guru, had set his first major composition at Asnières three years earlier.)

The canvases that Vincent painted of the riverbank, the adjacent greenery and the suburbs behind over the summer of 1887 would sometimes assent to, sometimes resist the new pictorial techniques. If their exact sequence could be tracked, it might almost present a flickering, brightly hued dialectical argument. At moments they touched on the look of senior Impressionists such as Monet. There was much common cause with Signac, who shared Vincent's taste for in-between spaces and nowheresvilles, and some bidding also to reach across time and space to Hiroshige, the printmaker par excellence of strollers and suburban leisure. The startling cropping techniques of the Japanese were beginning to affect Vincent's picture making, as they had a considerable swathe of Parisian painting over the previous fifteen years. Yet Vincent was already too old, too odd and too strong to submerge his individuality in anyone else's style; compared with anyone else's version of plein air, his canvases are bristlier and more vital.

The painter driven by the peculiar inner seething was once again, as at Nuenen two summers before, working with ferocious vigor. It spilt over into further flower pieces, in which the fat blurts of oil color of the previous year got restaged as little firework sparks of complementaries: cyans with tangerines, violets with lemons, viridians with mauves. It was all in some sense research, and yet just possibly it could pay its way. Vincent not only courted Agostina with these proxy bouquets, but coaxed his beloved (whether ever actually his lover, one may doubt) into a paintings-for-platefuls arrangement at the Café du Tambourin. More than twenty canvases were mounted on the café's walls that summer, a new hang to follow up on Vincent's earlier Japanese print venture.

Unfortunately, come July the racket running the establish-

ment decided that Vincent — and in fact Agostina as well — were becoming a nuisance. She was obliged to withdraw whatever favors she had been offering him, and various warnings — a minder lobbing a beer glass at his face, a heavy calling with a message at the rue Lepic apartment — were issued. These Vincent ignored to the extent of returning to the Café du Tambourin and (according to the liveliest version of the story) getting one of his own canvases smashed over his head.[34] Still hoping to win back the lovely Italian's affections, Vincent then made her a present of the remaining exhibits. The only result was that when, very shortly after, in response to some untraceable underworld shenanigans, the racket moved its money elsewhere and the café went bankrupt, this stock of flower pieces moved permanently out of his hands, as did she.

5

A spluttering, barely comprehending report of the debacle was posted to the Netherlands, it being the season of Theo's home visit. Vincent added the rueful reflection that he was starting already, "at 35" (he meant thirty-four), to feel too old for marriage and children: "I blame this damned painting."[35] The letter's recipient was having little better luck. The marriage proposal that Theo managed this time to put to Jo Bonger got turned down, the twenty-five-year-old bluestocking's dreams being set elsewhere.

On the other hand, Theo now had a more stimulating role to return to at Boussod, Valadon & Cie. The current management was shifting from the Goupil & Cie era's dreary aesthetic conservatism to acknowledge that as of the late 1880s, there might be money in avant-gardism. They sensed that shrewd patrons were starting to buy into the principle of ongoing artistic research, even if its outcomes might appear raw and puzzling.

Thirty-year-old Theo had just managed to wrest the highly significant commercial asset of Claude Monet from the hands of a rival dealer. The firm now gave the junior manager his own section of gallery space in which to test out the latest "impressionists"—or whatever the young tearaways now called themselves. After all, Theo was based in bohemian Montmartre; he would know who to look for. Or, more exactly, Vincent would know who to look for—so Theo interpreted the situation. His ne'er-do-well brother, so garrulously stocked with art-historical recall and critical observations, might now earn his keep as a talent scout.

To be of service at last! Vincent's gratitude for this signal of recognition was expressed when, in the winter of 1887, he inscribed "*à mon frère Theo*" on a recent addition to his brother's stock. (One has to remember that almost the whole of Vincent's work was effectively owned by his brother, anyway.) To re-attune to this canvas's radical change of aesthetic—the third or fourth within two years—we need to look back over the previous few months.

Towards the end of his busy summer tangling with pointillism in Asnières, Vincent had met up again with Émile Bernard, whose parents had a house there.[36] The brainy ex-Cormon student—still only nineteen—was seeking a new stance in Paris's art-political infighting. Signac, pointillism's most vocal exponent, had somehow managed to annoy both Bernard and his older friend Anquetin in the spring of 1887, and in the summer the latter came up with a way to outflank the voguish style Signac epitomized, with its air of mechanistic, scientistic certitude. Tinted glass: that gave the clue. Once you looked through it at what you were painting, all the visual effects became more intense, more unified in a psychological rush—more spiritualized, one might say. And of course, tinted glass had a mighty art tradition of its own in cathedral windows, the black-wired

compartments of which suggested an alternative way for oil painters to set line apart from color. Bernard and Anquetin also linked these compartments, or cloisons (hence cloisonnism, the name their approach would soon receive), with the flat patches of color in Japanese prints. A searingly yellow harvest scene by Anquetin demonstrated the new doctrine's appeal,[37] while the idealistic Bernard argued that it could liberate art from banal, mechanical "realistic imitation."

There was much in this to attract the Monticelli enthusiast who even back in Nuenen had proclaimed that "COLOUR EXPRESSES SOMETHING IN ITSELF."[38] Yet as with the Signac-Seurat manner that he had interrogated over the summer and that Bernard was now claiming to revile, Vincent translated the concept of a unified visual rush into his own distinctive pictorial diction. The still life he inscribed to Theo, *Quinces, Lemons, Pears and Grapes,* is a single resounding chord of yellow played out on various vegetal instruments, almost entirely freed up from perspective and chiaroscuro. (It may be no coincidence that around this season, Vincent joined Theo in enjoying some Wagner productions.) The canvas even sports a frame hand-painted by the artist, the further to concentrate its impact. At the same time, rather than using stained-glass compartments to generate complexity within this unity, Vincent created an all-over crackle of visual electricity through the emphatic, poly-rhythmic hatching that was his and his alone. Progress in painting, canvases to change the world — or, at least, to start that task by transforming the homes they hung in; face-to-face with such a propulsive blast, such concepts might begin to make sense.

What Vincent couldn't stand was the bickering. Why, God damn it, wouldn't Bernard hang his pictures in the same gallery as Signac's? (After all, from a longer perspective, cloisonnism and pointillism had a very substantial overlap of aims.) The question mattered because his new advisory capacity in Theo's business life led Vincent to think as a curator. Over there, down

in the center of town, you could go and see the painters of *le grand boulevard,* the old guys — Monet, Pissarro, Degas and the rest. They weren't his immediate concern. No, what fell to him to represent was *le petit boulevard,* the painters around and outside Montmartre who as yet lacked any real status. To gain traction, they needed to act communally, without sectarianism, for "it's only unity that makes strength," as he insisted to Bernard.[39]

Vincent's hunch was that in order to make their mark, his artists needed to head a little *farther* out of town. There was a huge no-nonsense *restaurant populaire* on one of the avenues that led towards Asnières. Vincent made a bid to charm its manager (rather as he had approached Agostina) by painting an almost excessively subtle portrait — in this case, of a touchingly, innocently pompous buffoon. While the canvas in question remained unbought in the rue Lepic, this Etienne Martin gave the go-ahead for Vincent and a few friends, headed by Anquetin, Bernard and Toulouse-Lautrec, to bring art to the people.

For that — loosely, vaguely — was the notion. Already in Antwerp, the art students' bar-room chatter about the Belgian general strike of 1886 had encouraged Vincent to dream of "the beginning of the end of a society"[40] and the "colossal revolution"[41] to come. In Paris, Vincent's doughtiest supporter apart from Theo was Julien Tanguy, a veteran of the 1848 revolution who ran his art materials store as an artists' benevolent institution, swapping tubes of color for painted canvases that he would hang on the walls. The warm-hearted egalitarianism of *le père* Tanguy was of a piece with everything else that Vincent admired about the man. Nowadays, Vincent preferred to redescribe his objectives in his earlier life as "religious and socialist."[42] In some small way, he and his friends were aspiring to "take action ourselves in our own age" by presenting the urban masses with visual and spiritual positivity.[43]

It was, of course, from almost every point of view a farcical proposition. The squabbles weren't resolved, so no Signac. With-

out a pointillist contingent, the Grand Bouillon-Restaurant du Chalet proved far huger than the exhibitors had realized. After the initial hang in mid-November 1887, Vincent walked over barrowfuls of canvases from his own studio in order to fill the gaps. Monsieur Martin had a better idea: He would intersperse the modernist peculiarities with "patriotic escutcheons" (or so related a Cormon associate of Vincent's).[44] The proprietor was by all accounts almost as irascible a man as Vincent, and...well, need one say more? Yet — Vincent could reflect, as he wheeled the canvases back down the boulevard de Clichy, two or three weeks later — whatever the working-class diners may or may not have thought, Anquetin and Bernard had seen their first sales, and the formidable but reclusive Seurat had dropped in and said hello, a courtesy Vincent and Theo later repaid with a visit to his studio. Moreover, the show had been the occasion for Vincent to make the acquaintance of a painter just back from eight months in the Caribbean, Paul Gauguin.

This new arrival, almost five years Vincent's senior and part Peruvian, immediately impressed him. Since 1884, Gauguin had moved away from a career in stockbroking and then from his wife and children for the sake of his art. This art was, to date, a refined and quirky variation on Impressionism, responsive to the examples of Pissarro and Degas, to which Paris had paid little attention. In the Breton village of Pont-Aven, however, where Gauguin settled in 1886, he had become the center of an artists' circle. That failed to satisfy the increasingly complicated promptings of his self-esteem. Gauguin had a liking for heading towards cliff edges and then glancing back to see who cared, a brinkmanship in evidence in his recent Caribbean escapade, from which he had returned with several colorful views of "exotic" Martinique. Rangy, piratical, arrogant and original, Gauguin was an exciting find for Vincent to communicate to Theo, who straightaway took some of these works on commission for his gallery, and who managed to sell one before the

end of 1887. This new business connection would in fact prove the most significant outcome of Vincent's role as his brother's assistant.

But then, what more generally was Vincent's role? Fate pushed him along and tripped him up:

> I'm making rapid progress in growing up into a little old man, you know, with wrinkles, with a bristly beard, with a number of false teeth &c.
>
> But what does that matter? I have a dirty and difficult occupation, painting, and if I weren't as I am I wouldn't paint, but being as I am I often work with pleasure, and I see the possibility glimmering through of making paintings in which there's some youth and freshness, although my own youth is one of those things I've lost.

Vincent was writing to Wil sometime late in 1887, a bossy, bohemian elder brother scolding the unattached twenty-five-year-old for the po-faced piety of some literary effort she'd sent from Brabant, and telling her to get out more and love, live and laugh. Have affairs, even if they were as "impossible" and "unsuitable" as his own. (He brazenly asked after his old girlfriends, Margot Begemann and Gordina de Groot.) Learn what it means to be modern by reading Guy de Maupassant, Joris-Karl Huysmans, Alphonse Daudet and Zola. Above all (it was explicitly a message to Vincent's younger self), stop taking things so seriously! Nothing was all that sacred, not even art. In painting, the main thing was to try to be "very lively, with strong colour, very intense."[45]

He spoke as a weary urban roué. Too many cognacs following too many absinthes, chased down with too much beer, had become the pattern of the evening. If not the Café du Tambourin, Montmartre could still offer such louche delights as Le Rat Mort, L'Âne Rouge, La Brasserie des Martyres or even Le

Divan Japonais with its bona fide Japanese owner — after which, one could always move on to the girls of the Perroquet Gris.[46] Theo, on the rebound from his refusal by Jo Bonger, was now joining Vincent for the ride. They were nothing if not close, huddling together during the long, dreary Parisian winter of 1887–1888. And yet, would it not be even better to bond across an intervening distance? If the hangovers took their toll on Vincent, he could also observe their effect on his innately frailer brother, so prone to cruel coughing fits.[47] The background din of painters who should be allies squawking and bitching added to the cumulative oppression; during his time in Paris, Vincent felt he was "always dizzy in a dreadful nightmare," he would later remember.[48]

The only remedy was to reactivate the plan mentioned to Horace Livens the previous year. He would soon, he told his sister in late 1887, be leaving for the south. In the meantime, why not have fun with other people's compositions? Why trouble to invent them for yourself? Here were these sublime prints by Hiroshige, and what a wonderful cultural paradox it would be simply to translate them into oil paint! Alongside his three japonaiseries of late 1887, Vincent put his hand to an old publicity photo, filched from the Café du Tambourin, and had his last happy-sad word on his "impossible" but cherishable heartache: the canvas known as *L'Italienne.* He took a younger Agostina, dressed up folksy *alla ciociara,* and irradiated her until she became an icon, packed with electric crisscross striations like a Warhol turned holographic. *Very intense.*

He was pushed and he was shoved. Nonetheless, wasn't he pushing through to something? The final thing on his easel before he departed was another big canvas, another mirror study to follow two dozen or more attempted during the two years passed in Paris. This was not, the emphatic signature declared, just another research venture; this was delivery, its scrupulously close-stitched paint surface calculated to balance a maximum

of pulsating complementary color with a maximum of descriptive attention. What entity was this grim and glittering object describing? A man "quite unkempt and sad, ... something like, say, the face of — death," its creator wrote to Wil, "but anyway isn't a figure like this — and it isn't easy to paint oneself — in any event *something different* from a photograph?"[49]

5

"Japan"

I

HERE WAS VINCENT on February 20, 1888, stepping off a train once again with his bags, portable easel and perspective frame, two years after similarly disembarking at Paris's Gare du Nord. Paris was now behind him, sixteen hours to the north, while at the end of the track lay another big city — Marseilles, the birthplace and final destination of his private hero Adolphe Monticelli. But Vincent regarded Monticelli as the child of a Provence that stretched as far up the Rhône Valley as Tarascon, the town teased in the Alphonse Daudet novels he liked reading, and it was in search of such a countryside, with its promises of "more colour" and "more sun," that Vincent meant to travel.[1] In between Tarascon and Marseilles, the railway went to Arles, a onetime major port on the Rhône long famed for the beauty of its women. It seemed as good a base as any from which to make a start on the south.

The heavy winter that had oppressed Vincent in Paris was in evidence here also. He tramped down the snowbound station road, skirted a tree-planted traffic island and passed inside the old town's northern gate, where medieval towers gave onto close-packed streets. He checked into the nearest cheap hotel. Unpacking his brushes, he tried painting the view through the window. He got out his pen to tell Theo how even on the journey, his thoughts had stayed with him. The letters that would follow affirmed that more than ever, their relationship was now

secure and possessed of common purpose. Theo, for his part, had the task of establishing a market niche for the painters of *le petit boulevard* — art's new generation, ranging from Seurat and Signac to Bernard and Anquetin and to their latest find, the charismatic Gauguin — an undertaking on which Vincent had copious advice to offer, as he pondered in his distant hotel room. Whereas it fell to Vincent, as he himself saw it, to strike out, a pioneer prospecting for raw color.

It was not that easy to get going. The big freeze maintained its grip for over a fortnight after his arrival. Vincent tried painting a couple of snow-covered fields, but mostly he was holed up doing still lifes, much the same as in Paris: holed up, in effect, with the huge, bleary hangover that that city had left him with. After a one-off sitting given him by an elderly chambermaid, any plan of painting portraits was for the time being discontinued. His relations with the people serving at the hotel and in the shops were hesitant at most, though soon enough he sniffed out the local row of brothels, just a couple of street corners away. As for the passersby, they mostly gabbled Provençal.

Or alternately Italian, until in mid-March, when three of these foreigners got into a scrap in a brothel with two Zouaves — members of a locally stationed elite regiment of the French army — who ended up dead, after which the whole immigrant community got driven out of town. Theo received a laconic report on this ugly episode, and another, slightly later, on a visit to Arles's great central Roman arena, where soldiers, shopgirls, factory hands and field workers all cheered on *la tauromachie,* the young daredevils snatching ribbons from the horns of a rampaging bull. All this was undeniably exotic, as was the "Chinese nightmare" of the Romanesque stone carvings at Arles's Church of Saint-Trophime. But it was for Vincent an unengaging exoticism, belonging to "another world, to which I'm as glad not to belong as to the glorious world of Nero the Roman."[2]

No, to head south was to seek out an alternative type of

Orient. On the train journey, Vincent had kept looking out the window "to see 'if it was like Japan yet.'"[3] It was "childish," he was willing to admit, but the way the brightness of the sky matched the brightness of the snow, or, after the snows had vanished, the way that emerald fields and azure canals crisscrossed the Rhône Valley plains — these were effects straight out of a print by Hokusai, or possibly by Hiroshige.[4] (Vincent's knowledge of individual printmakers seems to have been fairly vague.) "I feel I'm in Japan," he repeatedly exclaimed through the following months — not only in letters to Theo, but also to two other regular correspondents, Bernard and his sister Wil.[5]

The actual Asian nation, it hardly needs saying, figured peripherally at most in Vincent's typically nineteenth-century European mind. The fatalistic reading of history that he had picked up from Zola and other French writers suggested to him that the Japanese themselves were probably now in decline, but that the cultural baton had been handed along — "There's no doubt that their art is being carried on in France."[6] By what means? For his own part, via a mental operation. Out on a limb in the south — untied to any local social circle, subsisting on slender rations of human contact — Vincent in the spring of 1888 found himself freer than ever before to construe the world before his eyes according to his own mode of vision. He had unrestricted license, in other words, to aestheticize.

The magic of "the south" that he had ventured out to seek would intensify his visual experience — "more colour, more sun." But what, literally, would he be looking at? Strangely, by leaving the train at the final crossing point in the Rhône's course to the sea, Vincent had converged — whether deliberately or not — on a transfigured Netherlands. So much of what he already knew and loved was re-presented to him, on this far side of his plunge into Paris, aglow with a fresh, faintly paradisal glory. Once again, as back in Brabant, he took enthusiastically to transcrib-

ing what he saw with a reed pen, prior to (or sometimes subsequent to) going at it in oils.

The first motif he latched on to after the weather improved was in fact achingly Dutch: a drawbridge over a canal just outside Arles's southern perimeter. Its system of beams and pulleys, as tightly logical as the looms he had painted four years previously in Nuenen, required his perspective frame to draw. Yet as Vincent laid on the paint, the mechanical structure was translated into a static template to be loaded up with vibrant oranges, blues and greens. Washerwomen kneeling at the water's edge and a passing carriage were his attempts to tether the chromatic blast to normal, workaday significances. From this subject — named *The Langlois Bridge,* after the man who maintained it — Vincent moved on to the orchards outside town. Again, here was material of a type he had explored at Nuenen; equally, nothing could smack more of Hiroshige than plum blossoms.

Through late March and all of April 1888 Vincent followed the petals. Not only plum trees but pears, peaches, apricots and almonds enticed him. He moved around the furrowed orchards, planting his easel wherever the bright blossom sang out most — whether against cirrus and hazy blue, or against fences and cypress rows raised up to shelter the fruit from Provence's prevailing north wind, the ferocious mistral. After completing one particularly impassioned study of a couple of peach trees on March 30, he inscribed it *Souvenir de Mauve.* Anton Mauve, the painter who had introduced Vincent to oils, had died seven weeks before, and although Mauve had dismissed his student very soon after and never returned his entreaties, Vincent's love and respect for his mentor lived on. The older man, along with his Hague School colleagues, had believed in tonal harmonies and sober, stoic shades of grey. The fresh spring canvas was a respectful declaration that his pupil now stood on his own two

feet; a demonstration that brilliant color, when pursued far enough, could achieve harmonies all of its own.

What no painter could do, Vincent insisted, was to concentrate on color and on tone simultaneously. "You can't be at the pole and the equator at the same time."[7] This point was made to brush aside the first printed criticism that his work had ever received — from Gustave Kahn, a writer for a little Parisian review. Theo had just been advancing Vincent's cause by placing a couple of landscapes of Montmartre and a still life in the spring of 1888 Salon des Indépendants. Kahn might complain that Vincent's "vigorous brush" was hampered by a lack of "precision,"[8] but Vincent was breezily unbothered: "It'll be quite another thing they say later."[9] The high spirits in which he wrote spilled over, when he stood at the easel, into a reckless melange of streaks, spots, splodges and bare patches. "A fury of work" possessed him, he told Theo, banishing any "calm frame of mind," when face to face with the "tremendous gaiety" of the blossom itself.[10] Teasing the forever doctrine-hungry Bernard, he announced that "I follow no system of brushwork at all . . . I'm inclined to think that the result is sufficiently worrying and annoying not to please people with preconceived ideas about technique."[11]

It was meant to provoke people, this jumpy, high-hued mix-and-match of all that Vincent had imbibed in Paris, yet it was also developed with a hope to delight them. In the letter he had written to Wil the previous autumn, he had started to stake out his new position. What mattered these days was that art must be "very lively" — even if the artist himself might appear a laughing stock.[12] "Very cheerful" became the watchword of this spring, which was why vibrant orchards made such an excellent subject.[13] Positive color had a power to enhance viewers' lives. The viewers themselves might not yet be aware of it, but Vincent's paintings — or rather, work such as he was attempt-

ing, only better — would eventually prove of service to them. To that end, he had consigned himself to this crazy social marginality, for "it would be better to work in flesh itself than color" and "better to make children than to make paintings."[14] Family life, however, was not to be this artist's lot. The stance, expounded in his letters to Theo and to Wil, was complex, precarious, self-deprecating, post-political (we can't pretend, he told his sister, to be socialists or "founders of something new")[15] — and yet it was also transcendently ambitious:

> I still hope not to work for myself alone. I believe in the absolute necessity of a new art of colour, of drawing and — of the artistic life. And if we work in that faith, it seems to me that there's a chance that our hopes won't be in vain.[16]

How was that creed to be substantiated? In early May, after the springtime blossoms had all fluttered away, Vincent's thoughts on the theme of "the south" enlarged in scope. Old Monticelli, he wrote to Theo, had been "preparing the ground" in these parts. No, no, he hastened to add, it did not fall to himself to complete that John the Baptist–like figure of speech. "As for me, I'll work, and here and there some of my work will last — ... But the painter of the future is *a colourist such as there hasn't been before.*"

The painter of the future! Who might that be? "I can't imagine him living in small restaurants, working with several false teeth and going into Zouave brothels like me," Vincent observed, reverting to the wry drollery that had peppered his letters to Theo ever since they switched during his Paris sojourn from Dutch to French.[17] Nonetheless, it would be good to have other artists join Vincent in his rough-and-tumble existence in this outpost in the south. That, it seems, had long been his plan. He advanced it to Theo both as a noble cause and as yet an-

other of his schemes of economy. What if the painters of *le petit boulevard* were to relocate? (Vincent was less interested in joining forces with those nearer to hand in Provence, a Dane and an American, neither of whom he took seriously.) He suggested the notion in March in a letter to Bernard. Come May, he began to think of raising it with Gauguin. That "astonishing" poetic soul (as he described him to Bernard) was now back living hand-to-mouth in his Breton base of Pont-Aven, having long since run through whatever money Theo's dealing had made for him at the beginning of the year.

Vincent now had an enticement to beef up the proposal. At the turn of May he had finally fallen out with the people at the hotel inside the north gate; to accommodate his fast-mounting production of canvases, they demanded more than he was prepared to pay, and besides, the food disagreed with him and the lavatory stank. Looking for fresh air — "It's dirty, this town, with its old streets!"— he headed through the medieval towers and out across the little tree-lined park, the Place Lamartine, to the Café de la Gare.[18] Cheap proletarian transit zones were much more his style. Joseph-Michel and Marie Ginoux, who ran the café, had a room he could board in. They also knew Bernard Soulé, an estate agent with the keys to a long-unoccupied two-story property just along the park front. That was exactly the place! Vincent looked over the four little south-facing rooms behind the peeling yellow stucco and at once committed — not waiting for a by-your-leave from his paymaster brother — to take them on. The disrepair and the dazzle through the windows only added to their potential. He could start painting there instantly, as could the housepainters he hired to give the housefront a fresh coat of yellow. In due course, he would wholly move in, and then others might follow.

Vincent's invitation to the Yellow House, when it reached Pont-Aven, got snarled up in protracted negotiations, as Gauguin,

empowered by his recent relative success and by Vincent's admiration, tried to demand a subsidy from Theo as a proviso for his participation. For his part, Theo was once again unwell that May ("heart trouble" being the currently cited diagnosis) and at odds with his bosses. "I blame myself for wearing you out," Vincent lamented — unprofitably, for the only way in which he eased the burden was sometimes to switch from his splurging on oils to the reed pen. Vincent's thoughts also stretched out to Bernard and Anquetin. Their recent cloisonnist canvases were clearly in mind when he left off landscape work to paint an exultant still life in mid-May: a deep blue enamelled coffee pot, a cobalt-checkered milk jug and some oranges crisply compartmentalized against blaring lemon yellow. Some of the latest remittance from Paris had been splashed on the crockery, so as to consolidate his current dream of domesticity.

He had licence to aestheticize, he had room to think freely. He now began actually to explore. On May 30 Vincent took a stagecoach bound for Saintes-Maries-de-la-Mer, five hours away on the shore of the Mediterranean. Confronting for the first time the southern waves, he found wild new colors coming at him, which his brush rushed up to meet — a moment of innocent vision, of the kind the Impressionists had always been after. He returned from his five days in the little village with three canvases completed and drawings for several more — drawings in which, at last, he'd dispensed with his frame. That, he believed, gave him "a more Japanese eye," for "the Japanese draws quickly, very quickly, like a flash of lightning."[19] From here, his pen work started to open out into a polyrhythmic calligraphy. It appears at its most balletic in a drawing made later, *after* one of the oil paintings done at Saintes-Maries. (Much work went into communicating his latest efforts to his brother and his friends via such posted drawings, for want of instant photography.) It was orchestrated most spectacularly in a suite of drawings done

on Montmajour, a hill northeast of Arles, in the course of a few days in July.

Altogether emboldened, Vincent sensed that his art was now heading away from that of his Paris colleagues. Anquetin and Toulouse-Lautrec "won't like what I'm doing," he wrote after visiting Saintes-Maries;[20] nor, he later decided, would Seurat or Signac.[21] For Vincent now, effects needed to be "boldly exaggerated"[22] and he "could hardly give a damn about the *veracity* of the colour."[23] "Intensity of thought rather than calmness of touch" was the order of priorities, justifying the astonishing speed at which he was completing his canvases.[24] Eventually, in August, he would formulate just what set him apart from the Impressionists: "I use colour more arbitrarily to express myself more forcefully."[25]

By that point he had put a long distance behind him. Within a fortnight of his return from Saintes-Maries, two large canvases of prodigious plenitude emerged. Vincent had stridden through the June heat and mistral-whipped dust into the farmland east of Arles, the plain known as the Crau. In *The Harvest,* he interpreted this rich, radiant south country as if it were a panorama from the deep past of northern painting — the overview might almost be that of Philip de Koninck in the 1660s or Pieter Bruegel the Elder a century before — and with that distancing, a huge serenity prevails, embracing all the quirky little pockets of peasant activity. The canvas's classical composure and "firmness of colour" gave Vincent great satisfaction. He was less certain about its abrupt and "bizarre" intended counterpart, *Haystacks,* which zooms in on almost the same material from an alternate angle and focus.[26] Yet no canvas proclaims more the mode of "exaggeration" and of rapt attention that is uniquely Vincent's, none dramatizes more the shock of encountering things that are at once *there,* in the world, and *here,* in our minds. Summer; the wealth of the land; the probity of the peasant's labors; the

brashness of his handiwork; the material glare of pigment; the spiritual rush of yellow — no connotation is excluded, all in fact cooperate. All are good.

2

The hunched, sweaty foreigner in the straw hat would unlock the green door, push blearily into his ground-floor studio and lay down the day's work, then, pulling off his paint-spattered smock, head back out into the dusty Place Lamartine, passing the grocers and a side street, and enter the Restaurant Vénis-sac where he got his evening meal. These days, reversing years of bad habits, he was doing his best to eat properly, and here they made that a pleasure. Over coffee or a cognac, he might pore over articles about fashionable writers — Leo Tolstoy, Walt Whitman — in some little review or unfold that day's *Le Figaro* to follow, with a certain sympathetic fascination, the progress of General Boulanger, the militarist contender then making a bid to be the future of France. In due course, other appetites might require satisfaction, sending Vincent down the path between the plane trees and oleanders in the gardens of the Place Lamar-tine and into the old town, down the rue du Bout d'Arles or the rue des Récollets.

It was a loner's approximation to a workingman's routine. "Many days pass without my saying a word to anyone except to order supper or a coffee."[27] It was a solitude that worked. Through the long heat — from June to October 1888 — a quiet but furiously purposeful productivity held its course. After one more week of sweat and sunburn, "look, there's another Sunday got through, writing to you and writing to Bernard" ("you" be-ing Theo, the Sunday being July 15).[28] As for sex, "the sort of 2-franc women originally intended for the Zouaves" would do

for Vincent, who confessed himself no more than your average working joe when it came to the nudes in the galleries. "Why am I so little an artist that I always regret that the statue, the painting, aren't alive?"[29]

It was, to be sure, merely an approximation to a normal working life. Sometimes the cash ran out and the tubes were squeezed dry, and he could only draw and wait for the post. Often, his mental energies would overflow: The letter drafted on Sunday would be chased by another dated Monday or Tuesday, there would always be something more to say. Alternately, his physical equipment might fail him. "Painting and fucking a lot aren't compatible," he at one point thought it best to conclude.[30] And leaning on the maxim of an old Montmartre landscapist whom Theo and he remembered, he enlarged upon the issue:

> According to that excellent master Ziem, a man becomes ambitious the moment he can't get a hard-on. Now, while it's more or less the same to me whether or not I can get a hard-on, I protest when it must inevitably lead me to ambition.[31]

That protest, however, was in vain. The far-sighted observer who had surveyed the golden plains of the Crau now found his outlook reaching higher and higher. Within a few days of finishing *The Harvest* Vincent started mentioning—in a letter to John Peter Russell, his Australian friend from his Paris days—the direction in which he was thinking of heading. However premeditated, however deep-rooted in his career, the new development was nonetheless startling, showing Vincent's capacity to jump modes. He now intended to paint a spiritual allegory. "The Sower" would be his theme.

Religion had been the great tragic drama of Vincent's earlier life. He had battled his way out of his own disastrous piety, cruelly fixing on his ordained father as the butt for his own

self-criticism. From his most cornered moment onwards—his arrival at the Nuenen parsonage in December 1883—the aims that Vincent had stated for his art had been explicitly secular, couched in a materialism whose parameters came from French writers. Nonetheless, Vincent remained a Christian to this extent after his apostasy: that at heart, he still loved Jesus. The God of the Bible seemed all too scarily, oppressively, literally paternal. Moreover the present-day body of the church appeared to him either dead—a mouldering relic of medievalism—or deathly, in its modernizing evangelist or Methodist banality. Yet in rebuking Wil for her continued allegiance to that church, Vincent chose to quote the stirring voice that could be heard through the Gospels: "Why seek ye the living among the dead?"[32] The speaker of those words embodied the principle—also witnessed by the paintings of Rembrandt—that in every human being there was something of the infinite and eternal, and that one might help and console a fellow human by recognizing in him that spiritual dimension.

Jesus had his own word-based art form, the parable. Such an analogue for general ideas via homely, peasant realities might offer an inspiration to the nineteenth-century visual artist—above all, to Vincent's adored Millet. When Jesus told the tale of the sower, casting at large the seed that might serve both as food and as truth, he created an art about art, a word about the Word. Vincent now rethought Millet's *The Sower*—almost the first thing he copied after devoting himself to art in 1880—in the light of his own subsequent commitment to that cause. Potentially, this might be a painting about painting and its future, a proclamation of the redemptive power that this form of work held out. Potentially... For the time being, all his efforts on canvas could deliver in late June 1888 was a desperately earnest, quasi-pointillist thrash, its one clear component being a huge sun that with impersonal inevitability took on a God-like role in the symbolism.

That kind of natural analogy was very old Vincent territory. It had been at his disposal ever since the spring of 1882, when he discovered that tree roots could "express something of life's struggle," even as a human figure might.[33] Now, in the summer of 1888, his uplifted vision encouraged him to "express hope through some star."[34] Some half-formed thought of painting the night sky had been with him since early April, but it was not until late September that the concept took on substance — substance, it turned out, of such density that his big canvas *Starry Night over the Rhône,* which was painted by the riverbank a hundred meters from the Yellow House under a gaslight, ended up closer to a sculptural relief than a reproducible flat image.[35] All the stuff of the far cosmos was bludgeoned into immediate presence, coming forward as a fat, palpable, crisscross corrugation. By this brutally material Romanticism, the emotions shared by the couple on the foreground bank were equated with the constellation on high. For both types of phenomena "really exist," argued Vincent, calling, as so often in Arles, on his golden yellows and searing blues, his bold reds and raw greens:

> To express the love of two lovers through a marriage of two complementary colours, their mixture and their contrasts, the mysterious vibration of adjacent tones. To express the thought of a forehead through the radiance of a light tone on a dark background. To express hope through some star. The ardour of a living being through the rays of a setting sun. That's certainly not *trompe-l'oeil* realism, but isn't it something that really exists?[36]

The "marriages" and connections opened out yet further as Vincent sat scribbling to Theo, projecting further hopes upon his imagery. Suppose, suppose — everything got thrown up in creative play — we admit that this "cobbled together" world is merely one of God's "studies that turned out badly," and that in it, the efforts of humbler, merely human artists are misera-

bly recompensed: parity, nonetheless, must somehow be main-
tained.[37] Everything must be balanced out on the other side
of existence, in those worlds that shine above. "Just as we take
the train to go to Tarascon or Rouen, we take death to go to a
star."[38] Alternately, suppose the whole balance sheet, including
his own small life, cancelled out against the void:

> I always feel that I am a traveller, going somewhere and to some
> destination.
>
> If I tell myself that the somewhere and the destination do
> not exist, that seems to me very likely and reasonable enough.
>
> The brothel keeper, when he kicks anyone out, has similar
> logic, argues as well, and is always right, I know. So at the end of
> the course I shall find my mistake. Be it so. I shall find then that
> not only the Arts, but everything else as well, were only dreams,
> that one's self was nothing at all.[39]

A few weeks after sending Theo that prose poem, Vincent
tried depicting himself in the likeness of a Japanese Buddhist
monk — eyes Orientalized, gaunt and estranged in an aquama-
rine nowhere. Whether the painting kept pace with his medi-
tations on nirvana, he was also, that early September, attempt-
ing an inspection visit to hell. Instead of heading for bed chez
Joseph and Marie Ginoux, he spent three nights downstairs
working at his easel in the café they kept open through the small
hours — a hangout, in this northern transit zone of town, for
"ruffians," for streetwalkers and, indeed, for those whom the
brothel keepers had kicked out.[40] It was just the kind of place,
he liked to think, in which you could "ruin yourself, go mad,
commit crimes."[41] He was hugely, mischievously pleased that
the resulting painting, *The Night Café*, turned out to be "one of
the ugliest I've done" — up there, he added, with his personal fa-
vorite, *The Potato Eaters*. In case Theo was wondering what was
so marvellous about his pictorial tussle with the gaslight glare

and dozy riffraff, he continued: "I've tried to express the terrible human passions with the red and the green."[42]

"As if I gave a damn what he *wanted* to do!"[43] The objection submitted by Dries Bonger two years earlier, when Vincent tried explaining what he meant by his flower pieces' color contrasts, remains entirely relevant. Red and green remain red and green and emotion is something else. Even the yellow that Vincent was forever reaching for in Arles is not precisely human passion, stimulus though it is. *The Night Café* may not be "*trompe l'oeil* realism," yet the fascination of its ugliness lies more in its realist reportage than in its color contrasts per se. Should we, in other words, hesitate before buying the whole Vincent van Gogh verbal-visual package — *I paint it and I tell you what it means* — resisting it even here at its most potent?

And yet Vincent would have recognized the force of that objection. While he never sought to publish anything, he was clearly proud of his verbal skills and aware of their distinctness. "There's the art of lines and colours, but there's an art of words that will last just the same," he noted in the spring, subsequently deciding that however a poet's words might play on our emotions, "the painter says nothing; he keeps quiet, and I like that even better."[44] In August, as his visionary ideas made off and soared free from the painted evidence, a sequence of robustly argued letters to Bernard counterattacked against "sterile metaphysical meditations that aren't up to bottling chaos." By "chaos," Vincent meant the current historical condition. Modern humanity, straddled between a medieval past with its "architecturally constructed" society and a future in which "the socialists logically build their social edifice," was in a state of flux and anarchy. That being the case, the best hope for the artist lay in concentrating on a mere "*atom* of chaos," in concretely working "to define *one single thing*."[45] By which argument, Vincent redirected the pie-eyed young Bernard — and, by implication,

his own stratospheric tendencies — towards his long-stated personal ambition, which was to paint the modern portrait.

The first moderns, for Vincent, had been the great Dutch portraitists Hals and Rembrandt. Painting had changed somewhat since the seventeenth century, of course. "Today . . . we're working and arguing COLOUR as they did *chiaroscuro*."[46] Nonetheless, equivalents to the burghers and boors so decisively nailed down on canvas by Hals could surely be found in or around the local bars. Over beers in some brothel, most likely, Vincent struck up a friendship with a lieutenant of the Zouaves, Paul-Eugène Milliet, who remedied his lack of models by sending around a tough from the barracks to pose in the Yellow House in late June. The paint got slammed down angrily — "exaggeratedly" — in response to the soldier's cocky slouch and florid regimental rig-out, its Berber patterning being brandished like a punch in the eye. Lieutenant Milliet himself, a stylish young buck with Buffalo Bill whiskers, was also held down to his formal public persona — to the medal on his chest, to the braiding on his collar — when he sat for Vincent some three months afterwards. Likewise, Joseph Roulin, whose lofty, full-bearded figure would dominate the Café de la Gare after he had finished his duties at the station's sorting office. As the canvases celebrating his postal uniform made clear, Roulin — a knocker-back of the liquor, a holder-forth on politics, a disappointed republican and soon-to-be-disappointed *boulangiste* (General Boulanger's career would nosedive the next year) — was Vincent's very image of a working-class hero.

Everyone had a role. Vincent invented one for Eugène Boch, the only painter in the neighborhood to whom he positively warmed. The Belgian's "face like the blade of a razor" meant he had to be the Poet, stars twinkling about his head. It was a crude way to invest his sitter with "that *je ne sais quoi* of the eternal, of which the halo used to be the symbol," but then crude-

ness had become a virtue.[47] Securing a sitting from some un-known family's prim little adolescent daughter, Vincent's role casting turned naughty: He advertised the portrait to his cor-respondents as *La Mousmé,* in other words as a taste of Japa-nese jailbait. An old peasant farmer from out of town, posing in August, extended his coverage of the social range. In effect, Vincent's investigations over this period amounted to a pro-spectus for a radically personal encyclopedia, an atlas of modern conditions. The cosmos, history, the social individual — besides these and, of course, the geographical landscape, he found time to turn his sights to mechanization and the urban environment. Other canvases from these months fixed on rusty rolling stock, railway bridges and grungy walkways, barges, carriages and car-avans, and the leafy precincts of the Place Lamartine. He was looking in all directions. The great nineteenth-century novel sequences — Balzac's *La Comédie humaine,* Zola's *Les Rougon-Macquart* — imagine them boiled down to a flurry of home-made picture postcards, mailed from a provincial street corner.

Moreover, Vincent had his own microcosm to construct. In the second half of August he got busy improving the up-per rooms of the Yellow House, his projected "studio-refuge for one or other of our pals who are broke."[48] Theo received the usual unlikely sounding moneymaking preamble: If Vin-cent created a decorative scheme for the premises, it would in due course constitute a "10 thousand franc" asset, he was told.[49] Thus was born Vincent's series *Sunflowers.*[50] Returning to the massive, swaggering heads of yellow (he had tried painting sun-flowers earlier, in Paris), it was as if he had closed in on the heart of his fantasy about the south, the epicenter of his Arles sen-sibility, and the motif immediately became a personal emblem, repeated half a dozen times. This output was encouraged by a letter from Gauguin that at last, months after the idea had first been raised, made hopeful noises about joining him. When

Vincent received a substantial remittance from Theo on September 8, just after finishing *The Night Café*, he went furniture shopping, and on September 16 he was able for the first time to spend the night in his Yellow House, in one of the two beds he had purchased.

"I've never had such good fortune," Vincent wrote as he was painting *Sunflowers*. "Nature here is *extraordinarily* beautiful. Everything and everywhere."[51] The full-on, solar ferocity of his exhilaration was turned on his own street corner at the end of September, as he took advantage of road work to plant his easel on the east side of the Place Lamartine and pan from his evening restaurant to the train heading towards Paris across the railway bridge. And two weeks later, celebrating the Yellow House the other way around, he switched the temperature over also — in his own mind, creating a contrast and complement to *The Night Café*. "It's simply my bedroom," he explained, painted so as to "*rest* the mind, or rather, the imagination," the stoutness of its plain deal furniture proclaiming "unshakable repose."[52]

3

To "*rest* the mind, or rather, the imagination." The solitary working rhythm had Vincent in his grip and wouldn't let go. The subjects called him. "I have a terrible clarity of mind at times, when nature is so lovely these days," he wrote just before painting *The Yellow House*, "and then I'm no longer aware of myself and the painting comes to me as if in a dream."[53] And at the end of the following day, he wrote that September's radiant color "excites me extraordinarily. Fatigue doesn't come into it, I could do another tonight..."[54] But come Sunday, October 21, fatigue or something like it was hovering in the wings, as he had earlier feared it might. "I'm not ill, but..."[55] He told himself to

rest for a few days. Monday the twenty-second, he found himself describing a brand-new large-scale view of the Place Lamartine. "There you are, and yet I'd sworn not to work!"[56]

Wednesday the twenty-fourth, Gauguin arrived.[57] A tortuous to-and-fro had preceded his train journey from Brittany. Gauguin was hankering to get back to Martinique, where he had painted the previous year. But he was tediously in debt, stuck in Pont-Aven, and his best hopes of getting anywhere were placed in Theo van Gogh, the dealer who had managed to sell his work during the winter. Perhaps it might make political sense to take a detour and share accommodation with Theo's brother, who seemed likewise to rate him at his true worth. Meanwhile, at Theo's brother's urging, the high-flown and zealous Émile Bernard turned up at Gauguin's door in August. Gauguin was twice Bernard's age, but he was impressed by Bernard's contempt for realism and saw that Bernard's cloisonnist approach could recharge his own finicky aesthetic. Around September 10, the importunate Vincent wrote to Pont-Aven, suggesting that the three of them exchange portraits. After all, it was what the Japanese artists did, and they all shared the love of Japan.

Gauguin and Bernard obliged by sending self-portraits to Arles, each of which included an inset drawing of his fellow painter. What Vincent had waiting to present to them was his *Self-Portrait* as a bonze—his Buddhist monk impersonation. That canvas shows a man trying his best to distance and neutralize himself—except that every mark slammed down on it is supremely concrete and immediate. Compare *Self-Portrait with Portrait of Bernard,* the canvas Vincent received from Gauguin. Here, an edgy bruiser has drawn himself thrusting menacingly forward—except that bizarre things happen, the more his brushes fret and tweak: the wallpaper wavers like a mirage and a vibrant blue shimmer starts to bounce off his cheek. Gauguin paintings neither do *here* nor *there.* Instead, they open up rectangular pools for reverie, inviting the viewer to plunge in. Vin-

cent was enraptured by this "poetic" quality, as he saw it, though also perplexed: Poor blue-cheeked Gauguin wasn't looking at all well, he told Theo. He'd do best to head south.

The tiresome "yes, buts," "so difficults" and "it all depends" of the prefatory negotiations had notified Vincent that his awaited guest might be less than dependable. (Gauguin had a knack of showing his worst side in writing.) Nonetheless, Gauguin, with his seniority and refinement, would be entitled to regard himself as head of any Yellow House atelier, Vincent told him three weeks before his arrival — he for his own part being far too "coarse" and "commonplace."[58] In fact the man who turned up on October 24 turned out to be not only perfectly healthy but positively swaggering. He breezed around the unfamiliar southern town boasting to Vincent about his exploits on the oceans, about the charms of the tropics and, indeed, about how everything was bigger and better where he had come from in Brittany. How much, therefore, he would be buying into Vincent's vision of the atelier was uncertain, but for the time being he certainly meant to make his mark in Arles. Introduced to the brothels — Vincent's idea of the top local attraction — he strutted about "with the instincts of a wild beast," in the words of Vincent's somewhat awestruck report to Bernard.[59] Theo had lately managed to sell a little canvas of Vincent's,[60] but that did nothing to dent the huge burden of indebtedness that Vincent carried in his mind. However, more recently, Theo had made a hugely more substantial sale for Gauguin, who received enough money four days after his arrival not only to settle his accumulated Pont-Aven debts but also to buy a large roll of coarse canvas for himself and Vincent to work on.

Vincent was no more drawn to classical antiquity than to the Middle Ages, but a Roman cemetery in Arles named the Alyscamps attracted his charismatic companion, and Vincent joined him for this end-of-October painting trip. Vincent came back from the cemetery's avenues with yet another of his sur-

prise departures: a couple of provocatively formal compositions, playing self-conscious artistic games by using the trees to divide up the canvas's rectangle. The new tactics were prompted, not so much by what Gauguin was painting, as by what he had brought from Pont-Aven — a radically cloisonnist canvas by Bernard (which Vincent made a copy of) and descriptions of several others. Vincent was teasingly envisaging what a "painting of the future" might look like, even while working with subject matter from the past; between the vertical geometrical intervals, he inserted characters from some old Daumier cartoon.

The ideas bank of the distant Bernard got drawn on as his two friends talked over the dinner table in Arles. (Gauguin was now doing the cooking while Vincent did the shopping and some local woman — never named in his letters — did the house cleaning. When Vincent tried taking a turn at the stove, they both cracked up at the disastrous results.) Gauguin liked to try out novel buzzwords such as "abstract" and "symbolic."[61] (The Paris literary critic Jean Moréas had published a "Symbolist Manifesto" two years before.) The drift of thinking he was calling on argued that art should not be tied down to the material world but should rather, somehow, affirm the mind and the imagination. There was a side of Vincent ready to hearken to this — the side that had conceived the allegorical Sower and that had also, twice during the summer, tried to paint some kind of Delacroix-like *Christ in the Garden of Olives*. Neither version had worked, for want of a live model to pose as Christ. Each had needed to be "mercilessly destroyed."

Yet maybe one could train the memory, so as to produce something with "a more artistic look than the studies from nature," something more along the lines that Gauguin was recommending.[62] Vincent labored for a week or so during early November — an unusual length of time for him — to conjure up a "reminiscence," a memory of faraway loved ones (his mother and maybe Kee Vos) in some never-never garden. The mind and

the imagination, it turned out, were even more "Japanese" than the Rhône Valley; they seemed to talk a language of Hokusai swirls and crops. With nothing *there* to get hold of, Vincent's reminiscing turned pointillist as he caked his confected garden in multicolored dots, streaks and flowers. The painting, arguably the oddest sideways move in his career, didn't feel like a success to him. Yet from this japonaiserie he returned to his Sower dream and at last brought out its poetry, inserting a tree from a Hiroshige print. Late autumn light now lent his "painter of the future" parable more fateful, more elegiac overtones.

Vincent was listening to his housemate and "studio leader" (who had likewise used that Hiroshige tree in his *Vision after the Sermon,* painted before he came), but as with anyone Vincent dealt with, he was quick to defend his own corner. When the dashing Gauguin managed to persuade Madame Ginoux from the café—one of those good-looking women for which Arles was famous—to sit for him in the studio, Vincent managed to complete, sneaking a side view, a large-scale oil-on-canvas portrait of her within the hour it took his friend to do a much more cautious drawing. About a month after Gauguin's arrival, it amused Vincent to set out the way the two of them contrasted and complemented each other by recourse to the furniture. Being so coarse and commonplace, he would take a plain deal chair for his emblem, while refined, swanky Gauguin could land the curvaceous armchair. To Vincent, blues and yellows; to Gauguin, reds and greens. If the former canvas feels the stronger (despite the joke accolade placed in the latter chair—a big phallic candle for the man who signed himself "PGo," i.e., prick), this is because it brought to a head an ambition Vincent had been nurturing since August. "I'm beginning more and more to look for a simple technique that perhaps isn't Impressionist. I'd like to paint in such a way that if it comes to it, everyone who has eyes could understand it."[63] Populist simplicity had become a grand objective.

That, plus the new pursuit of memory, not to mention the continued pursuit of the "modern portrait." Around the end of November, Vincent somehow arranged with the bonhomous Joseph Roulin to paint every member of his family, all in the same week: Madame Augustine, four-month-old baby Marcelle, eleven-year-old Camille and seventeen-year-old Armand—the last being the subject of two studies, one of them among the finest portraits of Vincent's career. The brush was still leading Vincent everywhere, incessantly, as it had for nine stupendous months. And yet it seemed only to lead him into deeper debt to Theo. "I'm really in the shit, studies, studies, studies, and that'll go on for some time yet—such a mess that it breaks my heart," he wrote apologetically on December 1.[64]

Something might have to give. Gauguin spent several days in early December constructing—at his slower, dreamier pace—a canvas featuring Vincent, who sat almost directly below him in the studio, at work on one of the sunflower pictures that Gauguin particularly admired. To quote Gauguin's later recollections, the subject, when he was shown it, remarked:

> "That's me all right, but me gone mad."
> That same evening, we went to the café: he took a light absinthe. Suddenly he threw the glass and its contents at my head.

Gauguin ducked. He had noted the jitteriness at the time of his arrival, which came just after Vincent's "not ill, but..." spell. More than once lately, he'd woken in the night to find his picture's scenario reversed, with Vincent looming down on him, silent and brooding, from overhead. On those occasions, as now, he took hands-on control and marched Vincent off to bed, where sleep mercifully ensued. But back in his own room, Gauguin was forced to ask himself: What on earth was he doing here, anyway? (The "mad" canvas apart, the stay in Arles had done little to extend Gauguin's range.) It seemed he was ef-

fectively doing care work as a favor to his dealer, and that care work was now getting dangerous. The next morning Vincent was woozily apologetic. Gauguin's recollected reply: "I forgive you gladly and with all my heart, but yesterday's scene might recur, and if I were to be struck, I might lose my self-control and strangle you. Allow me, therefore, to write to your brother and tell him I am coming back."

He posted the decision around December 11. Then he retracted it, probably because it was just too shabby. Vincent was painfully needy, and all in all, Gauguin would rather go out on a good note. The love of art united them; a visit to the finest art collection in the South of France might prove restorative. Gauguin and Vincent took a round trip to Montpellier on Sunday, December 16, to visit the Musée Fabre with its canvases by Delacroix and Courbet. It was a cue for the old, familiar art-critical voice of Vincent's to pipe up the following day, reviving a correspondence to Theo that had lately seemed to falter. But that voice was struggling with its résumé, now on top of and now under the waves:

> Gauguin and I talk a lot about Delacroix, Rembrandt &c.
>
> The discussion is excessively electric. We sometimes emerge from it with tired minds, like an electric battery after it's run down.
>
> We've been right in the midst of magic, for as [the critic Eugène] Fromentin says so well, Rembrandt is above all a magician and Delacroix a man of God, of God's thunder and bugger off in the name of God.[65]

That single sudden spew of derangement might have concerned Theo when it reached him on Tuesday or Wednesday, but he had other things to think about. That week, while Vincent was trying to get going on his latest studio project—a new, grand populist icon, to be based on his study of Augustine

Roulin — Theo's harried and illness-ridden existence in Paris came to a point of transformation. It turned out that Jo Bonger was also in town, staying with her brother; it turned out that she wanted to see him. Everything came together, tumblingly. The sweetness and decency that shines through all his known letters had finally won out. By Friday the twenty-first, Theo knew where his life would now go. He sat down and composed letters announcing the happy news to the two people to whom that life mattered most: to his mother and — we must infer, although the document itself is lost — to his brother.

A filthy downpour kept up outside the Yellow House, making the year's shortest days almost as dark as its nights. Under the gaslight, on the easel, was a canvas that might bring together everything — simplicity, modern portraiture, the "abstract" and "symbolic." Madame Roulin, rocking her baby's cradle by a cord while she sat in "Gauguin's chair," would be transmuted, via a bombardment of spots and streaks and flowers, into an emblem of consolation, a pictorial lullaby. When the fug of gas and pipe smoke got too much, Vincent could dash for it and down an absinthe chez Ginoux. But the "electric" static crackled on, seemingly emitted by the hovering presence of this "wild beast" who had been threatening to abandon him but who might just strangle him first. Well, there was the post to wait for.

Over to Bernard, writing to a friend a couple of weeks later about the events of Sunday the twenty-third, after talking to

Gauguin who told me this: "The day before I left," for he was due to leave Arles, "Vincent ran after me (he was going out, it was night-time), I turned round, for he had been very funny for a while, but I didn't trust it. Then he said, 'You are silent, but I shall be too.' Since I had been due to leave Arles he had been so odd that I had been living on my nerves, he had even said to me, 'You are going to leave,' and as I had said 'Yes' he tore this sentence from a newspaper and put it in my hand: 'The murderer has fled.'"

Thoroughly unnerved, Gauguin took himself off to spend the night in an old-town hotel. Returning the next morning to the Place Lamartine, he saw crowds, and then a policeman was standing before him asking what he had done to his friend. The two of them entered the house. There were bloodstained towels strewn over the downstairs studio and blood going up the stairs. A short news item in *Le Forum Républicain* of Arles, December 30, 1888, translated with its punctuation intact:

> Last Sunday at 11.30 at night, one Vincent Vaugogh, painter, native of Holland, presented himself at the *maison de tolérance* [licensed brothel] no. 1, asked for one Rachel, and handed her . . . his ear while saying to her "Guard this object carefully." Then he disappeared. Informed of this act which could only be that of a poor lunatic, the police went around the next morning to the house of this individual whom they found lying in his bed, hardly giving any sign of life.
>
> This unfortunate was immediately admitted to the asylum.[66]

4

Briefly: Why the ear? (Or, more precisely, the lower part of the left ear.) The answer offered here — which stands or falls insofar as the remainder of the narrative persuades — inclines to the proverbial wisdom of the kingdom that was lost "and all for the want of a horseshoe nail." In other words, that big things may hang on little, and that history may sometimes be no more than contingency.[67] To ask "why the ear" is to seek a logic for what's grimly illogical. Yet certainly, it was a big thing for Vincent to discover that his life's great fixture, his dearest Theo, had suddenly slipped the moorings. It would have also seemed a big thing, growing up as he had, that Christmas was imminent. The newspapers around the Yellow House were full of little things.

There was that sentence about a murderer, which his slithering mind had linked to the worrisome Gauguin. There was also a hard-to-forget report from Vincent's beloved London (*Le Figaro,* October 3, 1888) about the latest deeds of Jack the Ripper. After one prostitute had been cut to pieces — including a severed ear — the police had received a letter threatening that next time, the ears would be sent their way. It was Christmas, and Theo would have his Jo, and wild beast PGo had presumably gone out to have his fun; but half-impotent, debt-dogged Vincent, what was he good for? Self-sacrifice and "merciless destroying" (as of the canvases of Christ) — not much else. Couldn't he at least do something to even things up for the sisterhood, by way of the girls he knew best? They had always been his friends.

That is sheer speculation, if along fairly orthodox Vincent-otological lines. It is patently tailored to serve my preferred focus, which is on a corpus of astonishing paintings and letters rather than on a lump of bloody gristle to which a social misfit is no longer attached. For parallel reasons, my account of the ensuing miseries will likewise be as brief as possible.

Gauguin telegrammed Theo. Theo caught a train, which arrived in Arles on Christmas morning. He sat by the bedside of his wandering brother for a few hours in the Hôtel-Dieu, the Arles town hospital, sometimes even snuggled up beside him, as when boys back at Zundert. Theo had a word with the medic in charge, Dr. Félix Rey, and requested help from the Protestant pastor Frédéric Salles. In the evening Theo took the train back to Paris, accompanied most likely by Gauguin.

For six days Vincent remained severely confused. A visit on December 27 by Augustine Roulin proved so distressing that the following day, her husband, Joseph, was not allowed contact. On December 30 Vincent started to come to his senses and on January 2 was able to write a short, reassuring note to Theo. Meanwhile Joseph and the cleaning lady had sorted out

the mess at home (the razor cut had severed an artery), and on January 4 this friend-in-need escorted Vincent on a trial return to the property. Afterwards Vincent sent Gauguin a few "words of friendship," asking him not to say "bad things about our poor little yellow house."[68] On January 7 he was discharged. He settled into his studio and began work again.

During his fortnight's absence, Soulé, the estate agent who was letting the house, spoke with a tobacconist named Viany, saying that it looked as if a convenient street corner premises, newly improved by a tenant, might soon be available for rent.

Writing to Theo after his return, Vincent ranged from expressing grief and remorse, to returning jitters (what had Gauguin really intended all along?), to droll self-deprecation of a "jerry-built" fellow with "a papier-mâché ear," to courageous attempts at making amends.[69] On February 2 he "went back to see the girl I went to when I was out of my mind. I was told that things like that aren't at all surprising around here" (i.e., in the crazy south). He was glad she had recovered from the shock. All his neighbors had been "particularly kind"; the landlord's agent, collecting his late rent, was also "very nice."[70]

A couple of days later, persecution fantasies welled up, and when Vincent told the cleaning lady that his food was poisoned, she contacted the police. On February 7 he was readmitted to the Hôtel-Dieu and placed in a padded isolation cell. After ten days it was judged that the derangement had sufficiently abated for Vincent to return daily to the Yellow House in order to paint, while remaining a boarder by night at the hospital.

It was probably during this second absence that the "very nice" Soulé, exasperated by the uncertain status of 2 Place Lamartine, had the enterprising idea of organizing a petition. There were ample supplies of hate for him to draw on. Later, Arles's municipal librarian recalled going around with a teenage gang who shouted abuse and threw cabbage stalks at the "odd" man who "always looked as if he were running away, without

daring to look at anyone."[71] Another teenager, serving in her uncle's haberdashery, remembered the foreign customer as "ugliness personified"—"dirty, badly dressed and disagreeable."[72] In fact Soulé, who lived just up the street from the Yellow House, was able to collect thirty-one signatures by a quick walk around the block. His document, supported by five witness statements all seemingly repeating a single instance of deranged behaviour—Vincent grabbing a middle-aged female neighbor by the waist in the street—began as follows:

> Monsieur Mayor, We the undersigned residents of the city of Arles, Place Lamartine, have the honour to inform you that the man named Vood (Vincent),[73] landscape painter, Dutch subject, resident of the said Place, has for some time and on various occasions shown proofs that he does not enjoy his mental faculties . . . [and is a] subject of fear for all the residents of the quarter, and principally for the women and the children. In consequence, the undersigned have the honour of asking, in the name of public safety, that the said Vood be as soon as possible returned to his family . . .[74]

Those signatories included Madame Vénissac of the restaurant and Joseph Ginoux of the tavern beyond—the white spectre who glares from behind the pool table in Vincent's *The Night Café*.

The mayor's office, having examined the petition, ordered on February 26 that Vincent be wholly confined to the hospital, once again in isolation. It was three weeks before he could next write to Theo. His letter expressed his reasonable anger at the cowards who had ganged up on him (though he seemed unclear exactly who they were), while admitting that "I would have preferred to die than to cause and bear so much trouble."

Even if he fully recovered, Vincent couldn't return from the Hôtel-Dieu to residence in the Yellow House. (Soulé and Viany

in due course fixed their deal.) His good friend Roulin had now been posted to Marseilles. Pastor Salles, also good to him, found a new place he could move to in Arles, but Vincent felt that this option was no longer tenable. With Theo married to Jo on April 18, it was time to accept his fate. It was better that he be consigned for an indefinite time to come in an asylum. Back in the summer of 1888, with what he now termed its "high yellow note,"[75] he had joked that if only he could work at the pace of his dreams, he "would be a famous madman — now I'm a not famous one."[76] Well, just so.

6

Broken

I

VINCENT VAN GOGH at times went mad. Moreover, at all times there were people who felt that he had something mad about him. Is there any way to improve on these crude, if irrefutable statements? An attempt to do so would involve stepping away from the drama of Christmas 1888 to consider the record both before and after, taking into account the six or seven subsequent psychiatric crises Vincent endured. One could begin with what Theo noted, upon reading the replies after he had sent home the bad news on that occasion: that chief among those who thought that Vincent had always been mad was their mother.

Anna van Gogh–Carbentus was a busy, cheery, pious and narrow-minded woman who would outlive all three of her sons. She had built up her resilience against an awareness that the Carbentuses were half cursed. Her older sister Clara was classified "epileptic" and her father was carried off by some form of mental disease eight years before Vincent was born. Very early — perhaps as soon as Theo's genial nature began to show — she seems to have sensed that his ever-obstreperous older brother was bad luck. At moments she might acknowledge Vincent's kind streak (as when he nursed her at Nuenen), his capacity to attract "good" people such as the prestigious Van Rappard, or even his ability to draw evocative landscapes, but whatever ma-

ternal love might have led her to place hopes in her oldest son she habitually withheld.

Her heartless gut judgment looks to have been genetically well reasoned. In 1875 another of Anna's siblings, her brother Johannes, fell apart and killed himself, and Vincent's dear Wil, the stay-at-home sister he always urged to have more fun, would enter an asylum in 1902 and there end her days after thirty-nine years of almost unbroken silence.[1] If some psychochemical snag did indeed run through the family, it expressed itself conversely in Vincent's everyday behavior. His frenetic mental activity seems to have been woven into his bodily fabric as ineradicably as the reddish gold of his hair. This singularity of mind steered Vincent on a blundering and insensitive path through others' lives while also, here and there, attracting admiration for its nobility, for its heroic, world-confronting, spiritual dignity. That, one senses, was the level on which Vincent interested the aristocratic Van Rappard and Toulouse-Lautrec and held the friendship of not just Theo and Wil but also Tanguy, Bernard, Gauguin and the Roulins. In other words, Vincent was able, after his own strange fashion, to forge a certain resilience in the teeth of his mother's lack of faith. We have seen how it broke down at the end of 1888, but we have also seen what it had creatively delivered before.

Vincent's letters indicate that he was already familiar with the quality, if not the intensity, of the disturbances that arose at that point. Besides the uneasy spell that preceded Gauguin's arrival, he made note of a comparable brief delirium when hospitalized for gonorrhea in 1882, and there were evidently other episodes he did not specify. From Christmas 1888 onwards, we have psychiatric reports on Vincent in the grip of hallucinations, at times acting aggressively, at times morosely and very often in self-punishment—blackening himself with coal dust, eating his own paint, eating "dirt." The doctors treating him di-

agnosed his condition as a "latent" form of epilepsy (in other words a variant without straightforward seizures), and this is a description that several more recent psychiatric researchers continue to find plausible, though others have opted for "acute intermittent porphyria." Vincent's intake of absinthe would have helped trigger epileptic brain activity, without in itself being the root cause of his disturbances. But an adequate medical overview would need to go beyond the specifics of Vincent's neuronal patterns. It would probably nowadays make use of the description "bipolar," to which Vincent's whole personality, from its earliest manifestations, seems to conform. There were, in other words, several levels of causation — from the incidental to the inherent — behind the difficulties that he faced from his thirty-sixth year.

Beyond the medical point of view, there is the human question of what it felt like to encounter these difficulties. Perhaps we come near to the rhythm of Vincent's experiences in a long central passage of a letter written to Theo shortly before one of his 1889 breakdowns (c. July 14). What the letter is trying to express is hard, though not impossible, to construe. It turns out to be a tremulously melancholy reflection on the closeness between the two brothers. But phrases of only the most tangential relevance keep clogging up the rhetoric and skewing the grammar. The sequence of utterances lurches, jolted hither and thither by a hard-to-govern pressure, forcing the writer to grab at near-random verbal handholds. At one point Vincent bears witness to the way that this mental acceleration is making disparate aspects of his world shuttle and weave together:

> *Things are so closely connected* that here [in the Provençal countryside] one sometimes finds cockroaches in the food as if one were really in Paris, on the other hand it can happen in Paris that you sometimes have a real thought of the fields.[2]

In fact the aptest image for that over-connectedness seems to lie in a letter sent long before, from The Hague in November 1882: "One feels a power *seething* inside one," Vincent wrote.[3] Picture, then, a frantic internal bubbling, driven by a heat from below, liable to boil over and spill beyond the container of personal identity. Foam heads of loosely associated aperçus surge up in the form of hallucinatory commands. After these are spent, the broth inside may subside to a listless, curdled residue, yet the pan holds firm; sooner or later, operations return to a normal workday simmer.

But note also the attempt that the quoted sentence makes to establish a far-straddling equation. Vincent the painter had a habit of doing this, for instance hanging in imagination a portrait he had painted in Arles alongside one painted by Toulouse-Lautrec back in Paris. It seems that in two poorly documented episodes of his earlier life — his period lodging with the Loyers in London in 1874 and his prolonged self-abasement in the Borinage around 1880 — Vincent was likewise trying to effect some imaginary parity between ostensibly unrelated phenomena, a fantastical moral resolution of the sort I have suggested underlay the gift of his ear to a prostitute.

Those were delusions from which he could awake, his keen capacious intelligence reasserting control. But the overwhelming accountancy problem of his life was, as we have seen, his debt to Theo, which he kept aggravating with further compulsive spending — more tubes of paint, more booze, more furniture. Vincent's no less compulsive productivity was driven by a yearning to even the balance. That, he knew — his ever-anxious, ever-guilty letters declare it — was the most tenuous and desperate delusion of all. And yet it was fundamental sanity. Insofar as Van Gogh the painter communicates to us, with an oeuvre that viewers for over a century have found uniquely thrilling and sustaining, it is not our business to call him mad.

Work was his own choice of remedy, the great counterbalance to the misfortune and absurdity that, he increasingly accepted, was his personal lot. As soon as he was back in the Yellow House, a week into 1889, he put his still shaking hand to a painted memo, placing a health guide on a tabletop alongside the letter in which Theo gave news of his own upswing of fortune: *From now on, let me too go straight.* He took stock of recent damage in the mirror, portraying himself in his head bandages twice. Then, flexing his fingers via a couple more still lifes, he returned to the big project in process before his breakdown. One might unkindly argue that *La Berceuse* — his image of Augustine Roulin rocking the cradle — was not worth the trouble of losing one's mind. The figure study Vincent had to work from was too flimsy and inert to carry his ambitions for a universal icon of consolation, and to compensate he invested the figure's background — a notional wallpaper of flowers, loops and dots — with a frantic gaiety that is the painting's high note in all of its five consecutive versions. To repeatedly return to the project through the early months of 1889 suggests at once the potential and the elusiveness it presented. The freestyle background patterning also spread into two thank-yous, a new portrait of Joseph Roulin and another of Dr. Rey of the Hôtel-Dieu.[4]

Overcoming the Lent-season cruelties of his neighbors and of the isolation cell, Vincent was able in early April to return to the countryside outside Arles and demonstrate, through a handful of firmly structured large landscapes, the persistence of the grip he had achieved the previous year. But his foothold in the town was coming to an end. A further personal stocktaking, a view of the ward in the Hôtel-Dieu in which he was currently passing his nights, was also a valediction to Arles — or to a reduced, huddled morsel of its community — after Vincent had accepted he must leave. Composure and stoicism: echoes of the blues and yellows of the previous year, only more wan, more muted, never again to risk such heat.

2

It was Pastor Salles who brought to Vincent's notice a retreat forty miles to the northeast of Arles, on the far side of a range of limestone crags known as the Alpilles. Saint-Paul de Mausole was a Romanesque abbey that had been converted, with its cloisters and gardens intact, into a lunatic asylum after the French Revolution. Immediately to its north lay the little town of Saint-Rémy-de-Provence. If one was forced to enter the company of madmen, one might at least opt for country breezes and the promise of a benevolent regime. As usual, Theo acquiesced in the expense. In fact Dr. Peyron, the ex-navy medic running the institution to which Vincent was admitted on May 8, 1889, turned out to be not so much enlightened as laissez-faire. There was no concerted program to address the mental problems of the thirty-odd male and female inmates and provisioning was on the cheap—recycled bean stews were their principal fare. With nothing demanded of them, the occupants of the male wing lounged about, farting their days away, a surrender to indolence that appalled the industrious new arrival.

Under-subscription was half of the managerial problem. But for the newcomer, that meant there was plenty of elbow room in the ancient complex, both to distance him from the spasmodic howls of other inmates and to provide him with a personal studio. From this he briskly strode out into the gardens to try his hand, tackling a lilac bush, a bed of irises and then a stone bench surrounded by ivy-clad tree trunks within his first week. Vincent was exploring, as previously in Arles, alternate ways of drawing with a loaded brush—whether to bring out the subject at hand by hatching and stippling, or to enclose it in cloisonnist outline like a "commonplace" color print "from a penny bazaar."[5] To zoom in on something good and vital and to pass on its gifts to the viewer—the notion of such a populist, conso-

latory art continued to allure him, even if his only community at present was a gaggle of variously bewildered souls obliged to look out for one another for lack of staff attention.

Then Vincent got interested in the view from his bedroom. His window was in the upper storey of the abbey's east facade, slightly towards its northern end. Under that facade, a square acre of wheat, bounded by a stone wall, stretched away. Vertical bars prevented too swift an exit from the occupant's miseries; a grid similar to Vincent's old perspective frame, except devoid of horizontal stabilizers. The painter of *The Sower* was at home with the wheat and with the morning sun that arose over the field "in its glory," but not with the Alpilles looming up as he craned to the right.[6] ("I've actually never seen a mountain in my life," he had written to Wil the year before.)[7] As he sketched and sketched, trying to understand what he was after, the conjunction of circumstances wrenched him out of orthodox perspective altogether. A new tilted panoramic take on the enclosed field made plain his own tangential, left-sided relation to it, even while thrusting the stuff of the crop dynamically forward at the viewer. It was an empowering breakthrough, and he would return to the stimulus of that wheat field in canvas after canvas through the months that followed.

Freed from orthogonal constraints, the forms of the observed world could start to dance to the patterned rhythms, loosely associated with Japanese art, that had entered Vincent's repertory the previous autumn when he accepted Gauguin and Bernard's advice and tried to work from the contents of his mind. Hence there was a programmatic logic to the new development. And yet undeniably there was something else as well. This is the slippery context in which Vincent roughed out what has become the most famous of all his projects, though one he remained deeply uncertain about at best. His 1889 *The Starry Night* was a "study" no more, when he mentioned it rather offhandedly in a letter to Theo dated c. June 18.[8] This large canvas is

indeed far less concretely worked than its September predecessor featuring the constellation of the Plough and the gaslights of Arles reflected in the Rhône, although it may have been even longer in gestation; Vincent talked of painting "a *starry night with Cypresses*" back on April 9, 1888.[9]

In late May and early June 1889, Vincent's purposeful demeanor gained for him permission to work beyond the abbey precincts, accompanied in principle by a warder. The meadows and olive groves on the slopes leading up towards the crags were overlooked by cypresses, and one such upward-shooting silhouette gave Vincent an axis for his composition. A vista of a Saint-Rémy church and the houses around it provided further material, relocated to nestle under the Alpilles to the abbey's south. Just possibly, popular science journals in the asylum library factored in too, with astronomical photographs of nebulae. But what did Vincent suppose he was after, conjoining such far-flung materials?

In the same letter, he defended himself against what he expected his prudent brother to say, when confronted with this rapturous vision. "It's not a return to the romantic or religious ideas, no."[10] In fact, only the day before he had received from Theo an anxious caution not to follow modish symbolist agendas to the point of "torturing the form," of drifting into "mysterious regions" and of tipping into "vertigo." "Give only a simple account of what you see."[11] For Theo, truth along such lines was exactly Vincent's forte. The advice came too late. Vincent had to avow that he was signed up to Gauguin and Bernard's cause — or at least, to that cause as he conceived it to be at his current remove. He claimed, however, that the cause at stake was to express a pure, uncorrupted vision of nature, something contrasted to blasé urbanism and gaslight.

That is part of the story with *The Starry Night,* but once again Vincent's pen supplied only half-truths with regard to his brush. The complex of speculations Vincent had developed over

the previous summer — the notion of a grand celestial equation, in which all our earthly cares got resolved — evidently fed into his current invention. In the interval, among the passing glistening bubbles of his derangement, there had been "moments when the veil of time and of the inevitability of circumstances seemed to open up a little way for the space of a blink of an eye," as he had noted in March.[12] That in itself was an uncommon, but not an insane, proposition. Yet perhaps we should rather picture the seething of his mind as a surge of curling and hooking movements, translated by his handiwork into visible analogues to its hyperconnectivity. *The Starry Night* pictures a mystical consummation, although Vincent with his choice of bold modern means declined to call it "religious," and at the same time, that great swirl was a vortex deeply structured in his soul.

The challenge of looking at it levelly is compounded by a set of drawings, done later that June, that takes the rippling, rolling, tumbling movements yet further, reaching for a highly personal, wild man's rococo. These turn out on inspection to be among the many sheets he posted to Paris to signify what had been going on in his studio, ink studies distilling what oils had attempted before. Hard work, one might say, was here resolving his mental turbulence by tapping and diverting its energies. But one must also consider that these were polished presentation exercises, in some ways the nearest Vincent's art ever got to mannerism. The canvases they represented, done on further escorted expeditions into the fields below the crags and heavily impastoed à la Monticelli, were largely of cypresses.

The trees "preoccupy me," Vincent wrote on June 25, "because it astonishes me that no one has yet done them as I see them," and he went on to compare them to Egyptian obelisks.[13] While he declined to name their age-old associations with mortality, the same batch of canvases included a vision of his chosen wheat field yielding its golden crop to the sickle, a Reaper con-

ceived as a counterpart to last year's Sower. Finally on July 2, he looked his brother's reproof in the eye:

> It is precisely in learning to suffer without complaining, learning to consider pain without repugnance, that one risks vertigo a little; and yet it might be possible, yet one glimpses even a vague probability that on the other side of life we'll glimpse justifications for pain, which seen from here sometimes takes up the whole horizon so much that it takes on the despairing proportions of a deluge.[14]

To hope for death was not an insane desire in the circumstances. Yet a passion for work drove Vincent onwards, quickened by his literary-critical exasperation with a soppy novel that Wil had posted his way. Édouard Rod's *Le Sens de la vie* (*The Meaning of Life*), with its twee vignettes of marital bliss among the mountains, "teaches me absolutely nothing whatsoever about the meaning of life," Vincent sniped to Theo, whose own marital bliss was about to be completed by confirmation that Jo was pregnant.[15] Nonetheless, the notion of mountains prompted an escorted excursion to the Alpilles in early July, from which Vincent returned with a spirited wild rendering of their naturally contorted rocks. Meanwhile, the notion of romance had never wholly left his mind, as a letter in April near-distractedly confessed:

> From time to time, just as the waves crush themselves against the deaf, desperate cliffs, a storm of desire to embrace something, a woman of the domestic hen type, but anyway one must take that for what it is, an effect of hysterical over-excitement rather than an accurate vision of reality.[16]

Now, in July, he obtained permission from Dr. Peyron to visit Arles. As later became plain, his thoughts in his melan-

choly had fixed on the handsome face of Marie Ginoux, the sitter whom Gauguin had lured from the café to their studio the previous autumn.

But when he and his minder came into town, she wasn't to be found, nor was the kind Pastor Salles, nor Dr. Rey, while Roulin was now in Marseilles. It was bad luck; it was fate. He was functionless, unfriended. Vincent and the orderly returned to the hills some windy day in mid-July; soon after he had posted Theo his sorely distressed rant about connectivity and cockroaches. The attack came as he was painting a view of a quarry. The brush carried on painting as the surges hit. The canvas got completed.

3

This time, Vincent was under for about six weeks. His hallucinations teemed (one infers, from later evidence) with the blue-cloaked figures who bustle through the middle distance of the ostensibly realistic *Ward in the Hospital in Arles* and who were currently working the asylum's female wing — the *réligieuses,* the strange "sisters" and "mothers" of the alien Catholic south. Die, they told him. Drink the kerosene from the gaslight, suck the paint from your tubes. It was necessary to confine Vincent to his bedroom and lock away his materials. He surfaced briefly on August 22 to send a poignantly lucid note to Theo, reporting the throat damage he'd suffered from eating "filthy things," although his own "memories of these bad moments [were] vague," and to protest that the outlook in all directions was "ABOMINABLE."[17]

At last, around the turn of September, a coherent Vincent regained control and, with astonishing speed, clarity and vigor, returned to action. Reunited with his brushes, he at once went to the mirror to take stock. It presented the painter to himself as a gaunt, racked specimen, looking all the sallower for the dark

blue shirt and surround that complemented this self-portrait's flesh hues. Vincent started a second treatment, lighter in tone, with a will to lift himself above such a state of being. In fact this succeeding self-portrait, begun around September 5 and brush-drawn with ferocious rigor, thrusts the consciousness of the painter forward so as to occupy the whole canvas in a manner unparalleled in art. What must have been quite a late decision in the brushwork — to carry onwards the roll of the folds of the jacket into the space around his head — delivers to the viewer not so much a metaphor for the subject's state of mind as a total shock immersion.

Vincent sensed he'd achieved something, but as with *The Starry Night,* he seemed less than sure what; "vague and veiled" were the terms he reached for to describe the quality of the picture's gaze.[18] He was contrasting it to a formidable portrait of the beady-eyed asylum orderly, Charles Trabuc, that he painted just a few days later. Vincent had often passed Trabuc's house on his way to paint the cypresses, and the orderly's "faded" but kindly wife now attracted him as an object lesson in humility, explicitly likened to his close-ups of plant life — "a dusty blade of grass" whose very insignificance demanded his portrayal.[19] Such resignation as hers was wisdom. Vincent was too fired up with work to adopt that virtue, but at least he could demonstrate persistency. For that was the spirit of his new autumn campaign, an approach that in effect led him to long labors of reiteration and repetition.

Vincent was, from early September onwards, back with the motif of the wheat field through the window, and later, when permitted outside, he returned to the crags. He painted an-other version of *The Reaper,* and afterwards redid *The Bedroom* from Arles. More bravely, he took a potent image that some of his hallucinations had evidently distorted and nailed it down in concrete color. This was a lithograph he owned of a Delacroix painting, a pietà in which a blue-robed Virgin bewails a red-

headed dead Christ. He painted that twice over, also. From re-
thinking that reproduction into a scheme of blues and yellows,
he moved on to other material, starting an indefinite series of
colorized versions of his old familiar Millet prints, the starting
line of his artistic training.

It was a sideways tactic, this insistent recursion — half cau-
terization of the damage that Vincent carried within him and
half anaesthetic. Twist, hook, curl, stroke, pat, pat, pat went the
brush, first probing then docile, the knot of the preordained im-
age resolving itself into a balm that soothed. A "lightning con-
ductor for this illness" was how he now regarded his art, a de-
scription borne out most vividly by a wildly excited study of a
mulberry tree done in early October.[20] Apart from that, two
main new motifs entered Vincent's repertory. The olive groves,
glimpsed briefly back in June, now spoke to him with their low,
regimented tree boles and their mounds of raw red earth as a
comfortable pictorial terra firma — one that carried just suffi-
cient connotations of the garden of Gethsemane to remind him
of his love for Jesus. Sometimes overseen by an omnipotent sun,
at other times silvery in twilight, eventually attended by late-
autumn harvesters, the groves proved a pictorial consolation as
reliable as morphine; in many passages, the steady stenographic
brushstrokes applied to these eight-odd large canvases become a
zombie facture, unimpeded by thought.

And then by contrast there was the walled garden over
to the monastery's west side, planted with "proud, unchang-
ing," lofty and muscular pines.[21] Here perseverance and repeti-
tion took on a heroic demeanor. Vincent's series of studies cul-
minated in a mid-November canvas that stands as the tightest
weave of all his researches into color and into brush drawing, in-
tegrated with his unique instinct for botanical symbolism. The
tumultuous polyrhythms of *The Garden of Saint-Paul Hospital*
march over the objection that reds and greens can never equate
to human passions (the Dries Bonger objection "As if I gave a

damn what he *wanted* to do!") with a hard-fighting intellectual orchestration. Vincent saw the first pine as

> a dark giant—like a proud man brought low—contrasts, when seen as the character of a living being, with the pale smile of the last rose on the bush, which is fading in front of him... A ray of sun—the last glimmer—exalts the dark ochre to orange—small dark figures prowl here and there between the trunks. You'll understand that this combination of red ochre, of green saddened with grey, of black lines that define the outlines, this gives rise a little to the feeling of anxiety from which some of my companions in misfortune often suffer...[22]

This extended ekphrasis was for the benefit of Émile Bernard. Vincent meant to teach his occasional correspondent a lesson in the relation between intention and execution. The ideologically driven Bernard had by now moved on and was trying his hand at screechy, mock medieval "naive" paintings of the passion of Christ. Photographs of them provoked Vincent to a superb outrageous tirade—as ever, even in a letter so rude that there was no way to reply to it, Bernard received the finest of Vincent's art criticism. The target of the assault was the pursuit of "abstraction"—of working from mind rather than from matter—that had so fascinated Vincent only a year before, when listening to Gauguin. In fact, he now thought he had been a fool in June to attempt "to do stars too big, &c." Yes, Vincent argued, painting should attempt passion, and "it is—no doubt—wise, right, to be moved by the Bible, but modern reality has such a hold over us," and it was only through persistent attention to nature, through a reverence for "the true, the possible," for "a few clods of earth," that genuine achievement might arise.[23]

The keenest arguments are with oneself. Vincent had two months earlier reflected that the painter's "touch," or use of the brush, was caught in a permanent tension, for what was "true

and essential" came from observations grabbed roughly out-
doors, whereas what was "harmonious and agreeable" belonged
to afterthought in the studio.[24] His present reassertion of realist
values was something of a feint, for soon after he was express-
ing a desire to paint "a far-off thing like a vague memory soft-
ened by time."[25] The phrase concerned the olive grove pictures
with their hypnotic monotony, but a yet more dreamlike feel re-
sults in a contemporaneous study of a blue-dressed female pass-
ing under a canopy of trees, conjuring up a narrative space more
mysteriously "medieval" than anything of Bernard's.

If Vincent was indeed trying to walk a psychological tight-
rope, he succeeded in holding his course through the year's clos-
ing months. While he spoke of melancholy and even, some-
times, of abandoning painting altogether, he readily accepted
an invitation to exhibit with Les Vingt, a Belgian group due
to show in the New Year. Finally, Theo's diplomacy on his be-
half was beginning to pay off. In November the asylum's most
hard-working inmate was allowed to attempt another visit to
Arles, despite the bad precedent of the July excursion. This time
he was in luck. Madame Ginoux and her two-faced husband
gave Vincent an agreeable welcome; in fact everyone seemed
friendly. A few weeks later he was also permitted to try painting
in the streets of Saint-Rémy.

On December 23, remarkably, Vincent actually wrote a lov-
ing letter to his mother. They had been almost out of contact
between his ejection from the Nuenen parsonage in 1885 and
the traumas of Christmas 1888, after which he had posted her a
couple of bland and circumspect "don't worry too much, I'm all
rights." By comparison his communications with Gauguin over
the same year had been far more genial, if also somewhat awk-
ward. But thoughts of the north started to revive in Vincent's
heart after he emerged from the summer's attacks, made anx-
ious by nuns and cloisters and the "superstitious" notions that

seemed to cling around the Midi.[26] He tugged at Theo's sleeve with schemes to get away. At the same time he was aware that Theo, with a child on the way, now had other things to think about. It was time to look over Theo's shoulder, at the one who knew them both best. Vincent tried for once to look his mother in the eye:

> I often have terrible self-reproach about things in the past, my illness being pretty much my own fault, and in any event it's doubtful whether I can make amends for faults in any way. But reasoning or thinking about this is so difficult, and sometimes my feelings overwhelm me more than in the past. And then I can think so much of you and of the past. You and Pa have been so much, so very much to me, possibly more even than to the others, and I don't seem to have had a happy nature.[27]

Alas, coming clean did not earn Vincent remission. On Christmas Eve, just as he had feared, a fresh attack blew up, a year on from his first. As on that occasion, he was out for a week. He came to to find his brushes locked away. As 1890 began, the only policy was to face his illness as a permanent liability, a matter for pragmatic negotiation with Dr. Peyron. His supervisor—an affable if unimaginative placeholder—proved compliant when Vincent requested another trip to Arles in mid-January. The sentimental journey might be harmless to Madame Ginoux, but it was not so to Vincent. Upon returning, he succumbed to a new bout of derangement that lasted some ten days. Peyron appears to have shrugged. Maybe it was best to let the voluble foreigner keep as busy as he was able in his ground-floor workroom, "translating certain pages of Millet" (not to mention of Doré and of Daumier) into oil paint, as a steady, procedural work for the winter.[28]

Did this artistic drudge's role—sketched out in a letter

to Theo on February 1 — represent an embrace of humility? No, rather another feint and deflection. Far away, in certain recherché quarters of Paris and Brussels, Vincent was suddenly the news. In his thirty-seventh year, after almost a decade of furious but virtually unsold and unremarked labor, he was being hailed as an "extraordinary and intense" aesthetic sensation, a "great painter" who was the "worthy compatriot and heir" of the likes of Frans Hals.[29] There had been a little whisper in October, when Joseph Isaäcson, an acquaintance of Theo's, snuck a line into a Dutch art review about "a solitary pioneer... His name, Vincent, is for posterity."[30] And then in early December, Theo mentioned that "a friend of Bernard's called Aurier" had called around to look through the piles of canvases mounting up in the Paris apartment.[31]

Albert Aurier was an ardent young critic in cahoots with a circle of Symbolist writers who launched a little review named *Mercure de France* in January 1890. After talking his subject through with Bernard, Gauguin and no doubt also Theo, Aurier presented the periodical's opening number with a startling five-page essay that, for all its outdated bombast, identifies aspects of Van Gogh's later work that remain critically crucial to this day. The first impression, Aurier wrote, is of "a man whose mind is constantly erupting," leaving "the whole of nature strangled in a frantic paroxysm." Then beyond that violent "excess" and seeming "crudeness" of touch, one starts to note "the conscientious study of character, the continuing search for the essential meaning of each object" that links this painter to the Dutch Old Masters. And yet deeper inside that naturalism, "within this most material matter, there lies, for the mind able to perceive it, a thought, an Idea..." Aurier, instancing Vincent's picture of "a sower of truth" who might "regenerate our decrepit art and, perhaps, our mindless, industrialized society," claimed him as a hero for Symbolism at its most utopian. Vincent's hopes for "a new,

very simple, almost childlike painting, destined to move the most humble unsophisticated people," were, Aurier suspected, as excessive as his art, which was in fact only destined to be understood "by his brothers, the truly artistic artists."[32]

Vincent was, therefore, one of *les isolés* — "the isolated" — as the essay's title had it. What finer recommendation could there be to the avant-garde connoisseur? The article, published in shortened form in Brussels to coincide with the January opening of the group show of Les Vingt, helped galvanize attention to Vincent's six exhibits — two from the *Sunflowers* series, two landscapes from Arles and two from the asylum. They quickly became the talk of the town. In February one of the Arles canvases, *The Red Vineyard,* painted during Gauguin's stay, became Vincent's first serious sale. The purchaser was Anna Boch, sister of the Eugène whom Vincent had also painted in Arles as the Poet.

Arriving at the asylum in late January, young Aurier's critical essay met with still more sophisticated criticism in turn, albeit from a convalescing mental patient. "An article like that has its own merit as a work of art, as such I consider it worthy of respect," Vincent remarked appraisingly to Theo. The article had certainly "surprised" him — he hoped he didn't "paint like that" — but then in this case the artist's tables were turned and he was "*posing* a little for THE *model*" — that is, for the critic's idealistic agenda.[33] Composing a letter of thanks to Aurier himself, Vincent bowed self-effacingly, insisting that Monticelli and indeed Gauguin were worthier subjects of critical attention. Obscurity felt homely, one infers; a little earlier, he had judged that "as I have dizzy spells so often, I can only live in a situation of the fourth or fifth rank."[34] Ah, but the heart might so easily start to race, particularly when sales receipts were on the way. "Pride intoxicates like drink," Vincent wrote to Wil. "When one is praised and has drunk one becomes sad."[35]

4

On January 31, 1890, Vincent Willem van Gogh was born. Seven years earlier his uncle, forced to part with Sien Hoornik, had been heartbroken to let go of her little son Willem. A baby, for Vincent, was simply "the best thing"—life's first fresh bud, irresistibly calling for the consolation that makes us human, a primary reality of a kind he himself was fated never to produce.[36] That Theo should name his son after a brother who by now was no more than "a broken vessel" was almost too affecting.[37] "I'd much rather"—once again, Vincent was confiding in his mother, on February 19—"that he'd called his boy after Pa, whom I've thought about so often these days, than after me, but anyway, as it's been done now I started right away to make a painting for him, to hang in their bedroom. Large branches of white almond blossom against a blue sky."[38]

Here at the turn of the 1890s was an easel painting that no previous European artist would have produced—Vincent himself included. None of his earlier japonaiseries had opened up a space so freed from perspective and pictorial composition. His wish for his brother—that "the family will be for you what nature is for me"[39]—got expressed in an expanse of loving attention that is without a center, or rather with centers that are anywhere and everywhere: it became a dream of paradise.

> You'll see that it was perhaps the most patiently worked, best thing I had done, painted with calm and a greater sureness of touch. And the next day done for like a brute.

The mental disorders that followed the completion of *Almond Blossom* took on a different character from their predecessors. On the day in question—Saturday, February 22—Vincent's heart was juddering and racing, not just with fame ("Please tell

M. Aurier not to write any more articles," he later told Theo; "[it] pains me more than he knows"),[40] but with his all-too-tender feelings for Madame Ginoux. Gauguin, fleeing Arles, had left behind a charcoal sketch of the patronne, which Vincent had employed as a basis for painting five closely resembling icons of his *Arlésienne*. He now intended to present one of them to her in person.

No memories of his mission to do so were ever retrieved, nor was the canvas itself. All we know is that on Sunday the twenty-third, Dr. Peyron was obliged to send two men with a carriage to Arles to scoop up an incoherent Vincent, who had been found wandering the streets. The next word that we have is Vincent pulling himself together just sufficiently to report to Theo on March 17 that after the sudden plummet, he had been "without pain, it's true — but totally stupefied."[41] His wits then slipped back out of sight until the final week of April.

It seems to have been decided during this latter period that the patient was so morose and demotivated that he was unlikely to endanger himself if allowed to use his art materials. A great number of pencil drawings and a handful of canvases resulted. "Reminiscences of the North," Vincent afterwards termed them; woozy, homebound sleepwalkings restating his first pictorial impulse — *there were people in a land* — in terms of folksy working peasants and their cottages in the countryside of Brabant. Interestingly, while Vincent's linear command was shot to pieces, reduced to a threadbare clutch of cuppings and curlicues, his color instincts stayed strong. The orchestrator who four months earlier had symbolized the anxieties of his "companions in misfortune" now found a palette mournful enough to communicate his own.[42]

The nine weeks spent adrift left the man who returned to articulacy on April 29 "more sad and bored than I could tell you, and I no longer know what point I'm at."[43] Just one thing was clear: Vincent had to get out.

Which he did. Within three weeks. Reason one: Theo for months had been in touch with a doctor with artistic interests who lived just north of Paris and who might act as a suitable chaperon for a painter prone to nervous disorders. Reason two: Everyone in Paris was suddenly talking to Theo about the amazing canvases by his brother in this season's Salon des Indépendants, and the question followed, where was the man himself? Reason three: Inspection systems were slack, allowing the insouciant Dr. Peyron to sign the release papers on May 16, pronouncing his reeling charge "cured."

Before he boarded the Paris train, Vincent, in a returning rush of energy, completed some ten large canvases during those liberation weeks: two bristly close-ups of the asylum gardens, four stately and sumptuous flower pieces, three more "translations"— this time from prints of Rembrandt and Delacroix and an old drawing of his own named *Worn Out* from his time in The Hague — plus a mystery narrative of two walkers down some road in Provence, within a delirious, perspectiveless mosaic of cosmic symbols. It was painted seemingly with Gauguin in mind, for it was to him that Vincent described the picture. "Very romantic if you like"; "star with exaggerated brightness, if you like"; "a last try."[44]

This southern journey, he wrote to Theo, had concluded in "shipwreck."[45]

5

Penultimate scene: High time to meet the female lead. Johanna van Gogh–Bonger, more than any single person aside from Vincent and Theo themselves, was responsible for the iconic status that Van Gogh now possesses. Vincent's well-bred, well-read sister-in-law was by no means his own style of woman. Nonetheless, the twenty-seven-year-old mother to whom he was in-

troduced on the morning of May 17 struck him as "charming and very simple and good" (he was writing to Wil).[46] The goodness that Vincent saw in Jo was both tactical and effective. On the one hand, she found her beloved husband's beloved and ever-needy brother a neurotic nuisance. On the other, her literary tastes drew her to Romantic rebels, to Percy Bysshe Shelley and Multatuli, and while she knew little about painting she was happy to place Vincent among that elect. To secure her marriage, she accepted its quasi-triangularity and opted for a charm offensive, writing Vincent radiantly generous letters long before they met face-to-face. She even dashed him a note as her labors started on January 29, 1890, asking him to pass her love to Theo should she not survive the birth.

When she herself ended up the survivor of the three, Jo, with her family background in finance, demonstrated great acumen in managing the estate. Vincent's first public advocate, Aurier (who was carried away by typhus in 1892), got just one main thing wrong: He supposed that the art could only ever be of interest to the avant-garde few. Jo, progressive and socialist in her sympathies, saw beyond this, sensing that on some levels Vincent's insistent and enraptured eye had indeed produced "a new, very simple, almost childlike painting," able "to move the most humble unsophisticated people."[47] Starting with a selective feed of outstanding items to exhibitions, she played a long game with the oeuvre, holding together the great mass of material that would eventually find a home in Amsterdam's Van Gogh Museum. Alongside her role in preparing modern art's most popular shrine, Jo as a sophisticated reader recognized that the letters constituted a literary masterpiece, and she was translating a near-complete edition of them into English when she died in 1925, passing on her responsibilities to her son, by then a successful engineer.

On that Saturday morning in May 1890, what she saw as the door of the young couple's apartment opened was "a sturdy,

broad-shouldered man" (to quote her invaluable memoir), one who in fact looked "much stronger than Theo." The brothers gathered over the baby's cradle, tender tears in their eyes. The reunion was precious and Jo found Vincent "cheerful," but apart from that, what was the plan? Things had been so rushed that no one seemed sure. Vincent, who also observed his brother's frailty, reviewed the accumulated stock of canvases he'd been posting on to the apartment; went out to see a couple of exhibitions and to call on Tanguy; and then on the Tuesday morning, sensing that he was de trop between the father's hacking cough and the infant's wails, abruptly headed on north.

A seventeen-mile train ride took Vincent to Auvers-sur-Oise, on the north bank of one of the low valleys winding down towards the Seine below Paris. He had the address of Paul Gachet, a doctor in his early sixties known to Theo through his association with the artists who had flocked to the village. Charles-François Daubigny, long cherished by Vincent as a colleague of Millet's and Corot's, had painted lyrical views of the Oise before dying in Auvers in 1878; Pissarro and Cézanne had also received Gachet's hospitality, and Daumier his medical services. Gachet was a general practitioner, but the notion was that he could offer both stability and sensitivity while the insecure Vincent practiced his art in healthful country air. After calling on this contact on arrival in Auvers, Vincent wasn't so sure: The Gachet residence felt "dark, dark, dark" and the good doctor quite as "eccentric" as himself.[48] Ignoring his host's recommendation of a respectable inn, he checked into a no-nonsense cheap *relais* just up from the station, run by a couple who'd gotten out of Paris.

What was Vincent's status at this juncture, and what was his mental state? Before leaving the asylum, in his parting fury of productivity, he had written that "the brushstrokes go like a machine"[49] and a few days later, in a strikingly dissociated construction, that "my mind feels absolutely serene and the brushstrokes come to me and follow each other very logically."[50] Vincent's

painting hand and his verbal, articulate consciousness were now comfortably coexisting on separated planes, and this detachment shows through in many of the canvases he tackled as soon as he had a base to set out from in Auvers. He bashed at them, planting the primed rectangles of cloth with hooks, streaks and splurts in a heedless, headlong "translation" of the scenes before his eyes. His color instincts were ever more bold, unerring and lyrical, while the drawing now rode a rolling sea of waveforms, here coasting and skidding, there submitting to its rhythms.

The quaint thatched cottages of Auvers and its medieval church were nostalgically "beautiful" and pictorially malleable, in much the same way that the memories of rural Brabant had been when Vincent was cooped up in his asylum room not many weeks before.[51] And yet the intervening brief stopover in Paris, giving him a chance to check out the galleries and the magazines in Theo's apartment, had been just enough to plant the seeds of a fresh idea. Against all those old forms of beauty, new forms of beauty were emerging. In this suburban-train-line country refuge,

> there are many villas and various modern and middle-class dwellings, very jolly, sunny and covered with flowers. That, in an almost lush countryside, just at this moment of the development of a new society in the old one, has nothing disagreeable about it; there's a lot of well-being in the air.[52]

That optimistic reading of the environment got expressed almost comically on the rainy June 12, when Vincent planted his easel on the valley banks northeast of the village to picture the Paris-bound train rushing on behind its "stark red roofs" while a horse and carriage splashed their way into the boondocks.[53] One might even read the rococo mannerisms running through much of the month's work — which was frantic, even by Vincent's standards — as a foretaste of the coming decade's futuristic

art nouveau. But most immediately, for Vincent, the suburban "well-being" of Auvers appealed as an alternative to the cramped metropolitan apartment he had recently stayed in, which he was convinced the young family should leave for the sake of their health. His energies also fuelled a campaign to lure them into a property hunt in these parts; on the sunny weekend before that rainstormy day, he had blithely led them out for a picnic in the fields, presenting his five-month-old nephew with a bird's nest and his first startling glimpses of farmyard cocks and cattle.

What had inspired this line in positive thinking? An enormous new painting, viewed in Paris at the Salon du Champ-de-Mars, by Pierre Puvis de Chavannes, a senior figure of French art much in demand for public commissions. *Inter artes et naturam* presented, in a stately and "simplified" frieze, thinkers, artists, craftsmen, mothers and children in a spectrum of trousers, ball-gowns, classical drapes and heroic nudity, all at peace in a paradise garden planted with young upright trees. It was "a strange and happy meeting of the very distant days of antiquity with raw modernity," in Vincent's eyes — a resolution of all those tensions he had wrestled with in his former letters to Bernard. Old and new forever flipped places, this image of eternity informed him, so that in his yearning to paint "the modern portrait," he was really hoping to deliver "portraits which would look like apparitions to people a century later." In that light, Vincent could approach the melancholy Dr. Gachet with a new empathy. Portraying this elderly red-haired neurotic, it was as if he were sketching out a conceivable version of his future self. In fact, "by looking at [Puvis's design] for a long time" — and here, as so often, Vincent's copy wonderfully improves on the original — "one would think one was present at an inevitable but benevolent rebirth of all things that one might have believed in, that one might have desired."[54]

Might have, might have. A bright new future awaited society, perhaps. Vincent was happy to be working, thrilled (after

the day of the picnic) that "the nightmare should have ceased to such an extent,"[55] but it remained true that he had "no talent" for relations with people and that he had never "perceived those to whom I'm most attached other than through a glass, darkly."[56] That New Testament quotation was vouchsafed to his mother, whom he addressed on June 13 in contrite gravity: "the why of parting and passing away and the persistence of turmoil, one understands no more of it [of life] than that."[57] As usual, he switched from signing off to her "Your loving / Vincent" to opening a new sheet, addressed to "My dear sister." This other sheet for Wil, which also pictured verbally the train in the rain, approached "the veil of time" from an alternate angle.[58] "I'm trying to express the desperately swift passage of things in modern life."[59]

6

Little Vincent Willem wailed and wailed. His mother was exhausted; she lay moaning in her sleep. The apartment, on this final night of June, was hot and sweaty. Theo could no longer bear it. The syphilis that so long had been gnawing at his body was starting now to close in on his brain. He seized the pen —*"My very dear brother"*— and let fly.

We don't know what we ought to do . . .
those rats Boussod & Valadon treat me . . .
finally tell them, Sirs, I'm taking the plunge . . .
What do you say to this old chap . . .
old chap . . . we'll battle all our lives . . .
we'll pull the plough . . .
[we won't] forget the daisies and the freshly stirred clods of earth . . .
nor the bare tree branches that shiver in winter . . .
nor the sun as it rose above our aunt's garden . . .

Et cetera, et cetera. At last he wore himself out. But when the sun arose on Tuesday, July 1, it was fixed in his head *"in an unshakable way,"* as a postscript to the rant affirmed. He would *"finally tell them."*[60]

"What do you want me to say as regards the future, perhaps, perhaps, without the Boussods?" Vincent, unused to playing the role of sane brother, spent most of his reply commending the benefits of country living. Nonetheless, perhaps Vincent ought to catch a train to Paris to talk it over with the poor "old chap"? Theo, who had swiftly pounced on his good friend Dries to demand backup for his dream of going it alone, came back on Vincent's offer with a seesawing *"don't bother to come, though if you do,"* incidentally passing comment on the astronomical profit that a Millet painting had just fetched in auction. That market news struck a dark chord with Vincent, who, it turned out, had been reading his Aurier rather too uncritically after all. The painter who had aspired to be a populist had come to the paranoiac conviction — even if friends such as Gauguin were now praising his work to the skies — that he was indeed among *les isolés,* an unhappy scatter of living artists who were bound to be dispossessed of their place in the sun by the all too formidable dead.

Vincent rolled up at the apartment on Saturday the sixth. Toulouse-Lautrec was there for lunch and regaled the Van Goghs and the Bongers — Dries was now married as well — with some macabre drollery, but only Vincent had the stomach to laugh. After Toulouse-Lautrec left, Theo's big plan became the topic, and things turned foul. Jo couldn't conceal the fact that on every level it alarmed her. Vincent, no less anxious but defensive of his brother, started shouting at Jo about some problem with the picture hanging. Then, horrified by the wreckage mounting up around him, he beat a hasty retreat to the station.

The following day and the next, he took stretched canvases from the supply he'd just bought two weeks before. They were

as broad as they were high, stretching out like a Puvis or like a
train, fit to send the eyes on hurtling journeys sideways. With
"the brush almost falling from my hands," Vincent painted
"immense stretches of wheatfields under turbulent skies, and I
made a point of trying to express sadness, extreme loneliness."
Because, he explained, his life was "attacked at the very root." It
was Vincent, this unprofitable *isolé*, this broken vessel, who had
pushed Theo into such a giddily exposed position by "living at
your expense," and Theo might now need to cut off the finan-
cial lifeline on which Vincent had so long depended in order to
survive.[61] This explanation was posted to Paris some five days
after the row, a wise letter from Jo having arrived to calm Vin-
cent's heart with assurances of the couple's continuing steadfast
devotion. The very exercise of creating the two most frantically
fluent canvases of his life must in itself have done something to
resolve the crisis. The painter may be in hell, but painting is still
heaven.

There was the good cheer of the inexpensive Auberge Ra-
voux to return to, where, with his "agreeable smile," Vincent was
always "well appreciated."[62] The witness here was Adeline Ra-
voux, who was thirteen years old when she sat for a brisk por-
trait, as did some local peasant girl, plus one of a gang of teen-
age brats from Paris who liked hanging around and teasing him.
(He was used to that sort of thing; there had been the lads at
Nuenen and the cabbage chuckers in Arles.) The hotel, whose
clientele included various other struggling painters, formed a
welcome counterbalance to the heavy meals and decorum chez
Gachet, fond though Vincent had become of the doctor. There
was also the challenge of composing his complex and "deliber-
ate" homage to the *genius loci* of Auvers, old Daubigny, using
another of his big canvases.[63] There was the further challenge
of redoing *Inter artes et naturam* without the *artes* — his age-
old trick of forgoing human figures so as to let tree roots do the
emotional talking.

There was all that, and it was doable, and he had developed a certain resilience that somehow enabled him to do it, a certain dissociation of the mind. "I'm wholly in a mood of almost too much calm, in a mood to paint that."[64] That broken-backed phrasing, gesturing towards some new landscape subjects, occurs in a letter to his mother and Wil posted in mid-July — the last but one of Vincent's that survives. But it was Theo with his *"finally tell them"* who was now the bad luck. Dries pulled out on his mad friend a few days on from the unfortunate Saturday. Vincent likewise wrote, joining Jo in urging Theo to back off.[65] Too late: Theo had gone with an ultimatum to *"those rats,"* his bosses, demanding a raise or he'd quit. No fools, they faced him down. By the twenty-second, when Theo got back from a family dash to Holland to present Vincent Willem to his grandmother, his three-week fury had left him with a complete loss of face, and he simply couldn't manage to come clean when he wrote back to his brother.

A fifty-franc bill, and "I hope, my dear Vincent, that your health is good," and "I'm a little afraid that there's something that's bothering you" and "do go and see Dr Gachet." It was clear enough to Vincent that whatever giddy journey Theo was engaged on, he himself would no longer be involved.

> I'd perhaps like to write to you about many things, but first the desire has passed to such a degree, and then I sense the pointlessness of it.

Thus Vincent started his reply, as if to stop right away, but then rallied. Some things ought to be said at least, even if brotherly trust had broken down and with it the taproot of whatever kind of life he still lived. It ought to be recorded that "through my intermediacy you have your part in the very production of certain canvases, which even in calamity retain their calm." The balance kept swinging, from sentence to sentence. It was only

a "moment of relative crisis." Yet the tension went on, between "dead artists" and "living artists," and why not switch over to the side that was winning?

> Ah well, I risk my life for my own work and my reason has half foundered in it — very well — but you're not one of the dealers in men; as far as I know and can judge I think you really act with humanity, but what can you do

and there Vincent stopped.[66] But only to start the letter all over again, heading it off towards an upbeat conclusion he could pop in the post. He went back to work and, writing no more, proceeded with another three days' painting. The morning of Sunday, July 27, was devoted to his close-up of tree roots on a hillside bank — of life forms struggling upwards, almost slipping. It was over lunch back at the Auberge Ravoux, presumably, that the balance tilted and settled. It happened that Monsieur Ravoux had a revolver, and that the teenagers had filched it, and that when they weren't looking, Vincent had pocketed it in turn. In his other pocket lay the alternate draft letter, with its *que veux-tu,* its "what can you do."

That afternoon, out of sight behind some barns, Vincent fired the revolver. It was a bad shot. In effect, it killed his brother. Theo van Gogh would stumble around heartbroken after Vincent's funeral for a further nine weeks before *finally telling those rats* he was leaving and almost immediately being admitted into care for the tertiary syphilis that finished him off on January 25, 1891. Before that, Theo was obliged to confront the consequences of Vincent's firearms inexperience. The bullet entered Vincent's body too low to hit the heart, and after passing out at some length, the candidate for suicide found there was still a living body to drag back that evening to the inn, where it lay in intermittent howling agonies for some thirty-odd hours.[67] Theo, summoned by telegram, spent the last dozen by his bed-

side in the hotel attic. The dying man — who might have been saved, given a competent surgeon, "and all for the want of a horseshoe nail" — was clear and resolute. "It is I who wanted to kill myself," the policeman's report recorded. And finally, in the darkness, with Theo beside him, half an hour into July 29, 1890: "I always wanted to die like this."

For pains would be settled in the big account, and, as the would-be man of God had written, practicing his sermons at the age of twenty-four, "we do not belong entirely to ourselves, as it were"; and as the inmate of the asylum had written, many years later:

> Do you know what I think about quite often — what I used to say to you back in the old days, that if I didn't succeed I still thought that what I had worked on would be continued. Not directly, but one isn't alone in believing things that are true. And what does one matter as a person then? I feel so strongly that the story of people is like the story of wheat, if one isn't sown in the earth to germinate there, what does it matter, one is milled in order to become bread.[68]

It is not recorded whether Theo agreed.

Notes

Unless otherwise noted, all letters quoted are from Leo Jansen, Hans Luitjen and Nienke Bakker, eds., *Vincent van Gogh: The Complete Letters* (London: Thames & Hudson, 2009).

Abbreviations
Anna van Gogh-Carbentus (AvG-C)
Theo van Gogh (TvG)
Vincent van Gogh (VvG)
Wilhelmina van Gogh (WvG)

Chapter 1: Saint

1 VvG to Anthon van Rappard, Nuenen, c. August 8–15, 1885, letter 526.
2 Elisabeth Huberta Du Quesne-van Gogh, *Personal Recollections of Vincent van Gogh,* trans. Katherine S. Dreier (Boston: Houghton Mifflin, 1913), p. 4.
3 VvG to TvG, Isleworth, c. September 2–8, 1876, letter 90.
4 AvG-C to TvG, March 23, 1890.
5 Du Quesne–van Gogh, *Personal Recollections of Vincent van Gogh,* chapter 1, note 2.
6 VvG to TvG, The Hague, March 17, 1873, letter 5.
7 VvG to TvG, The Hague, December 13, 1872, letter 2, and VvG to TvG, The Hague, mid-January 1873, letter 3.
8 Du Quesne–van Gogh, *Personal Recollections of Vincent van Gogh,* p. 19.
9 VvG to TvG, London, August 10, 1874, letter 28.

10 VvG to TvG, London, July 31, 1874, letter 27.

11 VvG to TvG, Paris, August 13, 1875, letter 40.

12 VvG to TvG, Paris, December 4, 1875, letter 59.

13 VvG to TvG, Paris, December 13, 1875, letter 62.

14 VvG to TvG, Paris, September 17, 1875, letter 49.

15 VvG to TvG, Paris, October 11, 1875, letter 55.

16 VvG to TvG, Paris, January 10, 1876, letter 65.

17 VvG to TvG, Ramsgate, May 31, 1876, letter 83.

18 VvG to TvG, Dordrecht, March 8, 1877, letter 106.

19 VvG to TvG, Welwyn, June 17, 1876, letter 84.

20 VvG to TvG and AvG-C, Ramsgate, April 17, 1876, letter 76.

21 VvG to TvG, Isleworth, October 7–8, 1876, letter 93.

22 VvG to TvG and AvG-C, Isleworth, November 17–18, 1876, letter 98.

23 VvG to TvG, Etten, April 8, 1877, letter 110.

24 VvG to TvG, Isleworth, August 8, 1876, letter 88.

25 VvG to TvG, Dordrecht, March 23, 1877, letter 109.

26 VvG to TvG, Amsterdam, July 9, 1877, letter 121.

27 VvG to TvG, Amsterdam, August 3, 1877, letter 125.

28 VvG to TvG, Amsterdam, January 9–10, 1878, letter 139.

29 VvG to TvG, Amsterdam, December 9, 1877, letter 137.

30 Thomas à Kempis, *The Imitation of Christ,* trans. George Stanhope (London: Routledge, 1893), p. 5.

31 V. W. van Gogh, *Vincent in the Borinage and Etten: Artist in the Making,* (Amsterdam: National Museum Vincent van Gogh, 1977), 13.

32 All quotes in the above two paragraphs from VvG to TvG, Laken, c. November 13 and 15/16, 1878, letter 148.

33 VvG to TvG, Wasmes, December 26, 1878, letter 149.

34 Both phrases from VvG to TvG, Petit-Wasmes, April 1–16, 1879, letter 151.

35 VvG to TvG, Wasmes, c. June 19, 1879, letter 152.

36 Three quotes from VvG to TvG, Petit-Wasmes, April 1–16, 1879, letter 151.

37 VvG to TvG, Laken, c. November 13 and 15/16, 1878, letter 148.

38 VvG to TvG, Wasmes, c. June 19, 1879, letter 152.

39 Quoted in Louis Piérard, *La Vie tragique de Vincent van Gogh,* rev. ed. (Paris: Éditions Correa, 1939), reproduced in Van Gogh's Letters, http://www.webexhibits.org/vangogh/letter/8/etc-143a.html.

40 Ibid.

41 Three quotes from VvG to TvG, Cuesmes, c. August 11–14, 1879, letter 154.

42 Quoted in Piérard, *La Vie tragique de Vincent van Gogh,* reproduced in Van Gogh's Letters, http://www.webexhibits.org/vangogh/letter/8/etc -143a.html.

43 Shakespeare, *King Lear,* act II, scene 4, lines 263–4.

Chapter 2: Sinner

1 Baudelaire does so in the opening chapter of his *Salon of 1846* (1846), dedicated "To the Bourgeoisie."

2 From ibid., reprinted in *Art in Paris,* ed. and trans. Jonathan Mayne (London: Phaidon, 1965), p. 41.

3 All quotes in paragraph from VvG to TvG, Cuesmes, c. June 22–24, 1880, letter 155.

4 VvG to TvG, The Hague, c. April 2, 1882, letter 214.

5 All quotes in this paragraph from VvG to TvG, Cuesmes, August 20, 1880, letter 156.

6 Thomas à Kempis, *The Imitation of Christ,* chapter 29, note 1.

7 Anthon van Rappard's letter of condolence to Anna van Gogh–Carbentus on Vincent's death in 1890, quoted in Johanna van Gogh-Bonger, unpublished memoir. Accessed at www.vggallery.com/misc/archives/jo_ memoir.htm.

8 VvG to TvG, Brussels, April 2, 1881, letter 164.

9 Ibid.

10 Jan Benjamin Kam to Albert Plasschaert, Helmond, June 12, 1912, in "Concordance, Lists, Bibliography: Documentation," *Vincent van Gogh: The Letters,* Van Gogh Museum and Huygens ING, available at http:// vangoghletters.org/vg/documentation.html.

11 The above quotations from Johanna van Gogh-Bonger, unpublished memoir.

12 The phrase was used in Vincent's account of the incident, VvG to TvG, The Hague, c. May 16, 1882, letter 228.

13 VvG to TvG, Etten, c. December 23, 1881, letter 193.

14 VvG to TvG, The Hague, December 1–3, 1881, letter 191.

15 VvG to TvG, The Hague, December 29, 1881, letter 194.

16 VvG to TvG, The Hague, January 21, 1882, letter 201.

17 The Amsterdam bookseller Cornelis van Gogh last appeared in this story during Vincent's days training for the priesthood back in 1877, teasing him over his disapproval of academic nudes.

18 VvG to TvG, The Hague, August 19, 1883, letter 376.

19 VvG to TvG, The Hague, June 1–2, 1882, letter 234.

20 I'm citing two discussions of the subject by Vincent: VvG to Anthon van Rappard, The Hague, May 28, 1882, letter 232, and VvG to TvG, The Hague, c. July 21, 1882, letter 249.

21 VvG to TvG, The Hague, May 1, 1882, letter 222.

22 Nor for that matter have Vincent's biographers taken to his liaison with Sien. Starting with his supposedly progressive-minded sister-in-law, they have held firm to their class consciousness. "A coarse, uneducated woman . . . who spoke with a vulgar accent and had a spiteful character": Jo Bonger's dismay gets reiterated in nearly every retelling of the story.

23 VvG to TvG, The Hague, June 9, 1882, letter 238.

24 VvG to TvG, The Hague, September 3, 1882, letter 260.

25 VvG to TvG, The Hague, May 2/3, 1883, letter 339.

26 VvG to TvG, The Hague, May 30, 1882, letter 233.

27 VvG to TvG, The Hague, June 3, 1883, letter 348.

28 VvG to TvG, The Hague, November 26–27, 1882, letter 288.

29 This inference is from VvG to TvG, The Hague, April 30, 1883, letter 338, and VvG to TvG, The Hague, June 3, 1883, letter 348.

30 VvG to TvG, The Hague, August 19, 1883, letter 376.

Chapter 3: Dog

1 VvG to TvG, Nieuw-Amsterdam, November 2, 1883, letter 402.

2 VvG to Anthon van Rappard, The Hague, August 13, 1882, letter 256.

3 VvG to TvG, The Hague, August 21, 1883, letter 378.

4 VvG to TvG, Hoogeveen, September 11–12, 1883, letter 385.

5 VvG to TvG, Hoogeveen, c. September 14, 1883, letter 386.

6 VvG to TvG, Nieuw-Amsterdam, November 2, 1883, letter 402.

7 For example, see VvG to TvG, The Hague, July 23, 1883, letter 365.

8 VvG to TvG, Nieuw-Amsterdam, c. October 31, 1883, letter 401.

9 VvG to TvG, Nieuw-Amsterdam, c. October 7, 1883, letter 393.

10 VvG to TvG, Nieuw-Amsterdam, c. October 16, 1883, letter 397.

11 VvG to TvG, Nieuw-Amsterdam, November 2, 1883, letter 402.

12 VvG to TvG, Hoogeveen, c. September 14, 1883, letter 386.

13 VvG to TvG, October 12, 1883, letter 394.

14 VvG to TvG, Nieuw-Amsterdam, December 1, 1883, letter 408.

15 In his sudden departure from the inn, he left behind a considerable pile of oil sketches. Some of these, legend has it, ended up fed to a stove by the innkeeper's daughter.

16 VvG to TvG, Nuenen, c. December 15, 1883, letter 413.

17 Ibid.

18 VvG to TvG, Nuenen, c. January 15, 1884, letter 422.

19 Theodorus van Gogh to TvG, Nuenen, February 10, 1884.

20 VvG to TvG, Nuenen, c. July 2, 1884, letter 451.

21 VvG to TvG, Nuenen, c. March 28, 1884, letter 443.

22 My responses to these paintings were sharpened by reading Debora Silverman's excellent essay "Weaving Paintings: Religious and Social Origins of Vincent van Gogh's Pictorial Labor," in *Rediscovering History: Culture, Politics, and the Psyche,* ed. Michael S. Roth (Stanford, CA: Stanford University Press, 1994), pp. 137–68.

23 Quotes from François Coppée's "Sadly," transcribed by VvG to Anthon van Rappard, Nuenen, c. March 2, 1884, letter 433.

24 VvG to TvG, Nuenen, c. November 14, 1885, letter 541.

25 VvG to TvG, Nuenen, c. September 21, 1884, letter 458.

26 The account here relies on evidence presented in Steven Naifeh and Gregory White Smith, *Vincent van Gogh: The Life* (New York: Random House, 2011), though the interpretation differs somewhat.

27 Dialogue quoted verbatim from VvG to TvG, Nuenen, c. September 16, 1884, letter 456.

28 Theodorus van Gogh to TvG, Nuenen, September 30, 1884.

29 Fyodor Dostoyevsky, *The Brothers Karamazov,* trans. David McDuff (Penguin, 2003).

30 VvG to TvG, Nuenen, c. September 21 1884, letter 458.

31 VvG to TvG, Nuenen, October 2 1884, letter 464.

32 VvG to TvG, Nuenen, c. September 22–29, 1884, letter 461.

33 VvG to TvG, Nuenen, c. December 16, 1884, letter 476.

34 VvG to TvG, Nuenen, c. October 25, 1884, letter 467.

35 VvG to TvG, Nuenen, c. November 2, 1884, letter 468.

36 For example, see VvG to TvG, Nuenen, October 22, 1884, letter 466, and VvG to TvG, Nuenen, c. September 2, 1885, letter 531.

37 VvG to TvG, Nuenen, c. July 2, 1884, letter 451.

38 The canvases were of varying sizes, but none more than twenty inches high.

39 VvG to Anton Kerssemakers, Nuenen, January 1–8, 1885, letter 478.

40 All preceding quotes from VvG to TvG, Nuenen, c. December 10, 1884, letter 474.

41 VvG to TvG, Nuenen, c. December 14, 1884, letter 475.

42 VvG to TvG, The Hague, November 26–27, 1882, letter 288, and VvG to TvG, The Hague, May 30, 1882, letter 233.

43 VvG to TvG, Nuenen, September 30, 1884, letter 463.

44 VvG to TvG, Nuenen, October 2, 1884, letter 464.

45 Speech by Johan de Meester given in 1931, reported in Jaap W. Brouwer, Jan Laurens Siesling, and Jacques Vis, *Anthon van Rappard, Companion and Correspondent of Vincent van Gogh: His Life and All His Works* (Amsterdam: Arbeiderspers, 1974), pp. 189–205.

46 Isaiah 53:3.

47 This is to translate into plain speech Vincent's reference to Anna's "absurd reproaches" and "unfounded presumptions about the future" in VvG to TvG, Nuenen, April 6, 1885, letter 490.

48 Quoted in VvG to TvG, Nuenen, April 21, 1885, letter 495.

49 Anthon van Rappard to Vincent van Gogh, Utrecht, May 24, 1885, letter 503.

50 VvG to TvG, Nuenen, c. June 9, 1885, letter 507.

51 Anton Kerssemakers to De Groene, Eindhoven, April 14, 1912 (trans. Johanna van Gogh-Bonger, ed. Robert Harrison), available at Van Gogh's Letters, http://webexhibits.org/vangogh/letter/15/etc-435c.htm.

52 VvG to TvG, Nuenen, c. November 7, 1885, letter 539.

53 VvG to TvG, Nuenen, c. October 28, 1885, letter 537.

Chapter 4: Adventurer

1 VvG to Horace Mann Livens, Paris, September/October 1886, letter 569.

2 Ibid.

3 VvG to TvG, Saint-Rémy-de-Provence, July 2, 1889, letter 784.

4 *The Meagre Company,* begun by Hals in 1633, was in fact completed by Pieter Codde. Both Vincent and Manet were influenced by the fresh interpretations given to Hals's art by the nineteenth-century French critic Théophile Thoré.

5 This and quotes above in VvG to TvG, Nuenen, c. October 10, 1885, letter 534.

6 For example, see VvG to TvG, Hoogeveen, c. September 21, 1883, letter 388.

7 VvG to TvG, Nuenen, c. July 14, 1885, letter 515.

8 VvG to Anthon van Rappard, Nuenen, c. August 8–15, 1885, letter 526.

9 VvG to TvG, Nuenen, c. July 14, 1885, letter 515.

10 VvG to TvG, Nuenen, c. October 28, 1885, letter 537.

11 VvG to TvG, Nuenen, c. October 13, 1885, letter 535.

12 VvG to TvG, Antwerp, December 14, 1885, letter 547.

13 Quotes from VvG to TvG, Antwerp, c. January 2, 1886, letter 551.

14 Victor Hageman, interview by Louis Piérard, January 1914, available at *"Les Marges:* 'Van Gogh in Antwerp,'" Van Gogh Gallery, http://www.vggallery.com/misc/archives/hageman.htm.

15 Ibid.

16 An Antwerp doctor later recalled treating Vincent for syphilis, yet no note is made of this incurable infection in his medical records for the years 1889 and 1890. Assuming the doctor's memory was correct, the condition might have been in deep remission. But it is hard to specify any point during the remainder of his life at which awareness of a distinct medical death sentence factored into Vincent's thinking.

17 Andries Bonger to his parents, Paris, April 4, 1885, available at Van Gogh's Letters, http://www.webexhibits.org/vangogh/letter/15/etc-T42.htm.

18 Andries Bonger to his parents, Paris, March 17, 1886, available at Van Gogh's Letters, http://www.webexhibits.org/vangogh/letter/17/etc-462a.htm.

19 VvG to TvG, Paris, c. February 28, 1886, letter 567.

20 Strictly speaking, this is an inference with a good degree of probability; the evidence does not directly prove it. This is the case with many of the connecting details from this point onwards in the present chapter. In this section of the story, when Vincent is living with Theo, we have very few letters to use as documentary support.

21 A. S. Hartrick quoted in Martin Bailey, "Memories of Van Gogh and

Gauguin: Hartrick's Reminiscences," *Van Gogh Museum Journal* (2001): 96–105; available at http://www.dbnl.org/tekst/_van012200101_01/_van012200101_01_0007.php.

22 Or neoimpressionism or, later, divisionism. Vincent usually referred to all the types of painting he had seen at this point, including Seurat's, as impressionism.

23 Victor Hageman, interview by Louis Piérard, January 1914.

24 VvG to WvG, Arles, June 16–20, 1888, letter 626.

25 VvG to TvG, Nuenen, c. October 28, 1885, letter 537.

26 Andries Bonger to his parents, Paris, June 23, 1886, available at Van Gogh's Letters, http://www.webexhibits.org/vangogh/letter/17/etc-462a.htm.

27 That is all of her name that the records supply.

28 Andries Bonger to his parents, Paris, quoted in Naifeh and White Smith, p. 511, n. 179.

29 VvG and Andries Bonger to TvG, Paris, c. August 18, 1886, letter 568.

30 VvG to Horace Mann Livens, Paris, September/October 1886, letter 569.

31 The comment — or inference — as well as the remembered pronunciation *Ye-ssous* is reported by Thadée Natanson, a friend of Toulouse-Lautrec's, in her book *Un Henri de Toulouse-Lautrec* (Geneva: P. Cailler, 1951), excerpted in *Toulouse-Lautrec: A Retrospective,* ed. Gale B. Murray (New York: Hugh Lauter Levin Associates, 1992), p. 107.

32 The recollection drawn on here is not in fact Vincent's but Bernard's: "An extremely beautiful Italian woman who let sprawl her robust and imposing charms onto a bar-top she made exclusively hers."

33 TvG to WvG, Paris, March 14, 1887, available at Van Gogh's Letters, http://www.webexhibits.org/vangogh/letter/17/etc-fam-1886.htm.

34 I offer it because there is no way to know which is the most accurate.

35 VvG to TvG, Paris, c. July 23–25, 1887, letter 572.

36 This is no more than a *possible* inference from the available evidence as to Vincent's and Bernard's comings and goings, which appear contradictory.

37 Though Anquetin's canvas demonstrably affected Vincent's approach, it now seems to be in such bad condition that there is little point in reproducing it.

38 See VvG to TvG, Nuenen, c. October 28, 1885, letter 537, n. 9.

39 VvG to Émile Bernard, Paris, c. December 1887, letter 575.

40 VvG to TvG, Antwerp, c. February 6, 1886, letter 559.

41 VvG to TvG, Antwerp, c. February 9, 1886, letter 560.

42 VvG to WvG, Paris, late October 1887, letter 574.

43 Ibid.

44 The Spanish painter Antonio Cristobal's reminiscences, "Notes et souvenirs: Vincent van Gohg [*sic*]," was published in a Montmartre magazine named *La Butte* on May 21, 1891.

45 All above quotes from VvG to WvG, Paris, late October 1887, letter 574.

46 Gustave Coquiot, whose *Vincent van Gogh* (Paris: Ollendorff, 1923) offers lively reminiscences of the late 1880s Montmartre scene, claims to have met Vincent at this brothel.

47 Naifeh and Smith, in *Vincent van Gogh: The Life,* emphasize this anxiety, quoting a later letter Vincent wrote to his mother about Theo: "It is a good thing that I did not stay in Paris, for we, he and I, would have become too close" (VvG to AvG-C, Saint-Rémy-de-Provence, c. December 23, 1889, letter 831).

48 VvG to WvG, Arles, June 16–20, 1888, letter 626.

49 Ibid.

Chapter 5: "Japan"

1 VvG to WvG, Paris, late October 1887, letter 574.

2 VvG to TvG, Arles, March 21/22, 1888, letter 588.

3 VvG to Paul Gauguin, Arles, October 17, 1888, letter 706.

4 Ibid.

5 See, for example, VvG to TvG, Arles, c. March 16, 1888, letter 585.

6 VvG to Émile Bernard, Arles, March 18, 1888, letter 587.

7 VvG to TvG, Arles, April 9, 1888, letter 594.

8 Gustave Kahn, "Peinture: Exposition des Indépendants," *La Revue Indépendante* 7, no. 18 (April 1888): 163, quoted in ibid., n. 15.

9 VvG to TvG, Arles, April 9, 1888, letter 594.

10 Quotes from VvG to TvG, Arles, c. March 3, 1888, letter 592.

11 VvG to Émile Bernard, Arles, c. April 12, 1888, letter 596.

12 VvG to WvG, Paris, late October 1887, letter 574.

13 VvG to WvG, Arles, c. March 30, 1888, letter 590.

14 VvG to TvG, Arles, c. April 11, 1888, letter 595.

15 VvG to WvG, Arles, June 16–20, 1888, letter 626.

16 VvG to TvG, Arles, c. March 16, 1888, letter 585.

17 The above quotes from VvG to TvG, Arles, May 4, 1888, letter 604.

18 Ibid.

19 VvG to TvG, Arles, c. June 5, 1888, letter 620.

20 Ibid.

21 VvG to TvG, Arles, September 18, 1888, see letter 683.

22 VvG to TvG, Arles, c. June 5, 1888, letter 620.

23 VvG to Émile Bernard, Arles, c. June 19, 1888, letter 628.

24 VvG to Émile Bernard, Arles, June 27, 1888, letter 633.

25 VvG to TvG, Arles, August 18, 1888, letter 663.

26 VvG to TvG, Arles, c. June 15–16, 1888, letter 625.

27 VvG to TvG, Arles, July 5, 1888, letter 636.

28 VvG to TvG, Arles, July 15, 1888, letter 642.

29 Both quotes from VvG to TvG, Arles, c. August 12, 1888, letter 659.

30 VvG to Émile Bernard, Arles, c. June 19, 1888, letter 628.

31 VvG to TvG, Arles, July 9/10, 1888, letter 638.

32 Luke 24:5, quoted in VvG to WvG, Paris, late October 1887, letter 574.

33 VvG to TvG, The Hague, May 1, 1882, letter 222.

34 VvG to TvG, Arles, September 3, 1888, letter 673.

35 This is what Vincent himself reported. The tale that he painted *Starry Night over the Rhône* under the light of candles fixed to his straw hat is charming but implausible.

36 VvG to TvG, Arles, September 3, 1888, letter 673.

37 VvG to TvG, Arles, May 26, 1888, letter 613.

38 VvG to TvG, Arles, July 9/10, 1888, letter 638.

39 VvG to TvG, Arles, August 6, 1888, letter 656. For this sublime passage I quote from Mark Roskill, ed., *The Letters of Vincent van Gogh* (New York: Touchstone, 2008), p. 275. Though Jansen, Luijten and Bakker are impeccable translators, they have a less poetic ear.

40 VvG to TvG, Arles, September 8, 1888, letter 676.

41 VvG to TvG, Arles, September 9, 1888, letter 677.

42 All quotes from VvG to TvG, Arles, September 8, 1888, letter 676.

43 VvG and Andries Bonger to TvG, Paris, c. August 18, 1886, letter 568.

44 VvG to TvG, Arles, September 18, 1888, letter 683.

45 VvG to Émile Bernard, Arles, c. August 5, 1888, letter 655.

46 All quotes from ibid.

47 VvG to TvG, Arles, September 3, 1888, letter 673.

48 VvG to TvG, Arles, September 18, 1888, letter 682.

49 Ibid.

50 The irony of Vincent's underestimate should need no underlining.

51 VvG to TvG, Arles, September 18, 1888, letter 683.

52 VvG to TvG, Arles, October 16, 1888, letter 705.

53 VvG to TvG, Arles, September 25, 1888, letter 687.

54 VvG to TvG, Arles, September 26, 1888, letter 689.

55 VvG to TvG, Arles, October 21, 1888, letter 709.

56 VvG to TvG, Arles, October 22, 1888, letter 710.

57 Gauguin's stay in Arles is excellently described in Martin Gayford's *The Yellow House: Van Gogh, Gauguin, and Nine Turbulent Weeks in Arles* (New York: Little, Brown and Company, 2006) in closer detail than the scope of the present book allows.

58 VvG to Paul Gauguin, Arles, October 3, 1888, letter 695.

59 VvG and Paul Gauguin to Émile Bernard, Arles, November 1/2, 1888, letter 716.

60 The details of this sale, which is alluded to in a letter to Theo dated October 8, 1888, are unclear.

61 For example, in Paul Gauguin to VvG, Pont-Aven, October 1, 1888, letter 692, in HB.

62 VvG to TvG, Arles, November 10, 1888, letter 718.

63 VvG to TvG, Arles, August 21/22, 1888, letter 666.

64 VvG to TvG, Arles, c. December 1, 1888, letter 723.

65 VvG to TvG, Arles, December 17/18, 1888, letter 726. Jansen, Luijten and Bakker give either a Monday or a Tuesday for this report on a visit taken "yesterday." I think it more likely that the painters conformed to normal working habits and did their gallery visit on a Sunday.

66 Author's translation of newspaper cutting reprinted in Marc Edo Tralbaut, *Van Gogh, le mal aimé* (Lausanne: Edita, 1969), p. 268.

67 The approach is also indebted to the review of the evidence undertaken in Gayford, *The Yellow House*.

68 VvG to Paul Gauguin, Arles, January 4, 1889, letter 730.

69 VvG to TvG, Arles, January 28, 1889, letter 743.

70 VvG to TvG, Arles, February 3, 1889, letter 745.

71 M. Jullian quoted in Tralbaut, *Vincent van Gogh,* p. 269.

72 This witness, Jeanne Calment, died in Arles in 1997, a global celebrity on account of her 122 years and the last person to have seen Vincent van Gogh alive.

73 *Petition, proces-verbal et Enquete,* February–March 1889.

74 Author's translation of this public document.

75 VvG to TvG, Arles, March 24, 1889, letter 752.

76 VvG to TvG, Arles, August 15, 1888, letter 662.

Chapter 6: Broken

1 Vincent's youngest sibling, Cor, with whom he had little to do, seems also to have had troubled patterns of behavior before his suicide in the Transvaal in 1900.

2 VvG to TvG, Saint-Rémy-de-Provence, July 14/15, 1889, letter 790; emphasis added.

3 VvG to TvG, The Hague, November 26–27, 1882, letter 288.

4 The latter, privately, did not reciprocate Vincent's goodwill. Appalled by the colouristic outrages of this "miserable, wretched man," he used the gifted painting as the back wall of a chicken coop, a status from which it was rescued by a persistent researcher twenty years later. Rey's impressions of Vincent are collected in Susan Alyson Stein, ed., *Van Gogh: A Retrospective* (New York: H. L. Levin Associates, 1986).

5 VvG to TvG, Saint-Rémy-de-Provence, c. May 23, 1889, letter 776.

6 Ibid.

7 VvG to WvG, Arles, August 21/22, 1888, letter 667.

8 VvG to TvG, Saint-Rémy-de-Provence, c. June 18, 1889, letter 782.

9 VvG to TvG, Arles, April 9, 1888, letter 594.

10 VvG to TvG, Saint-Rémy-de-Provence, c. June 18, 1889, letter 782.

11 Quotes from TvG to VvG, Paris, June 16, 1889, letter 781.

12 VvG to TvG, Arles, March 29, 1889, letter 753.

13 VvG to TvG, Saint-Rémy-de-Provence, June 25, 1889, letter 783.

14 VvG to TvG, Saint-Rémy-de-Provence, July 2, 1889, letter 784.

15 VvG to TvG, Saint-Rémy-de-Provence, June 25, 1889, letter 783.

16 VvG to TvG, Arles, April 28 1889, letter 763.

17 VvG to TvG, Saint-Rémy-de-Provence, August 22, 1889, letter 797.

18 VvG to TvG, Saint-Rémy-de-Provence, September 10, 1889, letter 801.

19 Ibid.

20 VvG to TvG, Saint-Rémy-de-Provence, September 5–6, 1889, letter 800.

21 VvG to TvG, Saint-Rémy-de-Provence, c. October 8, 1889, letter 810.

22 VvG to Émile Bernard, Saint-Rémy-de-Provence, c. November 26, 1889, letter 822.

23 All the above quotes from ibid.

24 VvG to TvG, Saint-Rémy-de-Provence, September 10, 1889, letter 801.

25 VvG to TvG, Saint-Rémy-de-Provence, c. December 19, 1889, letter 829.

26 VvG to TvG, Saint-Rémy-de-Provence, c. September 20, 1889, letter 805.

27 VvG to AvG-C, Saint-Rémy-de-Provence, c. December 23, 1889, letter 831.

28 VvG to TvG, Saint-Rémy-de-Provence, February 1, 1890, letter 850.

29 Albert Aurier, "Les Isolés: Vincent van Gogh," *Mercure de France,* January 1890, in *Art in Theory, 1815–1900,* ed. Charles Harrison, Paul Wood, and Jason Gaiger, trans. Peter Collier (Oxford: Blackwell, 1998), pp. 948–52.

30 Joseph Isaäcson, "Parijsche brieven III: Gevoelens over de Nederlandsche kunst op de Parijsche Wereld-tentoonstelling [Paris Letters III: Feelings about the Dutch Art at the Paris World Exhibition]," *De Portefeuille,* August 17, 1889.

31 TvG to VvG, Paris, December 8, 1889, letter 825.

32 All the quotes in this paragraph from Aurier, "Les Isolés," in Harrison, Wood, and Gaiger, eds., *Art in Theory.*

33 VvG to TvG, Saint-Rémy-de-Provence, February 1, 1890, letter 850.

34 VvG to TvG, Saint-Rémy-de-Provence, September 10, 1890, letter 801.

35 VvG to WvG, Saint-Rémy-de-Provence, February 19, 1890, letter 856.

36 VvG to AvG-C, Auvers, June 13, 1890, letter 886.

37 VvG to TvG, Saint-Rémy-de-Provence, c. January 13, 1890, letter 839. Jansen, Luijten and Bakker translate the phrase more biblically as "broken pitcher."

38 VvG to AvG-C, Saint-Rémy-de-Provence, February 19, 1890, letter 855.

39 VvG to TvG, Saint-Rémy-de-Provence, September 5–6, 1889, letter 800.

40 VvG to TvG, Saint-Rémy-de-Provence, April 29, 1890, letter 863.

41 VvG to TvG, Saint-Rémy-de-Provence, c. March 17, 1890, letter 857.

42 VvG to Émile Bernard, Saint-Rémy-de-Provence, c. November 26, 1889, letter 822.

43 VvG to TvG, Saint-Rémy-de-Provence, April 29, 1890, letter 863.

44 VvG to Paul Gauguin, Auvers-sur-Oise, c. June 17, 1890, RM 23.

45 VvG to TvG, Saint-Rémy-de-Provence, c. May 1, 1890, letter 865.

46 VvG to WvG, Auvers-sur-Oise, c. May 21, 1890, RM 19.

47 All the quotes in this paragraph from Aurier, "Les Isolés," in Harrison, Wood, and Gaiger, eds., *Art in Theory.*

48 VvG to TvG and Johanna van Gogh-Bonger, Auvers-sur-Oise, May 20, 1890, letter 873.

49 VvG to TvG, Saint-Rémy-de-Provence, c. May 1, 1890, letter 865.

50 VvG to TvG, Saint-Rémy-de-Provence, May 13, 1890, letter 872.

51 Vincent reaches for the word in his first letter from Auvers: VvG to TvG and Johanna van Gogh-Bonger, Auvers-sur-Oise, May 20, 1890, letter 873.

52 VvG to TvG and Johanna van Gogh-Bonger, Auvers-sur-Oise, May 25, 1890, letter 875.

53 VvG to WvG, Auvers-sur-Oise, June 13, 1890, letter 886.

54 All quotes regarding Puvis from VvG to WvG, Auvers-sur-Oise, June 5, 1890, letter 879.

55 VvG to TvG and Johanna van Gogh-Bonger, Auvers-sur-Oise, June 10, 1890, letter 881.

56 VvG to TvG and Johanna van Gogh-Bonger, Auvers-sur-Oise, c. May 21, 1890, letter 874.

57 VvG to AvG-C, Auvers, June 13, 1890, letter 885.

58 VvG to TvG, Arles, March 29, 1889, letter 753.

59 VvG to WvG, Auvers-sur-Oise, June 13, 1890, letter 886.

60 All italicised quotes from TvG to VvG, Paris, June 30–July 1, 1890, letter 894.

61 The above four quotes from VvG to TvG and Johanna van Gogh-Bonger, Auvers-sur-Oise, c. July 10, 1890, letter 898.

62 Adeline Carrié-Ravoux, "Recollections on Vincent van Gogh's Stay in Auvers-sur-Oise," in Stein, ed., *Van Gogh: A Retrospective,* pp. 214–15.

63 VvG to TvG, Auvers-sur-Oise, July 23, 1890, letter 902.

64 VvG to AvG-C and WvG, Auvers-sur-Oise, c. July 10–14, 1890.

65 This letter is lost, though Theo's reply is extant (TvG to VvG, Paris, July 22, 1890, letter 901).

66 Above quotes from VvG to TvG, Auvers-sur-Oise, July 23, 1890, RM 25.

67 The hypothesis that the bullet was fired by one of the thugs from Paris, advanced by Naifeh and Smith in *Vincent van Gogh: The Life,* has been examined by Louis van Tilborgh and Teio Meedendorp from the Van Gogh Museum in Amsterdam ("The Life and Death of Vincent van Gogh," *Burlington Magazine* 155, no. 1324 [July 2013]: 456–62). The latter authors point out that what appears one of the strongest points in favor — that the gunshot was described as "too far out" to have been fired by Vincent — is based on a misunderstanding of the original French. By "*trop en dehors,*" the original report merely indicated that the bullet entered the body "too far to one side to hit the heart directly" — to quote van Tilborgh and Meedendorp, who proceed to dismiss the hypothesis conclusively, as far as I can see. My account of Vincent's final days is indebted to their scrupulous analysis.

68 VvG to TvG, Saint-Rémy-de-Provence, c. September 20, 1889, letter 805.

JULIAN BELL is a painter and writer who lives in Lewes, England. He is the author of *Mirror of the World: A New History of Art* and *What Is Painting? Representation and Modern Art*, among other books.

Made in the USA
Middletown, DE
06 November 2022

14193220R00106